WAYNE F. MILLER

Dear Wayne — A. — I think you are turning em out of a quality that warms the cockles of the old mans heart. Dont worry about hizote. You are headed in a warmer more human direction — dont be afraid to move in on close ups — Shoot more color — thats the only way to get national circulation — Hook is doing a Saratoga release story — and they are using the wounded gunner — I think its one of the finest pictures we have. —

I cant figure out how you can amuck of Cinpac photo to displeasure but they officially asked to have your orders altered and Cdr. Hollingsworth promptly complied — I think the original Pacific order, should be modified to cover our type of work as an exception — I believe that Admiral Radford feels that way about it — Bristol & Jacob are out there now with carriers — Wylee coming soon — The status of the unit gets better all the time — a job

Letter from Captain Steichen to Lieutenant Miller on his Pacific Theater photography, 1943

This book is dedicated to the Stephen Daiter Gallery.

—Wayne F. Miller, 2008

pH powerHouse Books Brooklyn, NY

WAYNE F. MILLER
PHOTOGRAPHS
1942–1958

Edited by Stephen Daiter Essay by Kerry Tremain

Introduction by Fred Ritchin Afterword by Paul Berlanga Additional commentary by Gordon Parks and Amy Dru Stanley

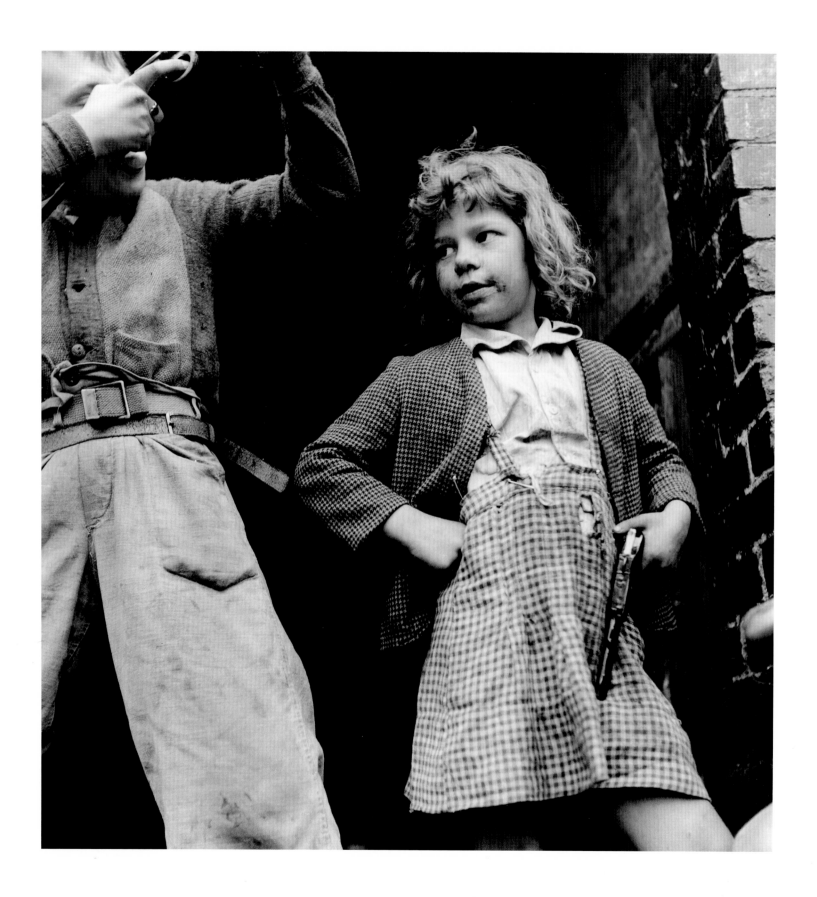

Younger siblings of Detroit gang members, 1947

Introduction

The world war was over. The planet had been engulfed by madness and tens of millions of people had died as a result. Families nearly everywhere had suffered horrific losses and were coping with the physically and spiritually wounded and the disabled. The existence of concentration camps and the immediate devastation caused by the atomic bomb had made it all too clear that murder on a mass scale was now part of modern life.

Due largely to the emergence of photography in the 1930s as an intimate recorder of events, Americans had become newly and viscerally aware of the results of large-scale violence and victimization. The development of more portable small-format cameras and light-sensitive films had only recently allowed pictures to be made both spontaneously and close up. Picture magazines such as *Life*, another relatively new phenomenon, had brought these depictions of war into millions of homes.

The photographers who had endured the repetitive horrors of the conflagration were themselves in need of new, more healing pursuits. Wayne F. Miller was among the select few who had documented World War II as a member of Edward Steichen's elite naval combat photo unit. His photographs of sailors were comradely and intimate; his images of Hiroshima a few weeks after the dropping of the atomic bomb were desolate and funereal. These extremes of war would instill in him, as they did so many others, the need to create an alternative way in which to frame the rest of his life. As one who had witnessed firsthand the unimaginable parameters of violence, Miller was among those ready to embrace more salutary points of view.

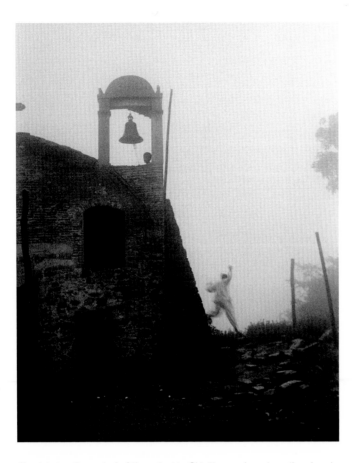

Proclaiming the arrival of the priest in Chintipan, a boy rings the church bell while another jumps down to greet him. 1957

While a disparaging and exotic regard for some other peoples labeled "primitive" remained, there was a tendency in mass media to find commonalities in a world so recently torn apart. (One wonders if after the September 11 attacks a similarly embracing spirit would have helped, rather than a vindictive one.) *Life*, where Miller worked for a time as a photographer, as well as other publications, began to explore the workings of diverse cultures. *The Family of Man*, an extraordinarily ambitious photographic exhibition that in ways was like a magazine-style collage, utilizing 503 photographs culled from some two million, stressed the similarities among peoples and their rituals and desires, intentionally glossing over many of their differences. Curated by Edward Steichen, who was again assisted by Wayne F. Miller, the exhibition opened at New York's Museum of Modern Art in 1955 and traveled worldwide; the book of the same name would sell millions of copies.

Similarly in pursuit of a global vision, Magnum Photos, the legendary photographers' cooperative that Miller would join, was formed in 1947, two years after the United Nations, as a way for its battle-scarred founders Robert Capa, Henri Cartier-Bresson, George Rodger, and David "Chim" Seymour to work independently, able to wander through large swaths of a more peaceful world while reporting on the emergence of new societies. Miller, who would not join Magnum until 1958, was already working in the late 1940s on a self-assigned documentary project supported by two Guggenheim grants in the South Side of Chicago. There he photographed a robust African-American community, searching for his own family of man. While he photographed many luminaries, including Gwendolyn Brooks, Duke Ellington, Ella Fitzgerald, and Eartha Kitt, his primary focus was on the lives of ordinary citizens: a father and son sitting together on the sand next to Lake Michigan, a strike captain at a protest, a kangaroo court for juveniles, and a Wednesday night Bible class. While some photographers would travel halfway around the world in pursuit of discoveries, for Miller new worlds could be found in a nearby hometown neighborhood that was to him previously unknown and, in many ways, a universe unto itself.

The straightforward, inquisitive imagery he made here and elsewhere reflected his own curiosity and feelings of solidarity with other members of a larger humanity. He was not one who suffered from the nearly generic compassion expressed by many photographers when confronted by situations that they sometimes barely understand. He was willing to work

modestly, not pretending in his pictures to know more than he did. As Miller once rather explicitly told a reporter, "I won't turn a nice guy into a son-of-a-bitch or a son-of-a-bitch into a nice guy."

He was less blunt and more celebratory in his extensive photography of his wife and their four children. Before many other professionals would focus on domesticity, Miller photographed its joys, its conflicts, and its quotidian details. He also collaborated on *A Baby's First Year* with the influential pediatrician Dr. Benjamin Spock, and created his own landmark photographic book project, *The World is Young*.

While his career as a photographer would turn out to occupy only a relatively small part of his life, Miller created a strong and indelible body of work ranging from the ethereal and surreal to the palpably compassionate. In fact, if the best of his photographs are placed together they constitute not only a powerful record of American hopes and tragedies during the middle of the last century, but a vision that evokes an artist's struggle with darkness while trying to find, both literally and figuratively, the light.

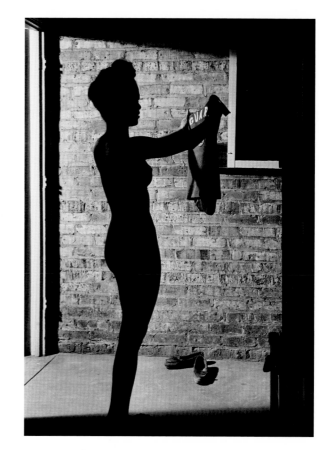

Bronzeville lifeguard in silhouette, 1946–48

Miller retired from photography in 1976 and changed careers, working in conservation. He and his wife Joan maintained a forest grove in Northern California; they would also establish their own vineyard. Now nearing 90, he and Joan (who, photographed by Miller, appeared in *The Family of Man* giving birth over half a century ago) still live near to their children in the redwood home they helped to design back in 1950. It is as if he, and his wife, have always kept a balance among family, work, and the concerns of a fragile planet.

After all, as Miller once put it: "Good images emerge from good dreaming." One has the sense, based upon his life's work, that if he had his way there would be no nightmares, even if they made for more dramatic pictures. At the core, people were always more important—whether his family or the larger planetary family—than any photograph.

This, in fact, may be the greatest compliment that can be paid to a social documentary photographer.

Fred Ritchin
Professor of Photography and Imaging, Tisch School of the Arts at New York University

LIFE

TIME & LIFE BUILDING
ROCKEFELLER CENTER
NEW YORK 20

October 28, 1950

Wayne Miller:

Although this is probably the
least pictorial of any LIFE issues I can
remember it really needed pictures like
yours. Thanks for the help you gave us.

Edward K. Thompson

RCE5

NY5/CE APR 9

TO: WAYNE MILLER (PERSONAL)

FROM: GENE SMITH

YOU HAVE MY SINCERE APPRECIATION OF YOUR DEEPLY SENSITIVE COVERAGE.

HB 426P

Ebony

January 23, 1953

Dear Wayne: We won two awards this year. Both
were your pictures. They had some
difficulty in printing the awards and I am still
waiting for one more award to come.

As soon as I get them I will send
both of your awards to you.

Congratulations and good luck for
the future. Will write you more later.

Sincerely,

LeRoy Winbush

Mr. Wayne Miller
10 Highland Court
Orinda, California

lw:dj

1820 SOUTH MICHIGAN AVENUE · CHICAGO 16, ILLINOIS

Telegram to Wayne F. Miller from W. Eugene Smith, 1944
Letters to Wayne F. Miller from Edward K. Thompson, *Life* Magazine, 1950,
LeRoy Winbush, *Ebony*, 1953

Seeing Feeling

From under the airplane, between the bomber's wheels, the camera catches the whir of the propeller, two taut lines of cable, and a man with his arm thrust upward toward the sun. Alert, on the other side of the aircraft carrier, crewmen watch for the signal. In an instant the arm will drop, and the cable will catapult pilot and plane into the ocean sky.

The unseen man holding the camera is a young World War II naval officer, Wayne F. Miller, whose entry into photography was likewise swift and eventful. A few short years after his father gave him a camera as a high school graduation gift, he was aboard the USS *Saratoga* in the Pacific, cataloging and sharing the battle anxieties and camaraderie of the carrier's crew. Edward Steichen, the twentieth-century photographic eminence, and a father figure and mentor to the younger man, commanded his combat photo unit from Washington, D.C. In three years of war, Miller witnessed the invasion of the Philippines, rendezvoused with troops preparing to land in southern France, recorded America's grief for its fallen president, and finally photographed the devastation of Hiroshima by the atomic bomb.

In California, over half a century later, Miller places a large print on his dining room table. The photograph shows the American invasion fleet in the Philippines, with puffs of black smoke scattered across the sky above the Lingayen Gulf. Miller is now almost 90 years old, with a bypass operation and a stroke already behind him. He is amiable and intelligent, a tall man whose silver-white hair still rolls in generous waves across his large head. An olive shirt and pants heighten the impression of an officer at ease. He lifts the edge of the print with thick fingers.

The Japanese, he explains, attacked at dusk when their fighter planes were hard to see against the fading sun and ocean clouds. The American ships shot into the air—the puffs of smoke—in an attempt to hit the suicidal kamikaze pilots before they could dive into their targets. Once, he watched helplessly as a kamikaze headed for his own ship. "My bowels were loose," Miller admits. Nonetheless, he aimed his camera at the approaching Japanese pilot, capturing his impassive gaze. Seconds later, confused by the ship's tall radar tower, the pilot overshot and crashed into the ocean. But four other ships in Miller's convoy were struck and the men on them killed.

Miller also photographed crewmen easing a wounded gunner from a bullet-ridden plane in the manner of Jesus being lowered from the cross. Steichen considered the image one of the finest of the war. But when he looked through the viewfinder, Miller didn't yet know that he himself had been saved from death. Hidden from view inside the plane lay the body of the air squadron photographer, who had begged Miller to let him take his place on the fatal flight.

Unlike some of his shipmates, Miller found no solace for such experiences in religion. When British Admiral Louis Mountbatten, standing on the deck of the *Saratoga*, asked God to protect the crew from enemy attack, he thought: "That doesn't make much sense. The Japanese are doing the same thing."

Hiroshima did not stand out, he insists, from the carnage he had seen elsewhere. Indeed, his photographs, some of the first after the bomb, can feel unsatisfying, unequal to writer John Hersey's searing descriptions of extreme suffering, or to the moral significance of the new weapon. Yet in Miller's images of his putative enemy, the defeated Japanese troops at the train station, you see the shape of the photographs to come. One soldier leans into another, sitting on his duffle on the platform, to light one cigarette with the other. It is an image of brotherhood, not only between the soldiers, but also with the viewer.

Reflecting his hard-won humanist convictions, Miller returned from the war to create a singular, emotionally rich document of South Side Chicago, a place that would alter national narratives about race and civil rights, and spawn an African-American creative renaissance, including a uniquely urban reinvention of the blues. In 1952, Steichen, then director of photography for the Museum of Modern Art, called him to New York, where Miller and his wife Joan helped create *The Family of Man*, the most widely viewed global photography exhibition and book in history. *The Family of Man* forcefully expressed the same plea for universal understanding and peace that had inspired the United Nations, a plea born of the war's horrors and for Miller personally in a never-forgotten pledge among his Navy buddies to create something good from what they had learned in hell.

Like those of his friend and fellow war photographer W. Eugene Smith, Miller's photographs are muscular in design and exquisite in tone. His prints are now exhibited in museums and sold in galleries. Yet he never conceived of himself as an artist; he was a photojournalist. The title's forthright descriptiveness suited him, for if his pursuits were characteristically driven by emotional intuition, there was also a stubborn practicality bred in this son of a former Illinois farm boy. Photojournalism assignments were paid work with topical subjects. For over two decades following the war, Miller was among the enviable cadre of photographers on regular assignment for *Life* during the golden era of picture magazines. A mark of his success was that he earned his living far from the publishing capitals of London, Paris, or New York, in the hilly San Francisco Bay Area suburb of Orinda, where he and Joan and their children settled in 1949. Miller would complete at least 150 assignments for *Life*.

Still, "photojournalist" fits Miller uneasily. His interest was always emotion, not events. "The personal involvement with the making of a photograph is all-important to me—to feel at one with that moment regardless of whether it be excitement, love, fear, or repugnancy," he says. He photographed his wife's labor and his kids' classmates facing off at recess with the same empathic deliberateness with which he shot sailors throwing down cards below deck and a teenager delivering blocks of ice to a South Side tenement.

Miller sought out varieties of emotional experience in search of visual language for a shared humanity—an ideal since diminished by more ironic and difference-sensitive sensibilities, but one held tightly by those who witnessed firsthand the slaughter and mass criminality of the mid-twentieth century. Still, Miller shied away from overt political statements. From the beginning, he was driven to use his camera to get closer to life, to penetrate its reality from the inside out.

Wayne F. Miller was born in Chicago in 1918, near the end of the First World War. He grew up on the North Side in ethnically mixed neighborhoods, including those he describes as "marginally black." For money, Miller hawked newspapers near the Uptown Theatre, which helped him blend into the neighborhood. "Because I was a kid, the prostitutes treated me well and gave me good tips," he says.

Miller met Joan Baker in 1939 in Urbana, Illinois, where she was a town girl and he was attending the University of Illinois while working part-time as a photographer for local publications. In 1941, to the dismay of his parents, he walked away from the university and a banking career to study photography at the Art Center in Los Angeles. The adventure turned out poorly. Miller was attracted to the emotionally expressive possibilities of photography; the school emphasized commercial art. Assigned to make a portrait, Miller impishly turned in a print from a train-station photo booth, and for a label pasted a bus ticket stub, a Chinese laundry ticket, and a beer label on the back of the mount. The school's director, not amused, gave him a certificate of demerit and invited him to leave. Miller returned to the Midwest, where he and Joan were married. To avoid being drafted as a foot soldier, he also joined the Navy and through a lucky introduction met Steichen. The young couple conceived their first child during one of his home visits as he crisscrossed the globe shooting for the Navy.

As the Second World War ended, Miller envisaged a restorative project. He was possessed with a new ambition to "explain man to man," which implied a prior misunderstanding, a division among us, and in the United States—in his native Chicago—the great division was between black and white. African Americans from the Mississippi Delta had poured into Chicago and other northern cities before, during, and after the war. In the North there were jobs, and a hope of escaping the Jim Crow discrimination of the South. This exodus constituted the largest internal migration in American history, and South Side Chicago was its epicenter. Miller was awarded two fellowships to complete his project, titled "The Way of Life of the Northern Negro."

By the time he moved back to Chicago in 1946, he and Joan had two children, Jeanette and David. His own parents still lived on the city's North Side. Miller always had a warm relationship with his father, who was an obstetrician and surgeon. But his harder-edged mother did not approve of Miller working on the South Side. At a family lunch with Joan's parents, she dug in.

"So, do you want Jeanette to marry a Negro?" she asked. Miller left in anger, but Joan's father followed him and calmed him down. "She was lace-curtain Irish," Miller says now, using a term for poor Irish immigrants with higher aspirations or, less charitably, an exaggerated concern for appearances.

Miller had trouble getting started on the new project, spending weeks at home trying to decide how to gain entrée into a community he little knew. In retrospect, it seems inevitable that he would eventually meet Horace Cayton, who was the director of an important South Side institution, Parkway Community House. The year before, Cayton and St. Clair Drake, both with the University of Chicago, had published *Black Metropolis: A Study of Negro Life in a Northern City*, which is still considered one of the best books on African-American urban life. Cayton gave Miller valuable introductions, including one to the editor of *Ebony*, Ben Burns, whose assignments helped propel his work. With Cayton's guidance and his own doggedness, Miller captured much of the neighborhood's postwar dynamism over the next two years.

The worth of what he accomplished in those two years is still appreciating. Beginning ten years ago with a new exhibition and book, *Chicago's South Side, 1946-1948*, the photographs took on a new life, especially in Chicago. In 2001, Northwestern history professor Adam Green spoke at the Woodson Library, where the work was being exhibited. Calling Miller's photographs "our best snapshot album of black Chicago at this time," he described their lasting value:

> Wayne F. Miller was fortunate to come to Chicago's South Side when he did—for at this time black Chicago was a community animated by the dramatic expansion in numbers, the deepening of institutions, and a growing feeling of maturity and confidence, within individuals and also through the community as a whole. The power of these images, then, testifies to a community's will and power to speak as much as it does to Mr. Miller's ability to listen and ultimately record. The photographs, seen by this light, become almost conversational…older viewers have come back to engage these photos once again, identifying friends, associates, and even, in some cases, themselves.

Miller says he always felt welcomed in Bronzeville, as the South Side community was called. He in turn was sensitive to the ways a camera can intrude. Working at the Provident Hospital emergency room, he wrote, "An ice pick sticking, a woman who had taken Lysol in an effort to kill herself, a kid who had fallen down and cracked his head…all came, passing over the dried trail of blood. How I can photograph this sort of thing, I just don't know. In order to really see things, one has to be so sympathetic—and to photograph them, one must be so brutal…I felt I had no right to trespass on their thoughts."

At the time, some magazine editors did use Miller's work in an exploitative way, such as the sensationalized account of a "reefer party" that he photographed. But the recent reception among African Americans of Miller's South Side pictures validates how successfully he executed his original intention, to reflect his subjects' points of view as best he could. This large white man could not realistically become a fly on the wall inside a black neighborhood. Instead, he brought out people's expressions in the quiet manner of a good listener. He created what Green aptly calls a conversation with his subjects, one that continues a half a century later.

There is also historical value in the project's breadth. Miller shot high society and low, a debutante ball at the Parkway Ballroom and late nights at a rough 45th Street bar, where he was once saved from a beating by the bouncers who knew

him. He photographed industrial workers and fish peddlers, gospel preachers and drunks, Ella Fitzgerald and Maxwell Street bluesmen, drag queens and street toughs.

Miller went looking for a universal truth and encountered a unique historical moment. In a revealing interview a few years ago with Chicago-based cultural historian and radio personality Studs Terkel, Miller repeatedly described the moods and feelings evoked by certain images, while Terkel often remarked on people he recognized, or referred to definitive political struggles of the time. Miller wasn't after local histories; he wanted to convey a people's humanity. He shows us a woman giving the grinning man on the next bar stool a weary eye over her shoulder, the aspiration of a skinny kid in trunks pounding a punching bag, and the strong, broad back of a father sitting with his young son on the Lake Michigan shore.

Miller's camera, which always seemed to find the children, ultimately found his own. The photojournalist's itinerant lifestyle is a notorious wrecker of homes and marriages. But throughout Miller's career, Joan provided stability and warmth, offered her critical eye, helped design the hillside home in Orinda where they still live, mastered the multiple skills needed to manage the redwood forest they bought on California's Mendocino coast, and minded their four children. The couple forged a bond that survived the vagaries of Miller's career, and his enduring affection for Joan is evident in his many photographs of her. In one shot early in her motherhood, she chats with a neighbor while leaning into a baby carriage, her body and skirt forming a curve as elegant and sensual as a caress. With the children, she invariably appears as the warm and wise mother—the play leader, the sympathetic tutor, the dispenser of justice, and the soothing healer of bruised knees and egos.

Orinda in the 1950s and 60s, Miller sensed, occupied its own place in the postwar American story. California had once again (if you count the Gold Rush a century earlier) become the repository for the nation's optimism, and nowhere more so than on its urban edges, where farmlands were yielding to new homes and new roads and the shiny new schools that, Miller says, residents were only too happy to tax themselves to build.

His inspiration for a new project came to him while sorting through countless thousands of photographs for the *Family of Man* exhibition. A photograph of his son David being pulled from Joan's womb by Miller's father became one of the exhibition's signature images. (Carl Sagan later called to ask permission to put a copy aboard the spaceship *Voyager I*. His parents gone, young David answered the phone. He assured Sagan that it was his picture and that he granted permission. The *Voyager I*, and David's photograph, still circle through outer space.) Miller had his birth image for *The Family of Man*, but he was struck by the dearth of childhood pictures, and he conceived of a book that followed his children as they grew. It became *The World Is Young*.

In less capable hands, children make poor subjects; their projection of Rousseau-style natural innocence produces a too-potent elixir for photographer and viewer alike. Indeed, one senses that the editors chose the cover for *The World Is Young*—an image of Miller's son with a butterfly on his sleeve—for its twin symbols of innocent purity. But Miller's many photos of children, in the streets of Naples and Chicago, in Oakland's juvenile detention center, had always resisted simple

sentimentality. There is the Italian boy peeing on a shell-pocked wall, a smoke in his mouth. Or the young Chicago boy with a look of seriousness beyond his years holding a sign: "Negro vets dared to vote. They were lynched." On closer inspection, even his son, with the concentration and stealth of a cat, is looking to snare the butterfly.

With an advance from a publisher, Miller organized the new project like a documentarian, first covering the children's home life, and then following them with their Orinda classmates from first through seventh grade. Children, he soon discovered, pose their own challenges to a photographer trying not to influence or disturb the action. As he writes in the book:

> At the start, I hung around the playground before and after school, at recess, at lunch. "Watcha doin'?" I told them. "What kinda camera's that?" I told them. "Can I see it?" I showed them. "What's he doin'?" "He's taking pictures." "Can I see the pictures?" Not now. Maybe later.

A fifth grader unwittingly offered him a breakthrough when he walked among a group of kindergarteners. Miller realized that the older kid was a giant next to the younger children. "From then on, all pictures were taken from the subject's eye level," he wrote.

The World Is Young became a popular success, reviewed favorably by childrearing guru Benjamin Spock, among others. In 1958, the year it was published, Miller also joined the famed Magnum Photo Agency begun by Robert Capa and Henri Cartier-Bresson. But by the early 1960s, Miller had already become less enthusiastic about photography. Around the same time, he and Joan bought their timberland on the coast, to which he devoted increasing attention. Although he continued to shoot for magazines for another decade, he abandoned professional photography in the mid-1970s. The golden age of picture magazines was over, supplanted by television, and for Miller, the assignments had begun to feel routine. One day, lying in the mud of a kennel to shoot a feature for *People* on prize Shar-Pei dogs, he realized his heart was no longer in it.

A camera can serve as a passport to other lives and cultures but it also paradoxically stands between the photographer and the world. "We're not participating, we're observing," Miller says. "We're trying to be inconspicuous; we're trying to be 'not there,' but there. So it's a pretty lonely life." Once while photographing in a village in Mexico, he designed a simple bed and table that could be folded down on the dirt floor, or tucked away in a family's tiny shack. Decades later at his dining table, he sketches the design with a pencil. "It was the only time I did anything practical to help," he says. All his life, he used photography to get closer to other people's experiences. Yearning to become more of a participant in life, Miller eventually put aside his camera and went home for good. Before he did, he created a personal, nuanced, and enduring record of major World War II and postwar experiences.

Kerry Tremain
Editor, *California* Magazine

JOHN SIMON GUGGENHEIM MEMORIAL FOUNDATION

551 FIFTH AVENUE · NEW YORK 17 · N. Y.

June 27, 1949

Mr. Wayne Miller
9739 South Hoxie
Chicago 17, Illinois

Dear Mr. Miller:

Since I came back from a journey and
found your portfolio "The Way of Life
of the Northern Negro", I have been
trying to find a way to express ade-
quately my thanks for so magnificent
report of your Fellowship.

Well! There is no way that I can say
adequate thanks; so this simple note of
appreciation will have to do; with this
addition; that you will please come in when
you are in the neighborhood and let me try
to do better face-to-face.

All good wishes to you, always, from

Sincerely yours,

Henry Allen Moe

M:n

Letter to Wayne F. Miller from Henry Allen Moe, John Simon Guggenheim Memorial Foundation, 1949

THE WAR YEARS 1942–45

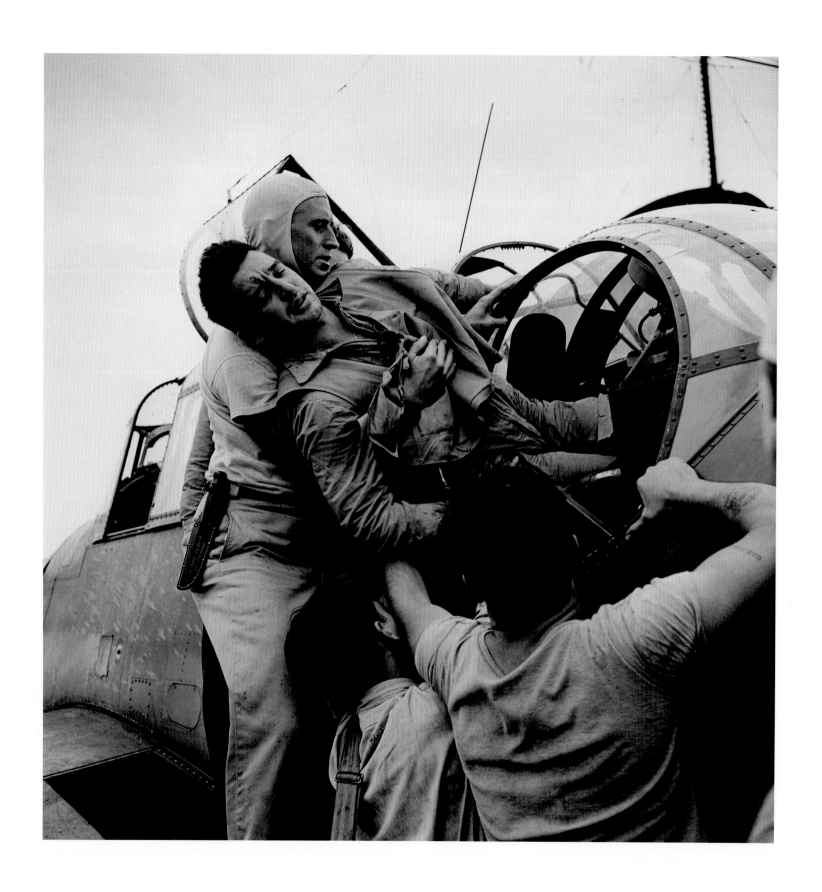

Pacific Theater

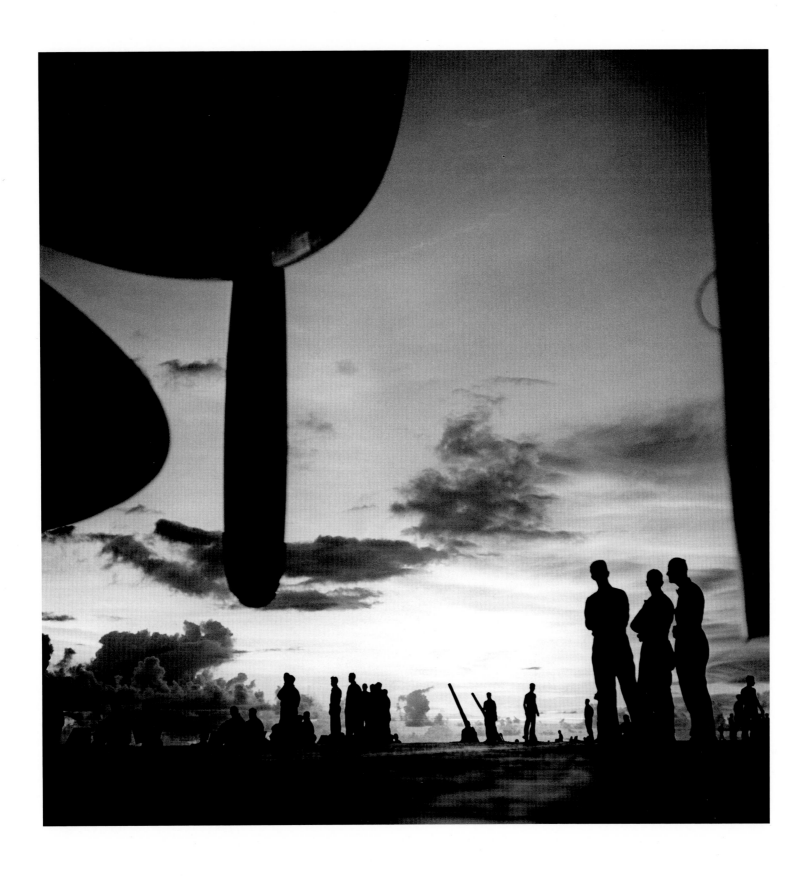

23

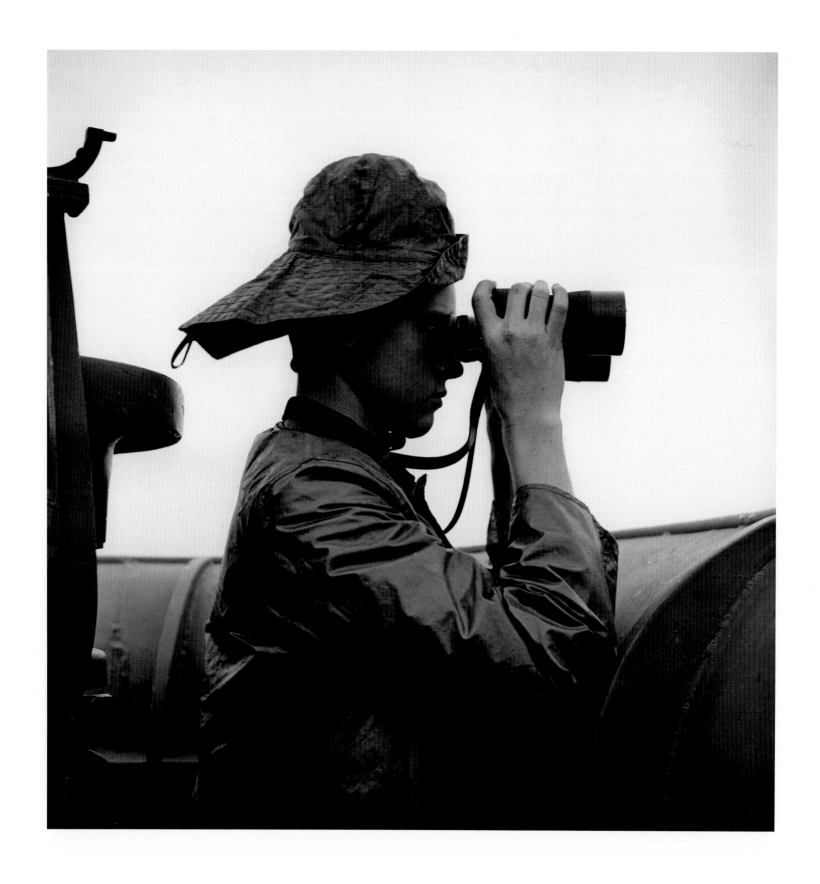

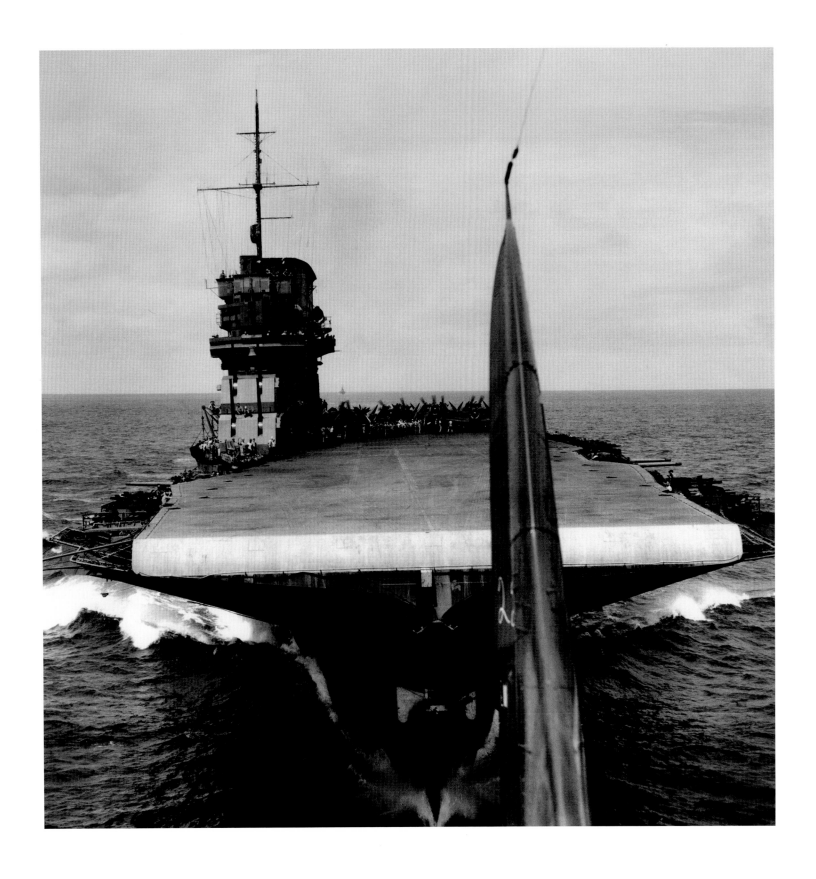

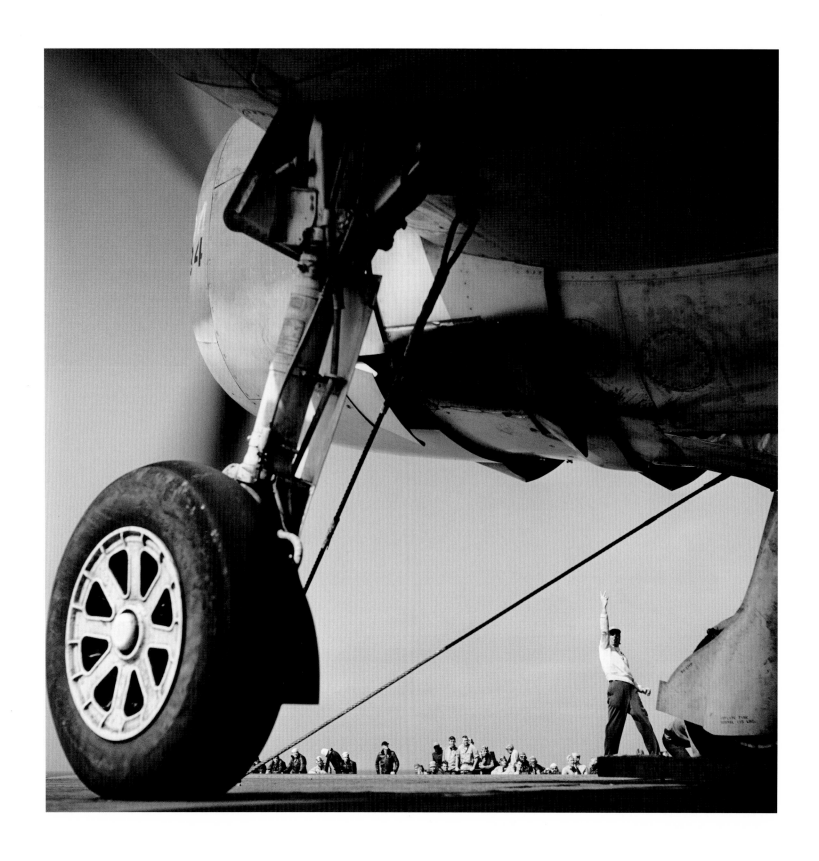

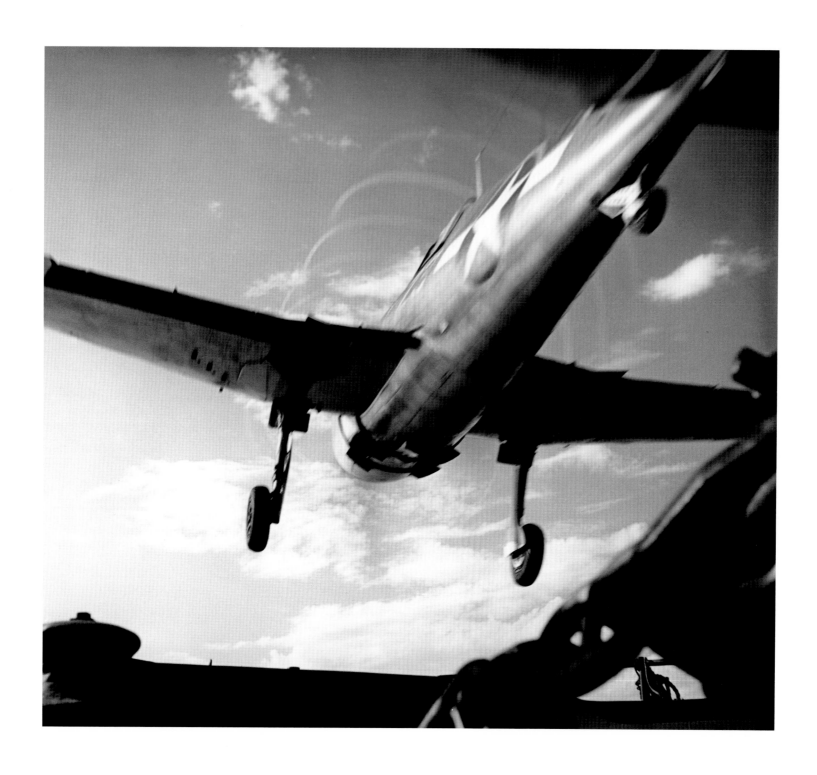

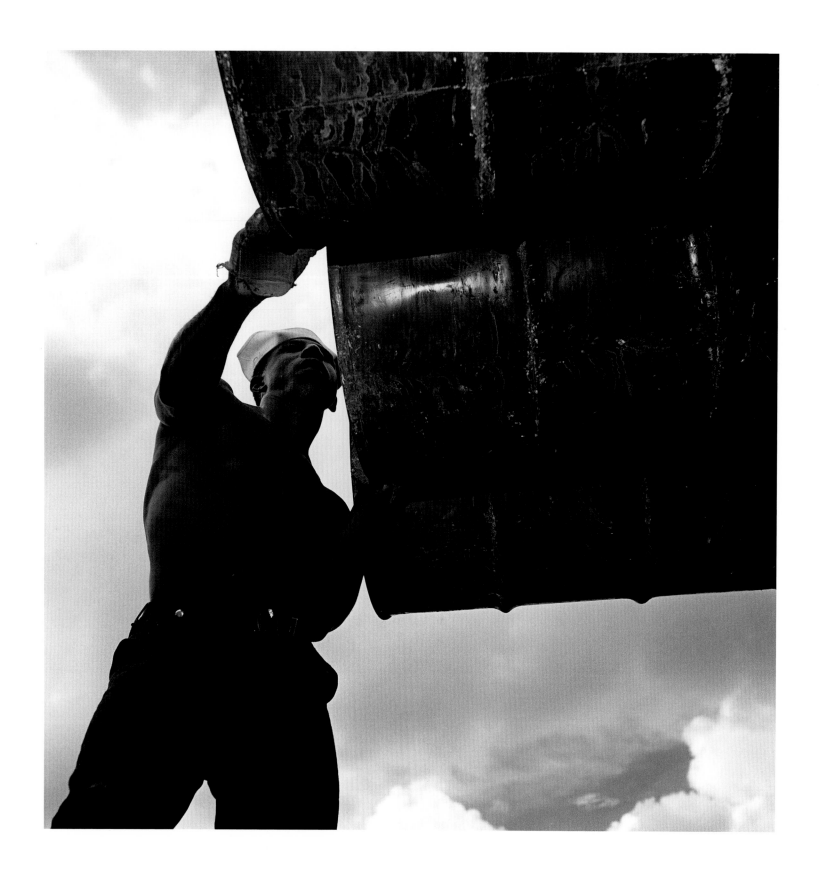

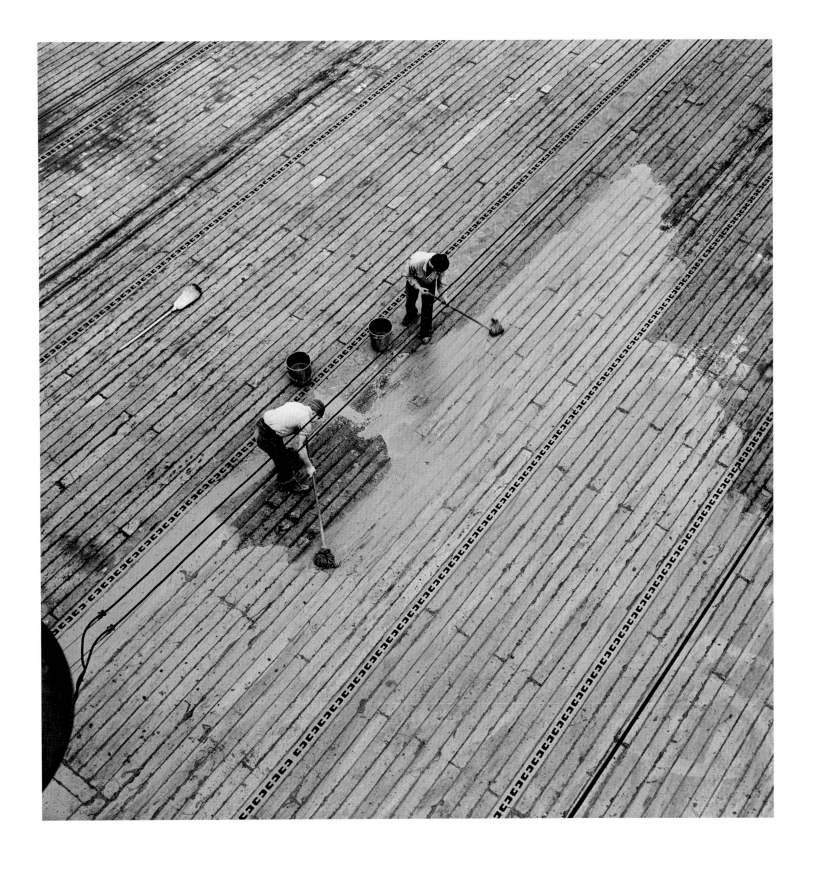

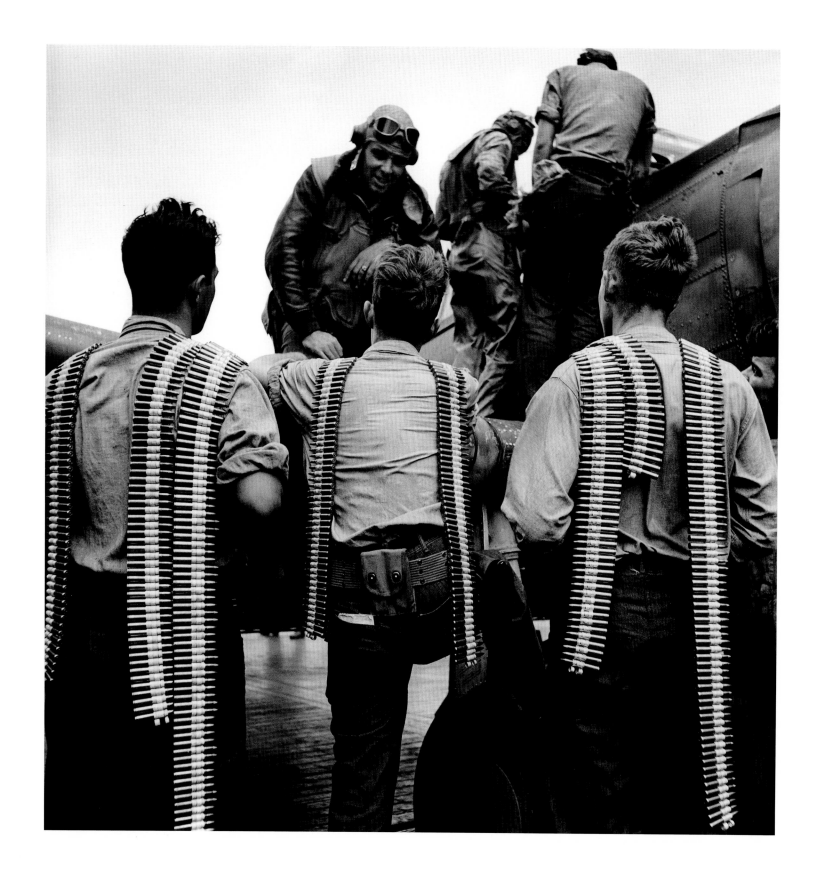

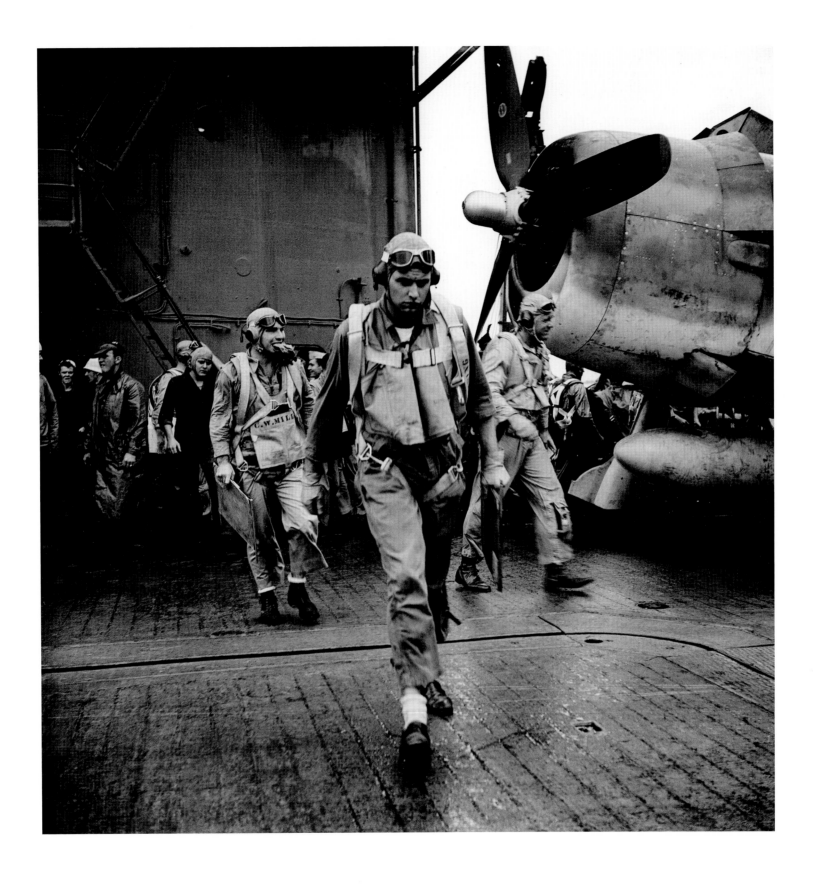

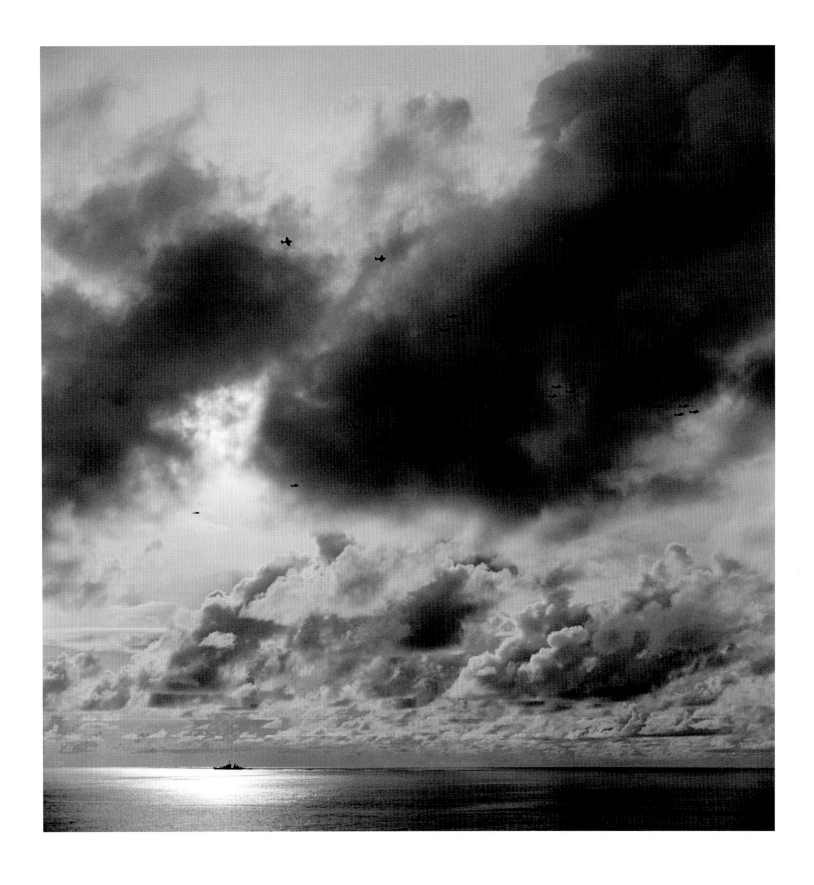

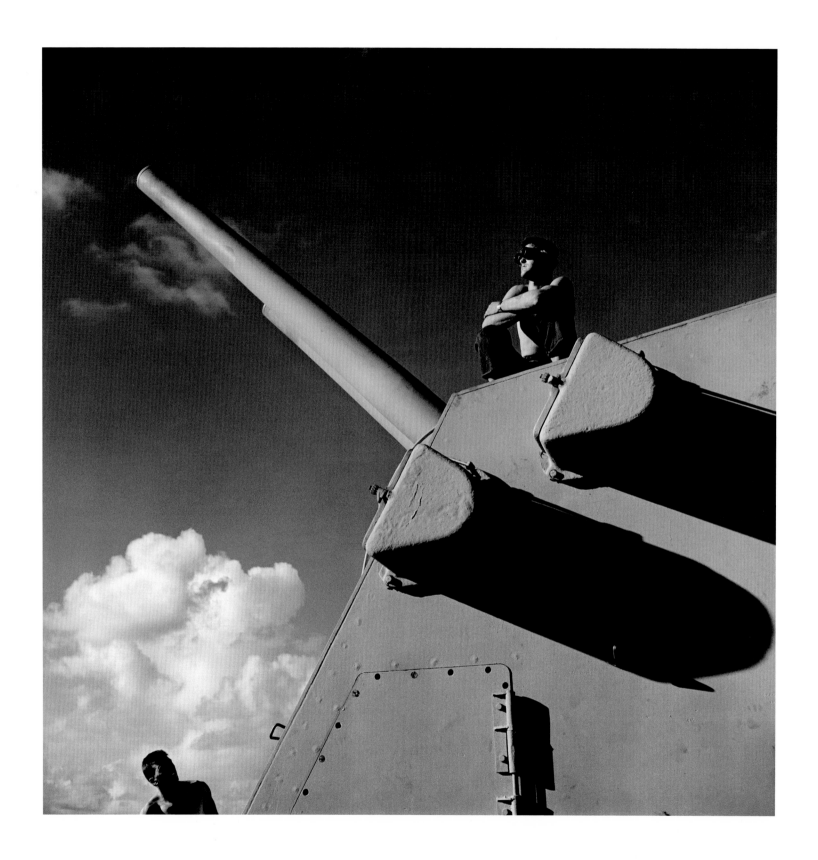

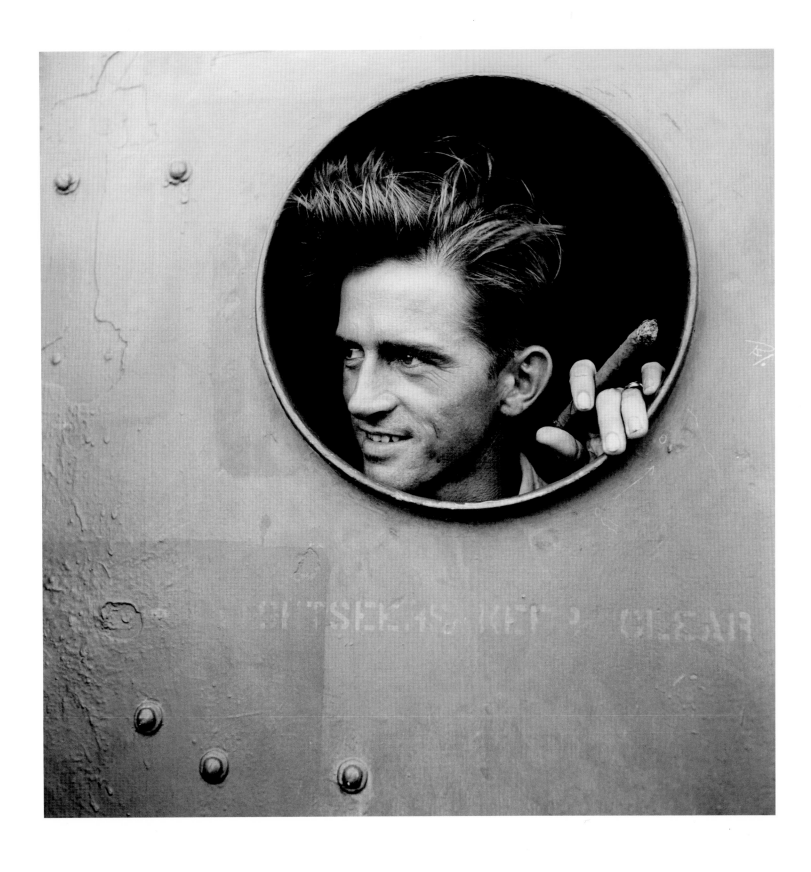

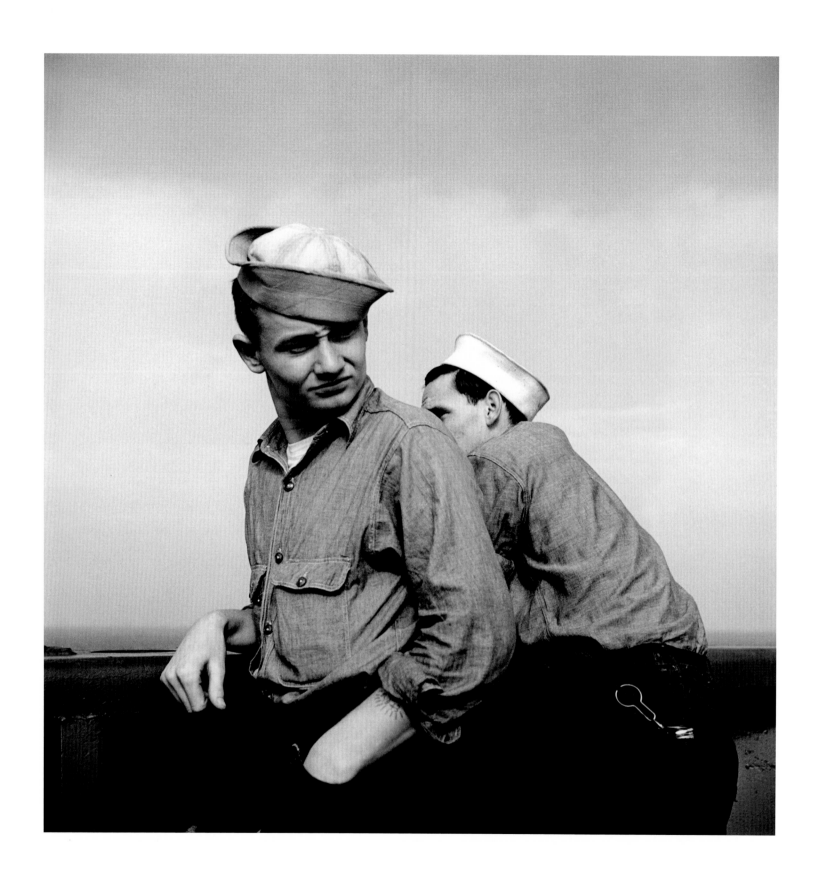

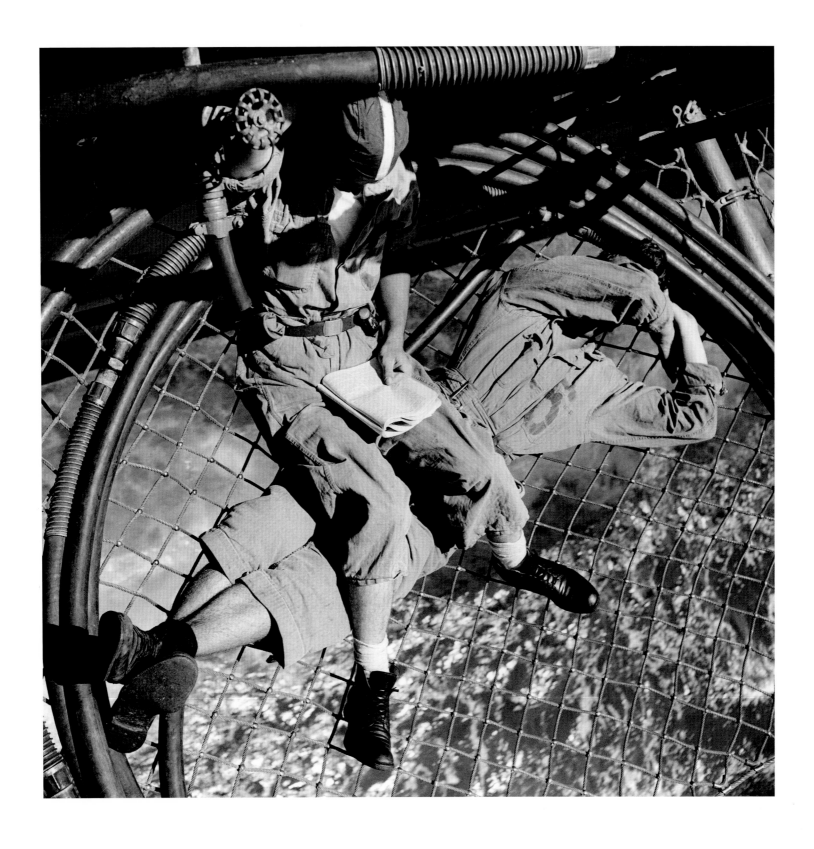

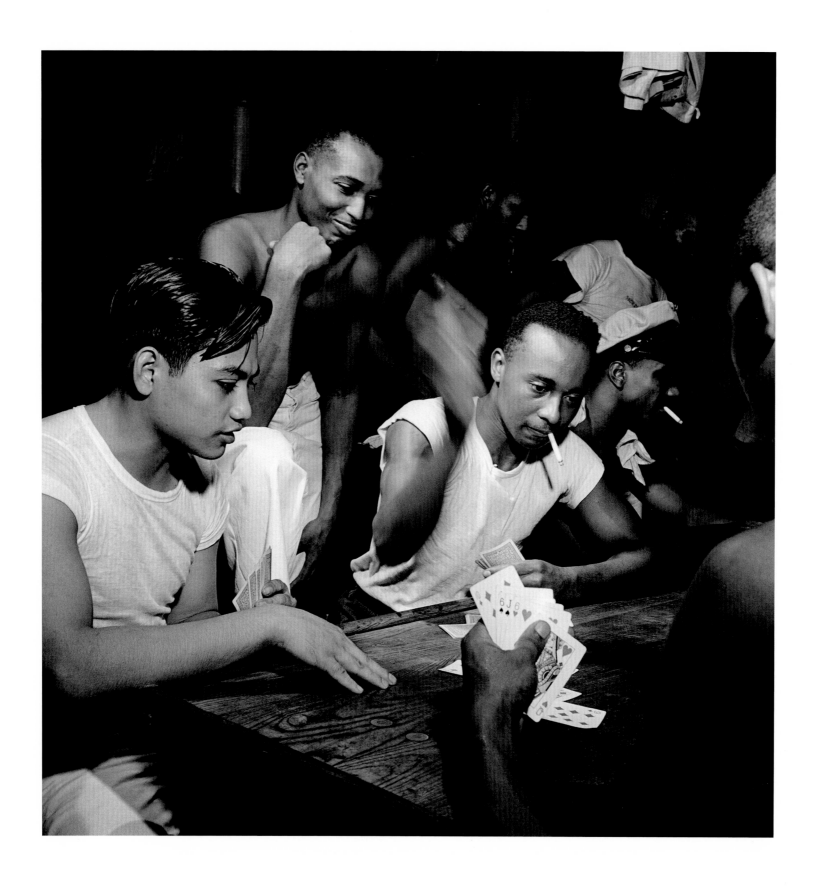

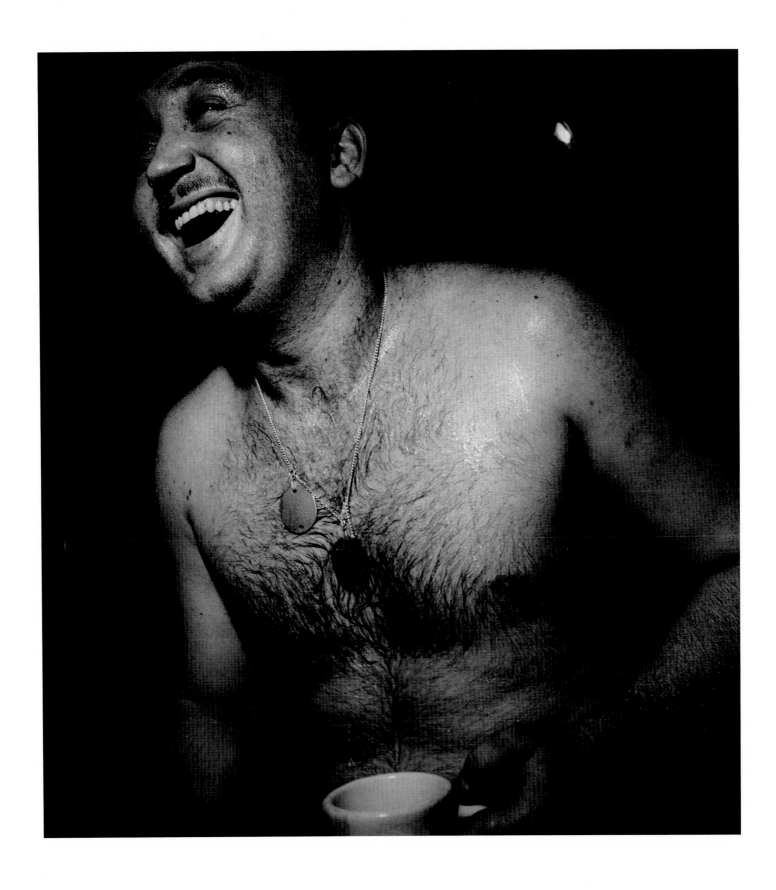

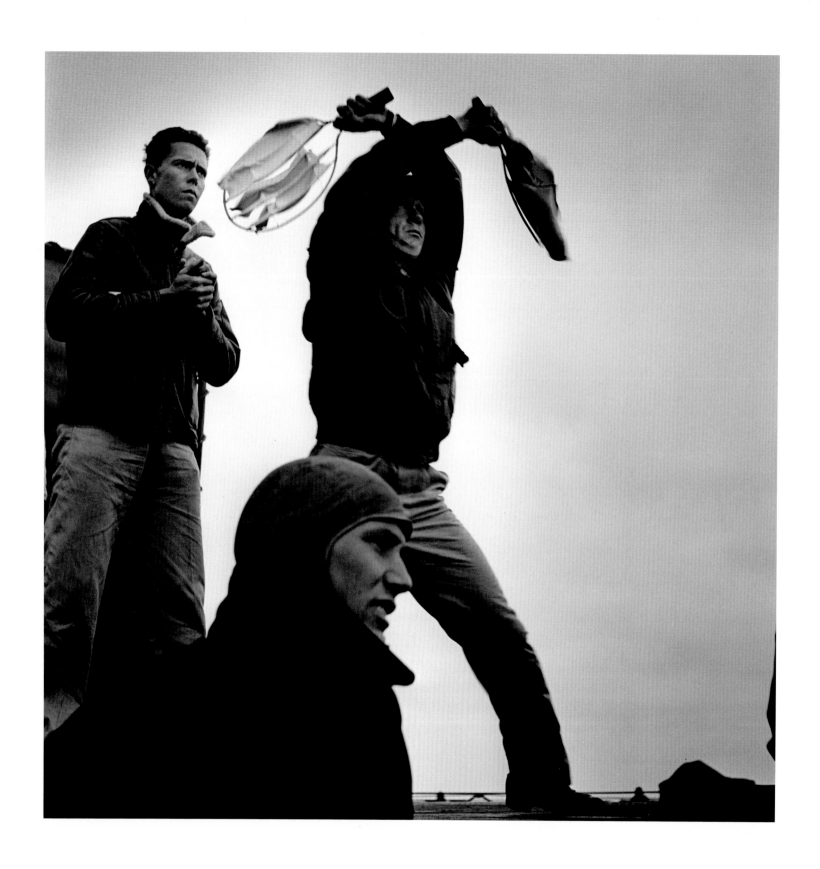

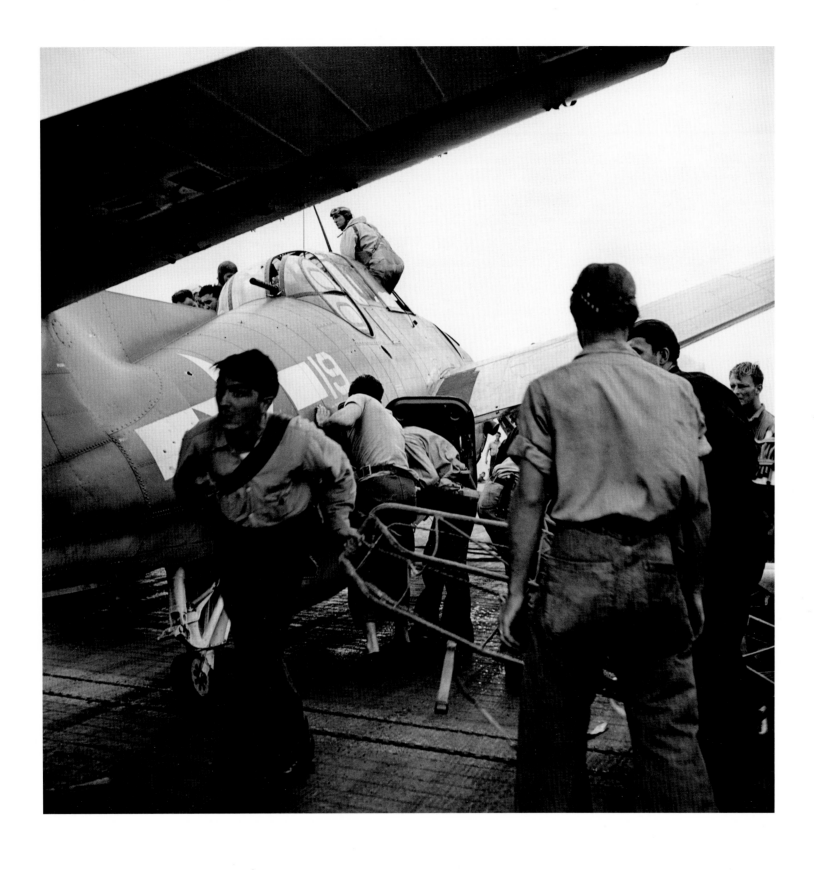

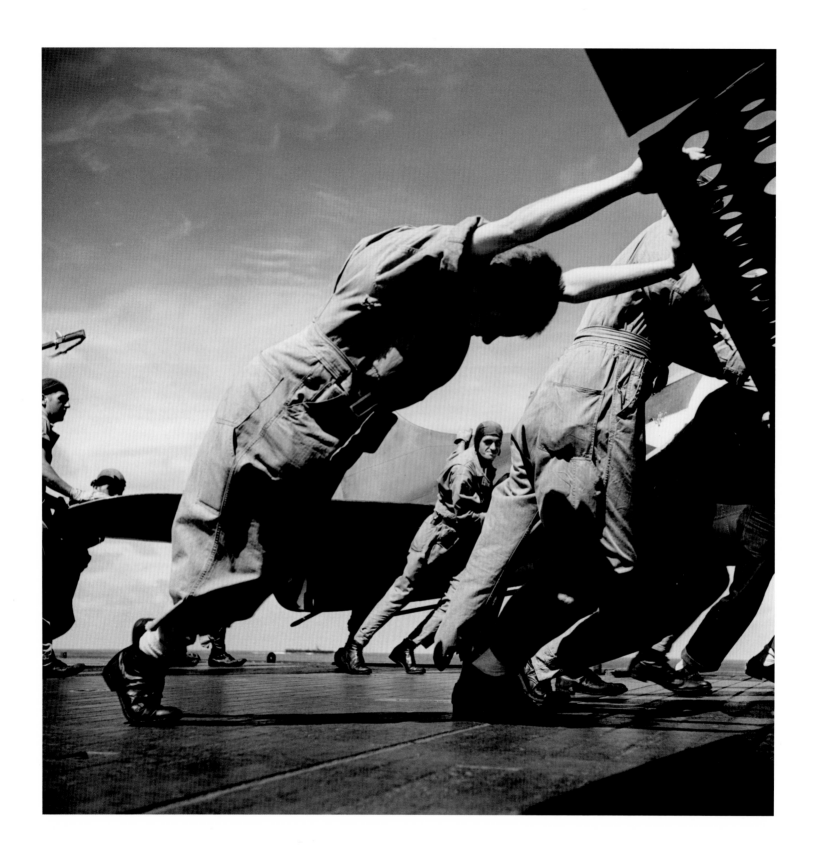

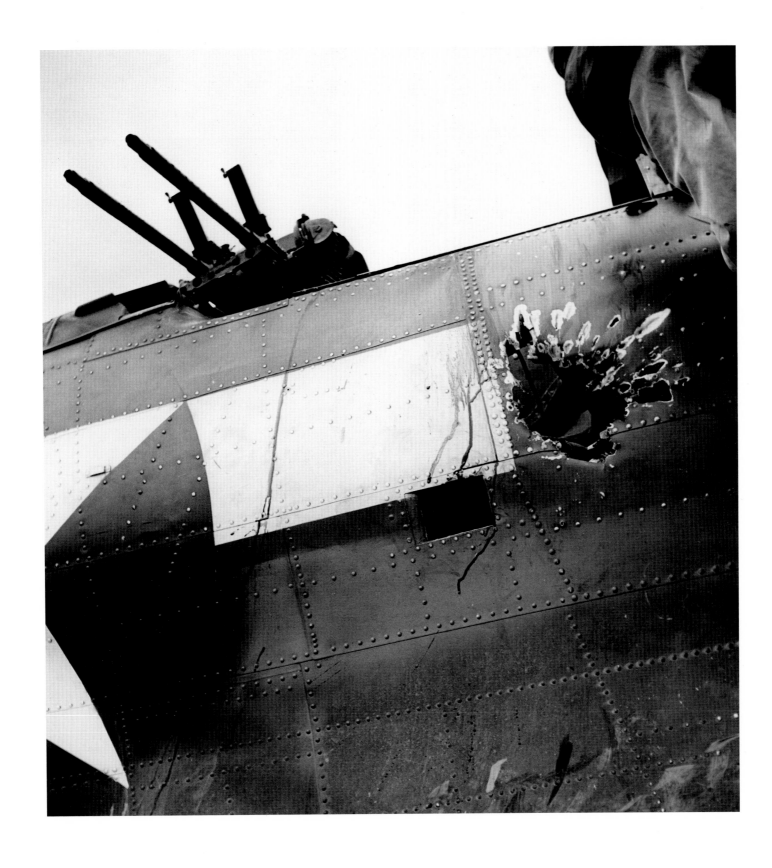

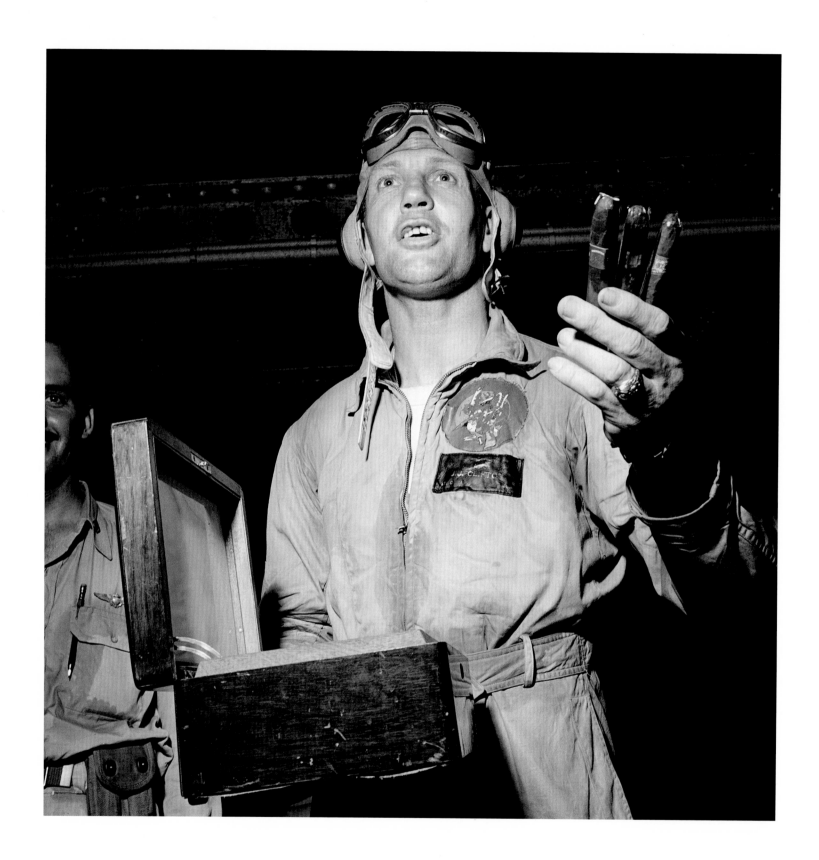

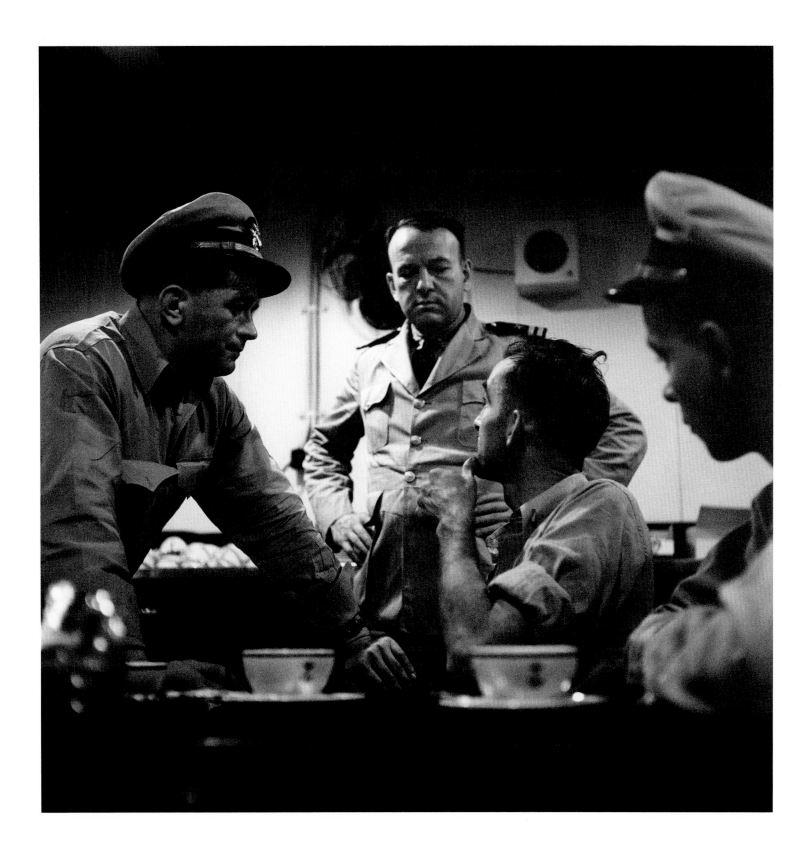

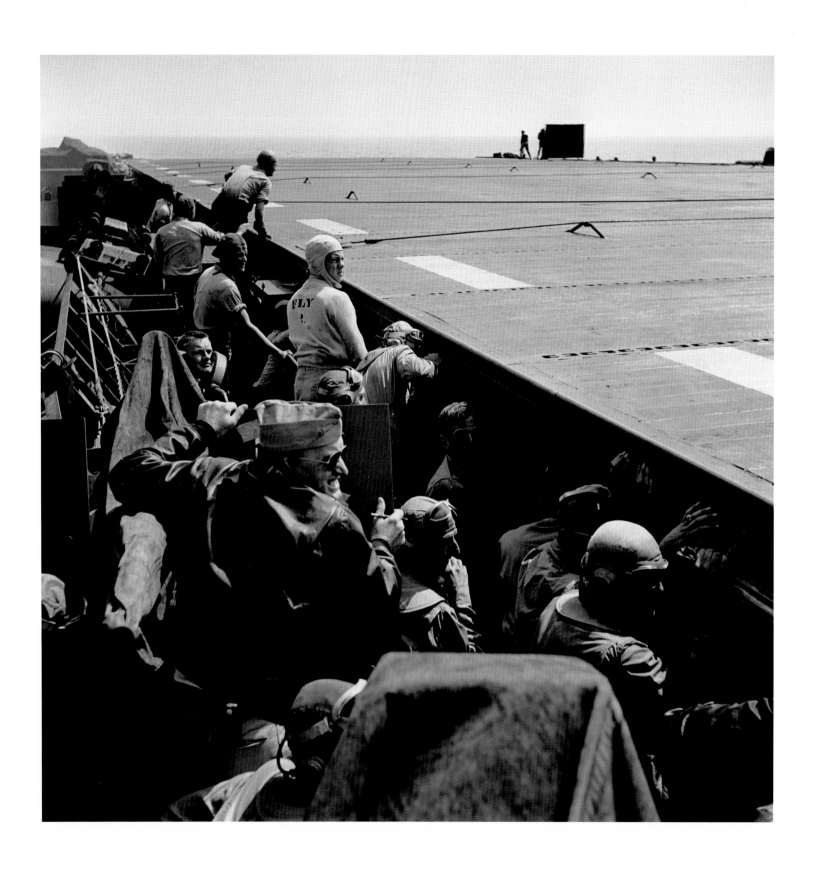

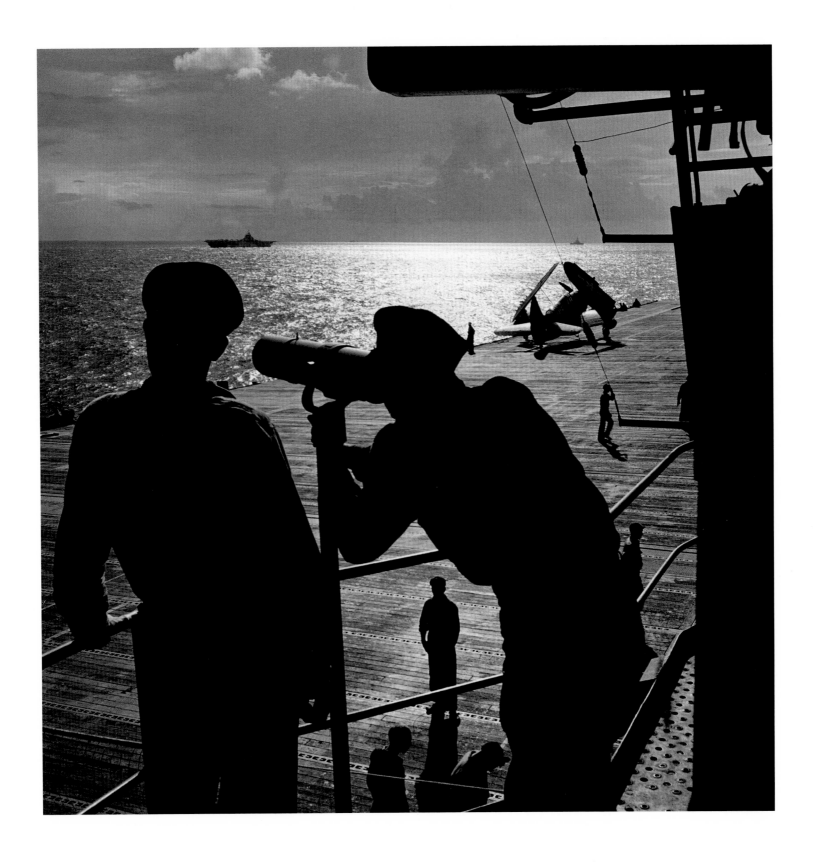

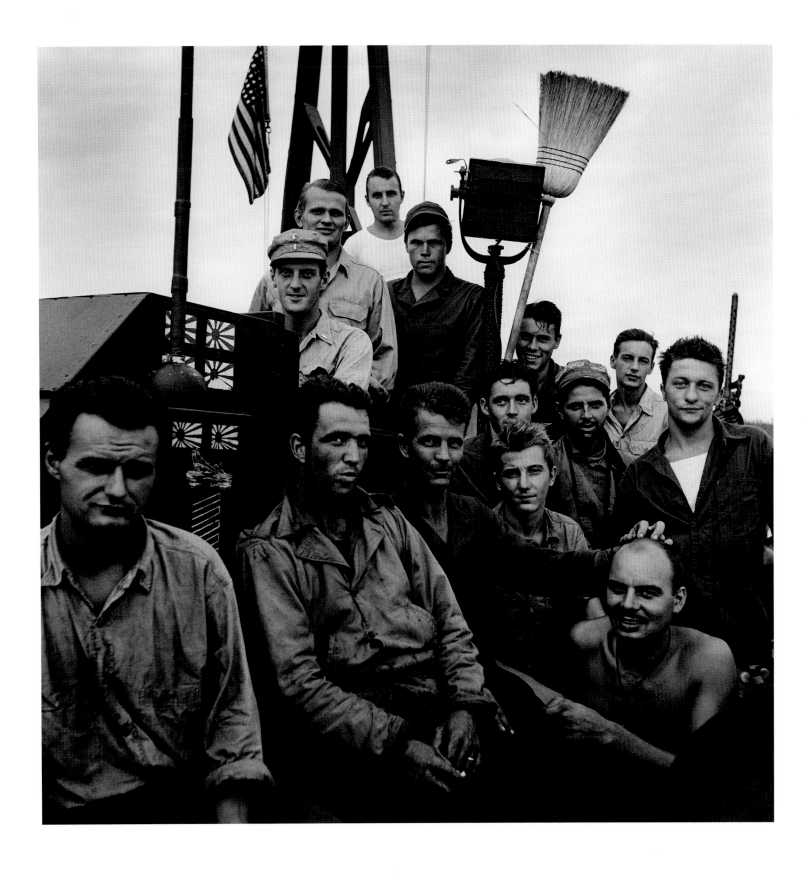

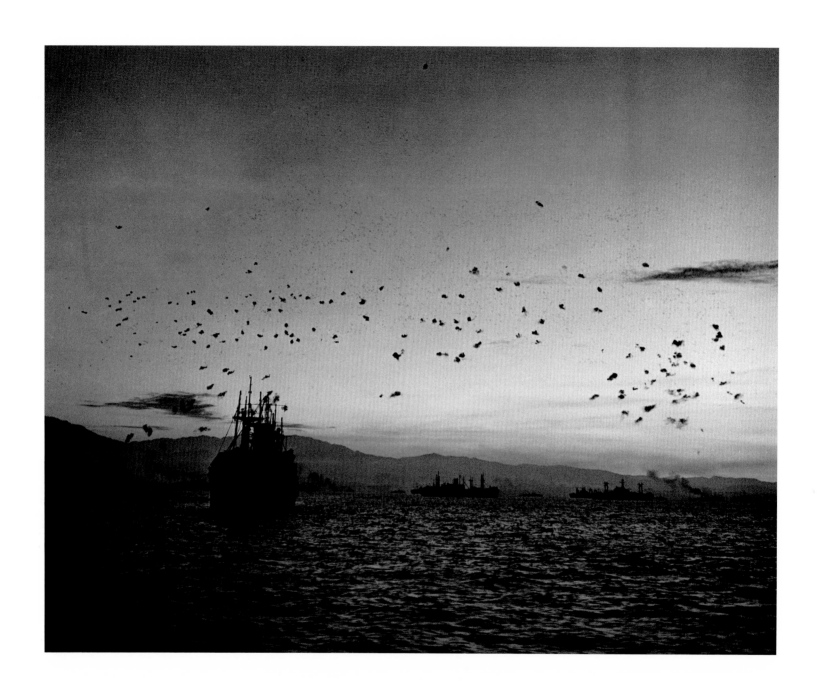

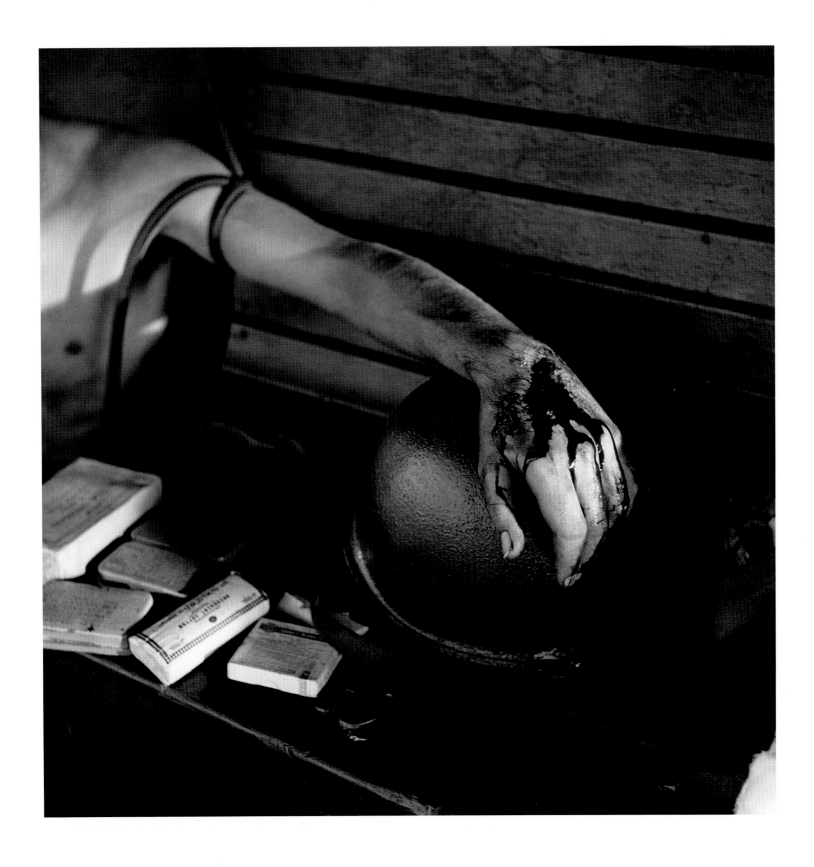

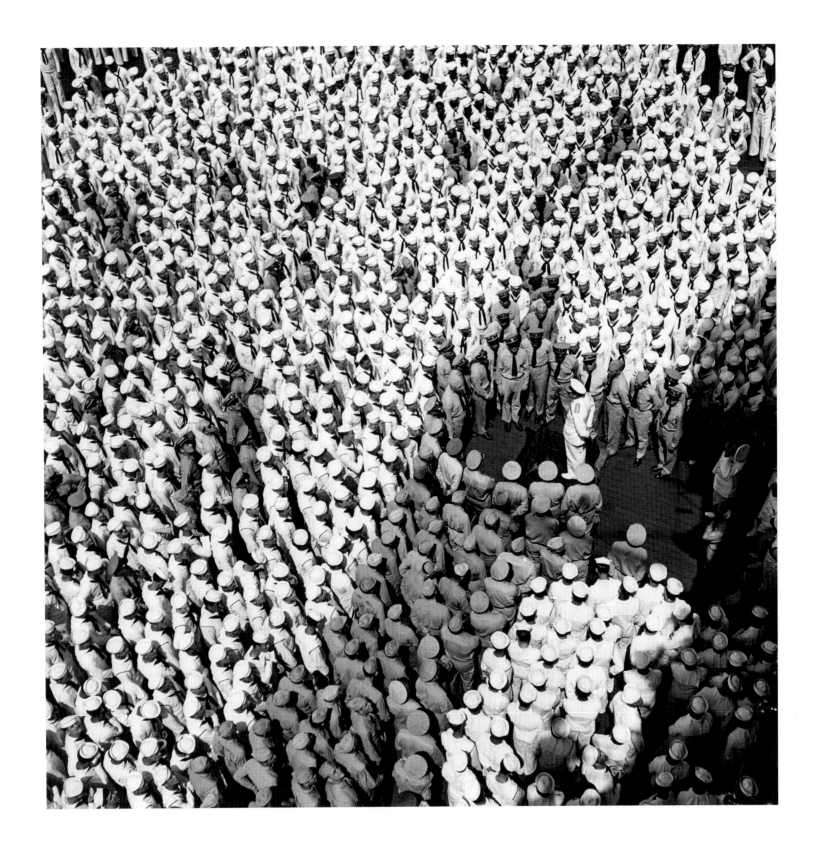

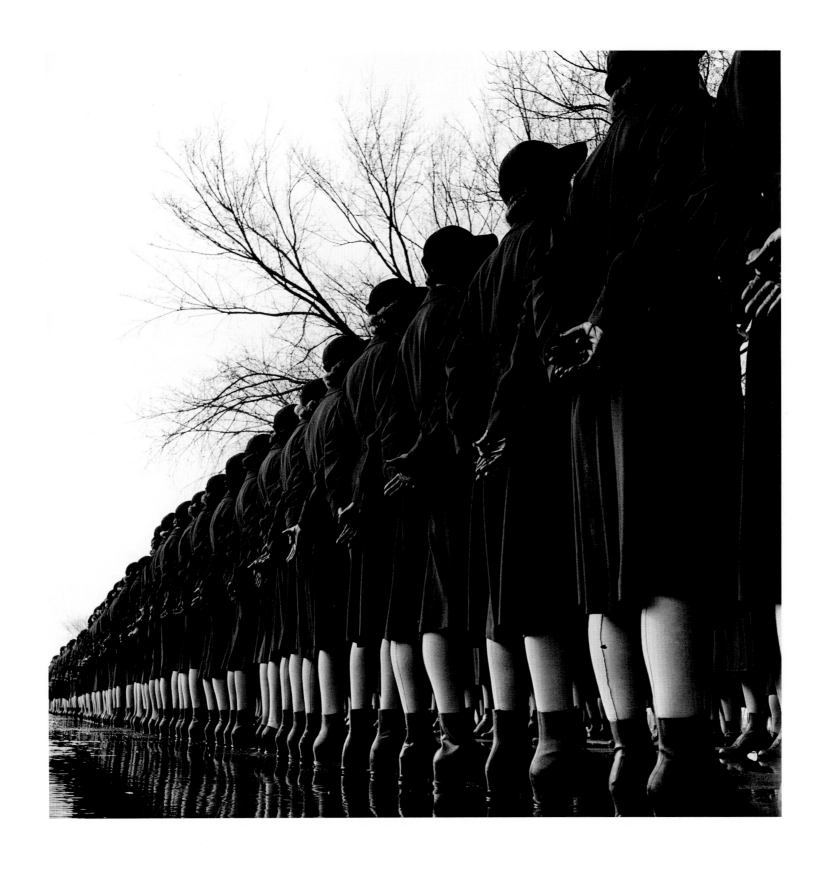

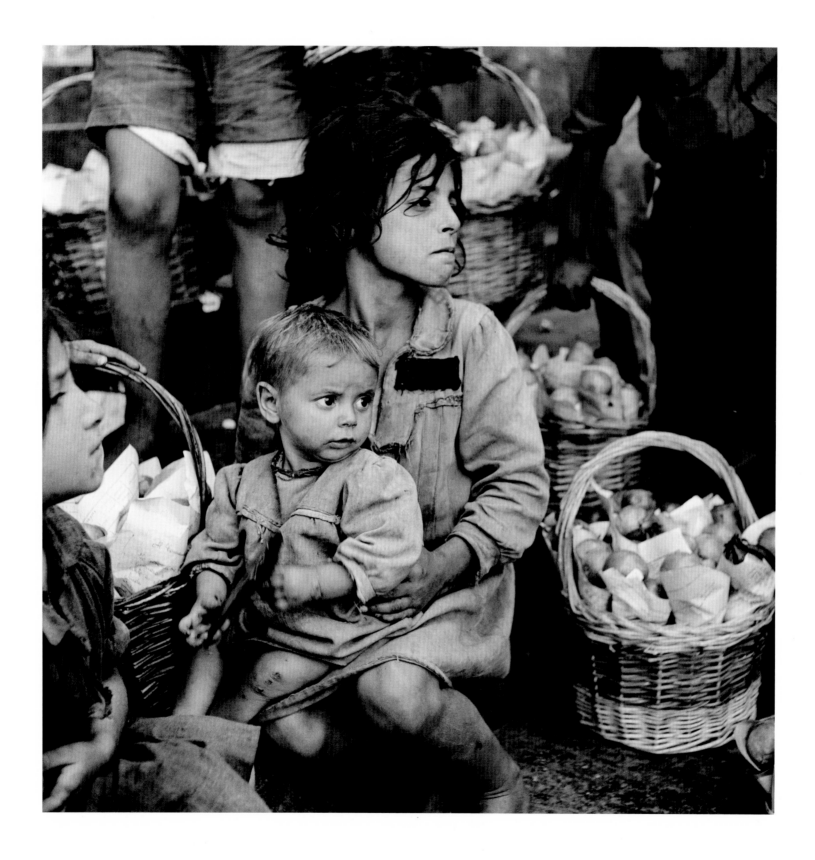

Naples, Italy

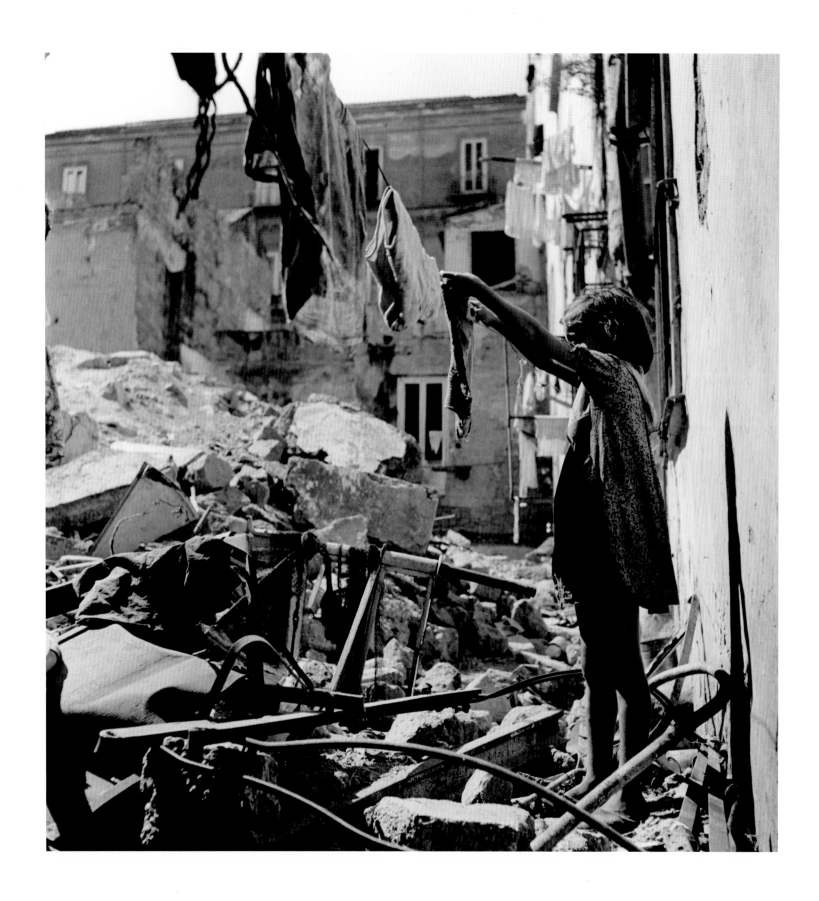

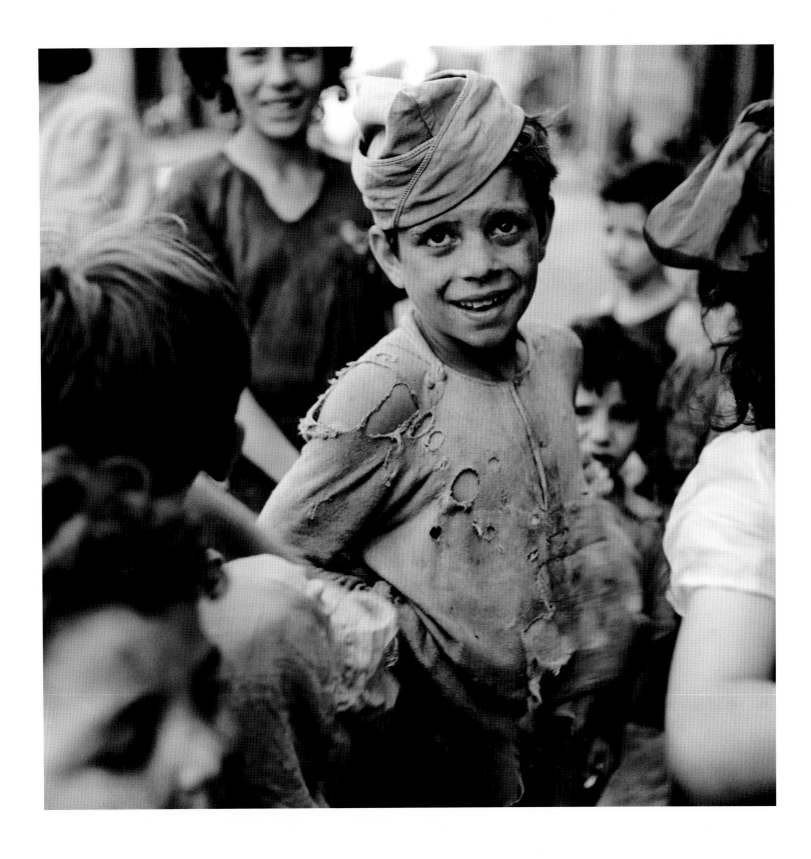

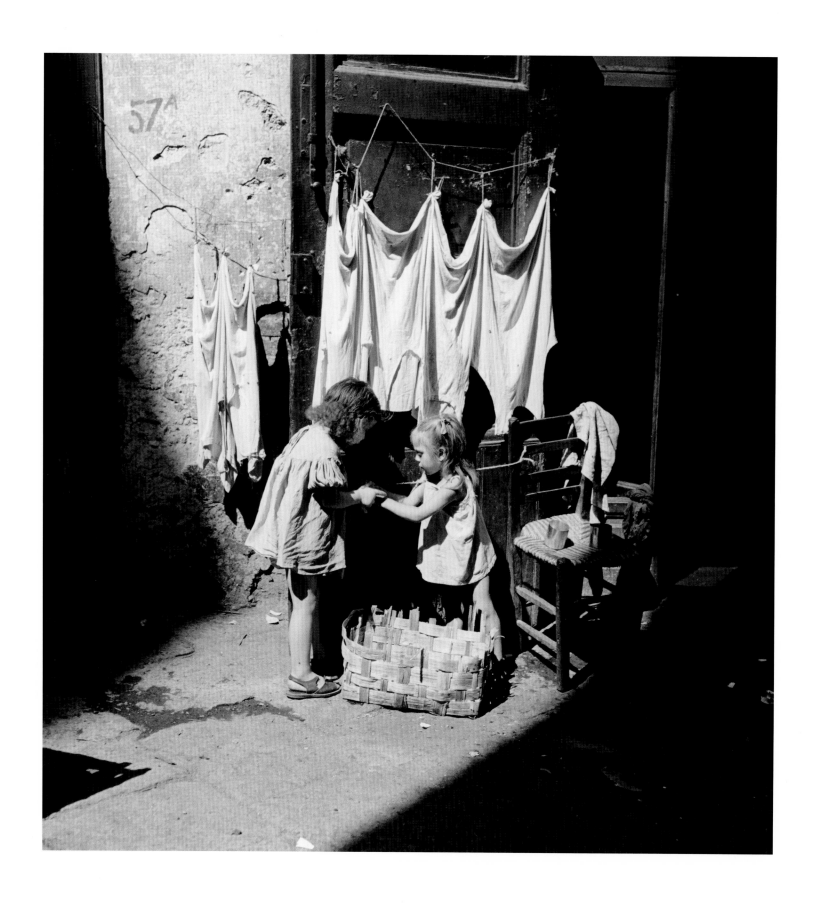

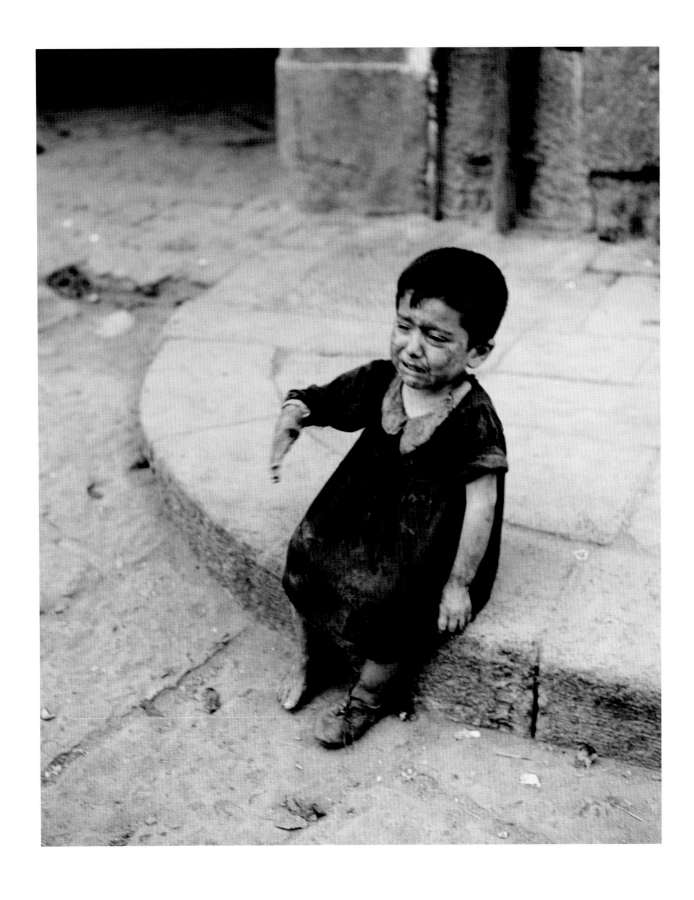

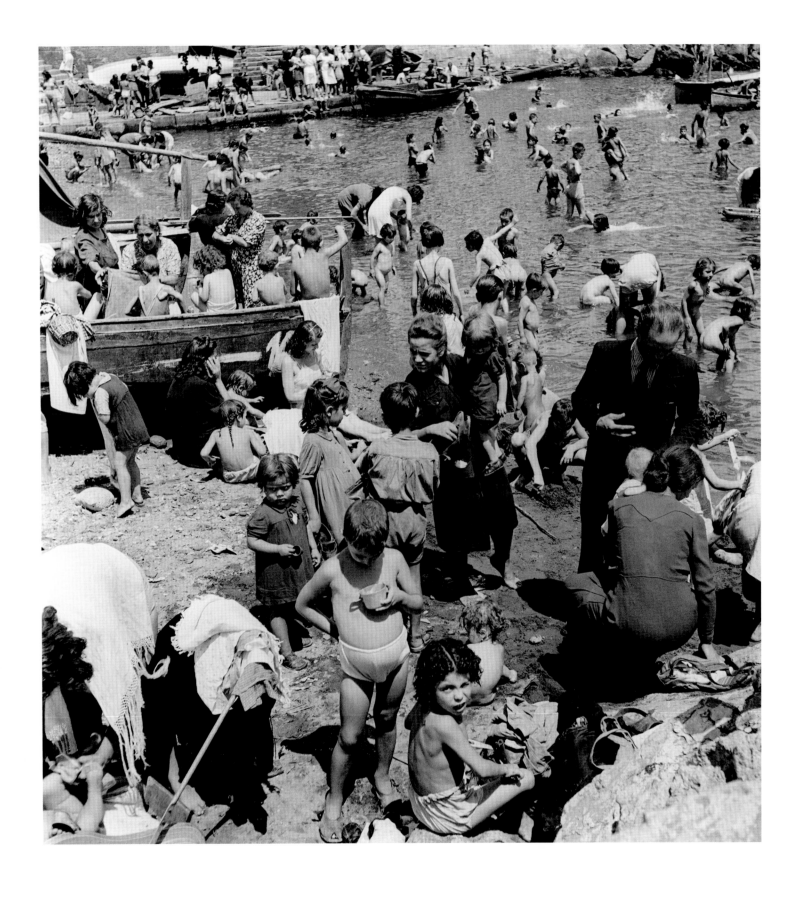

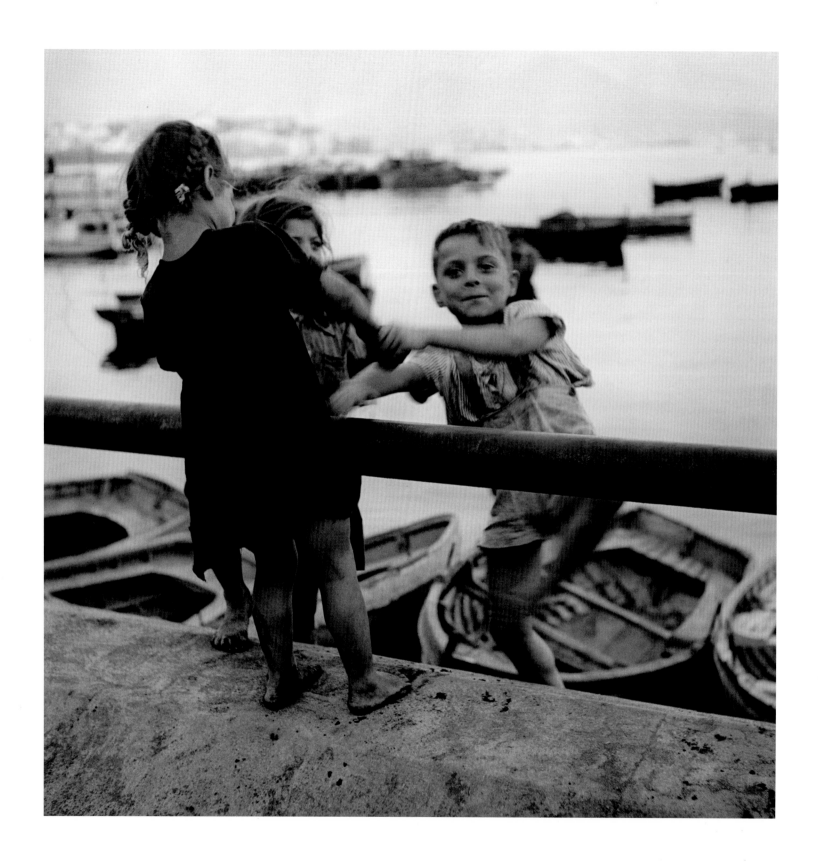

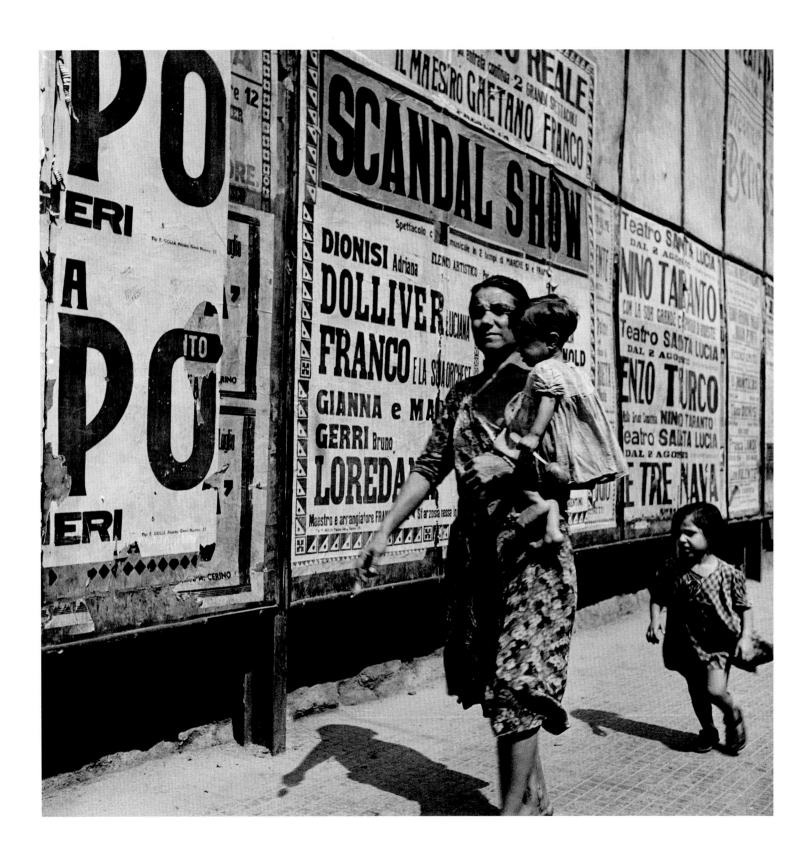

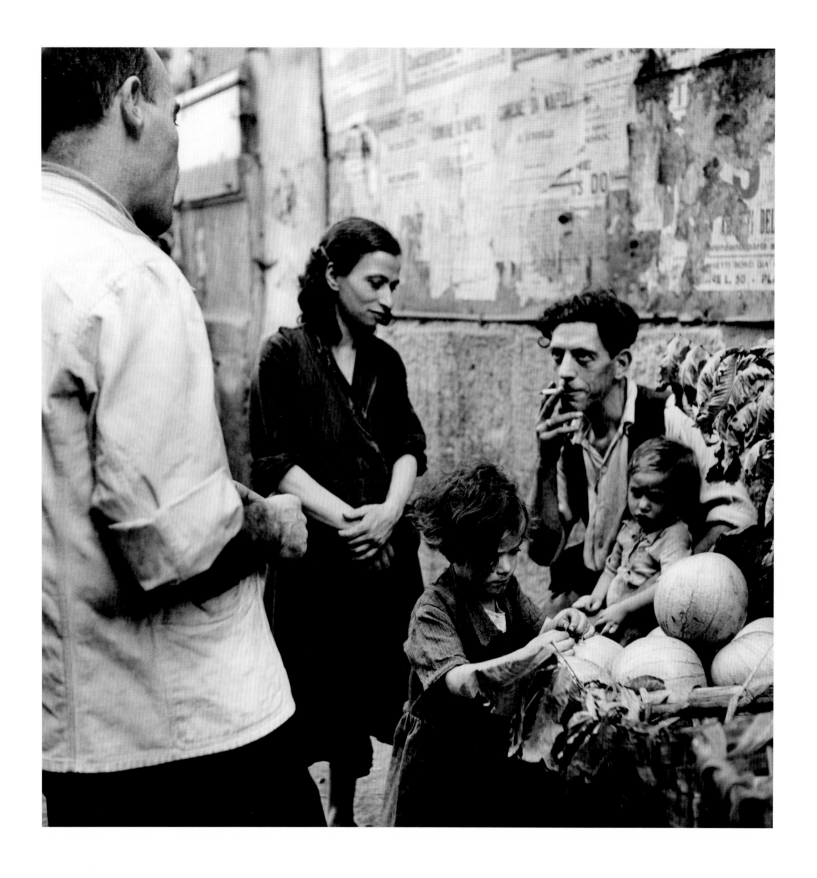

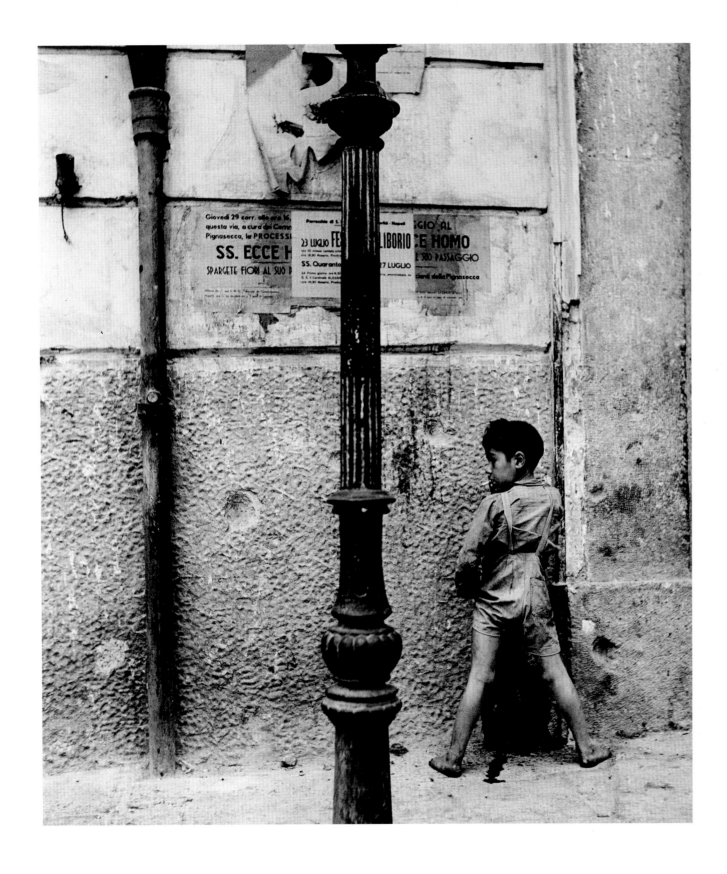

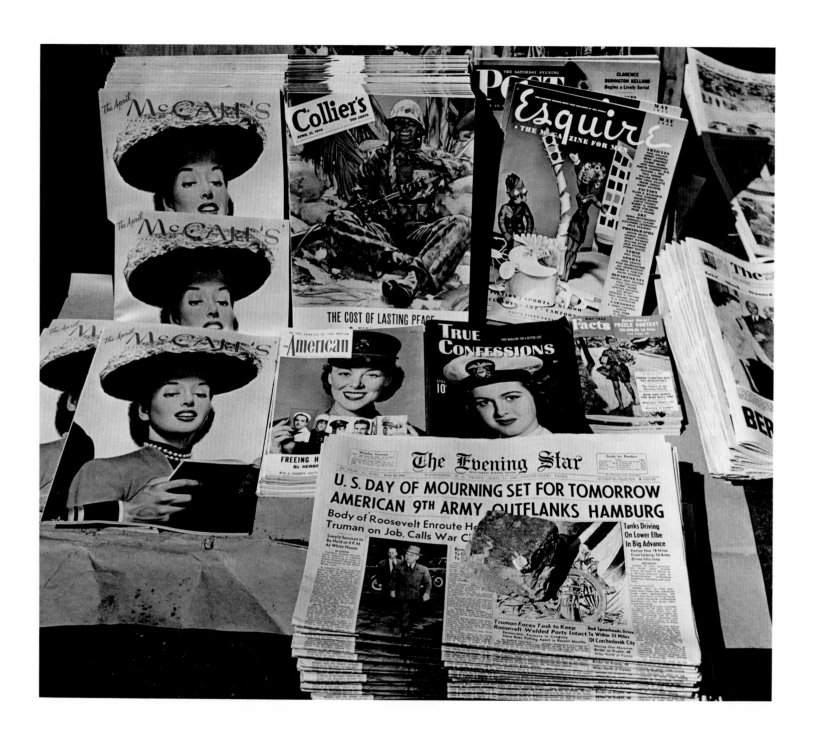

Franklin D. Roosevelt Funeral

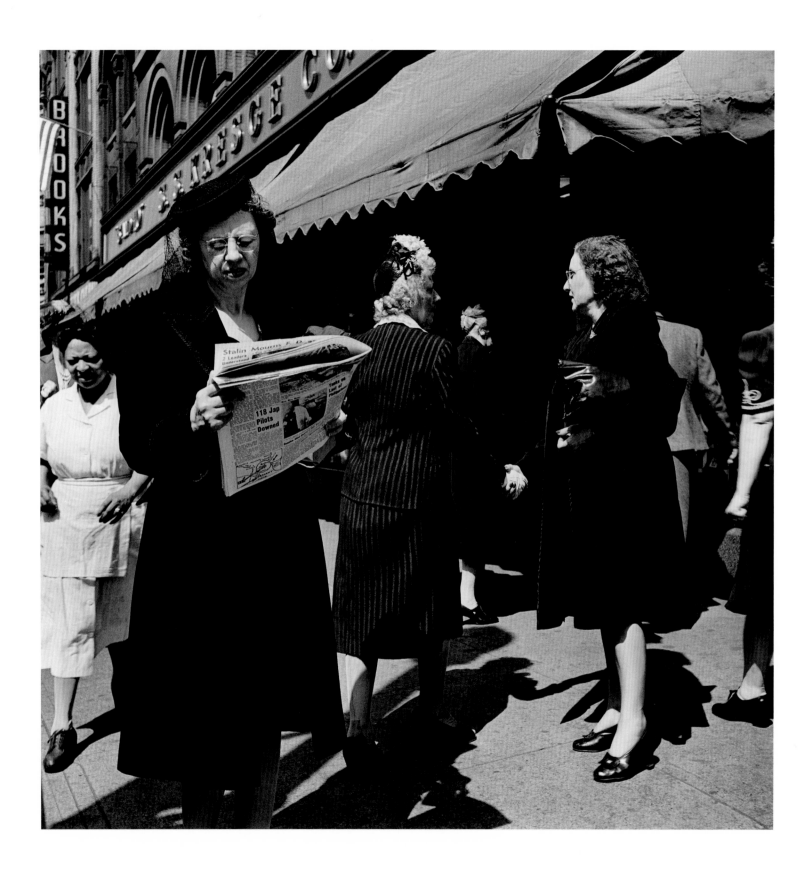

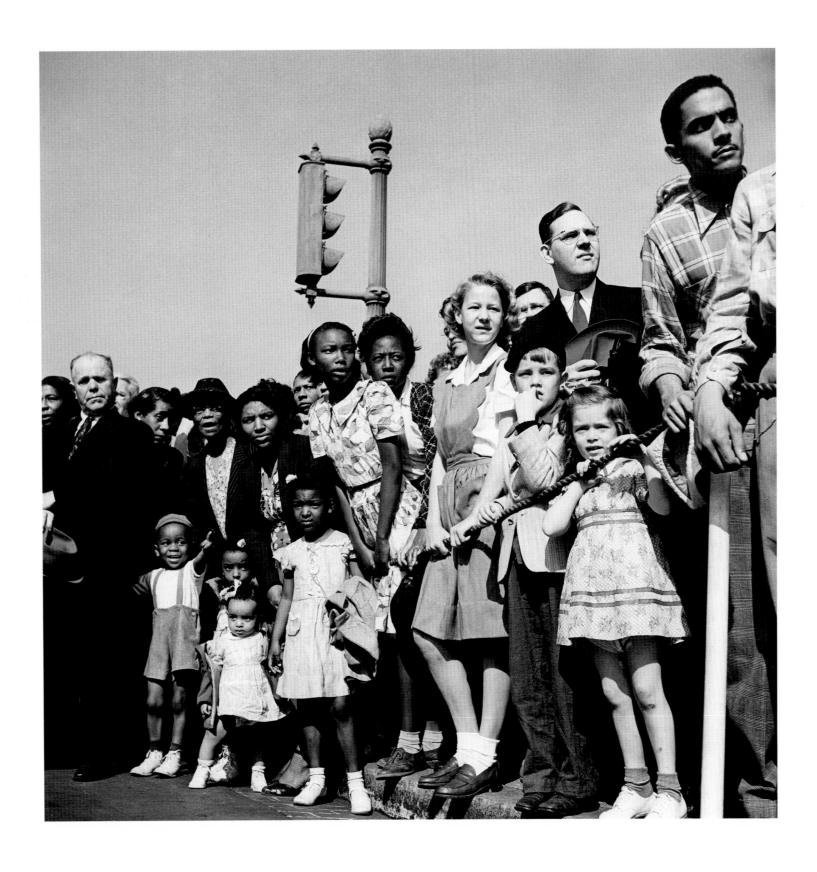

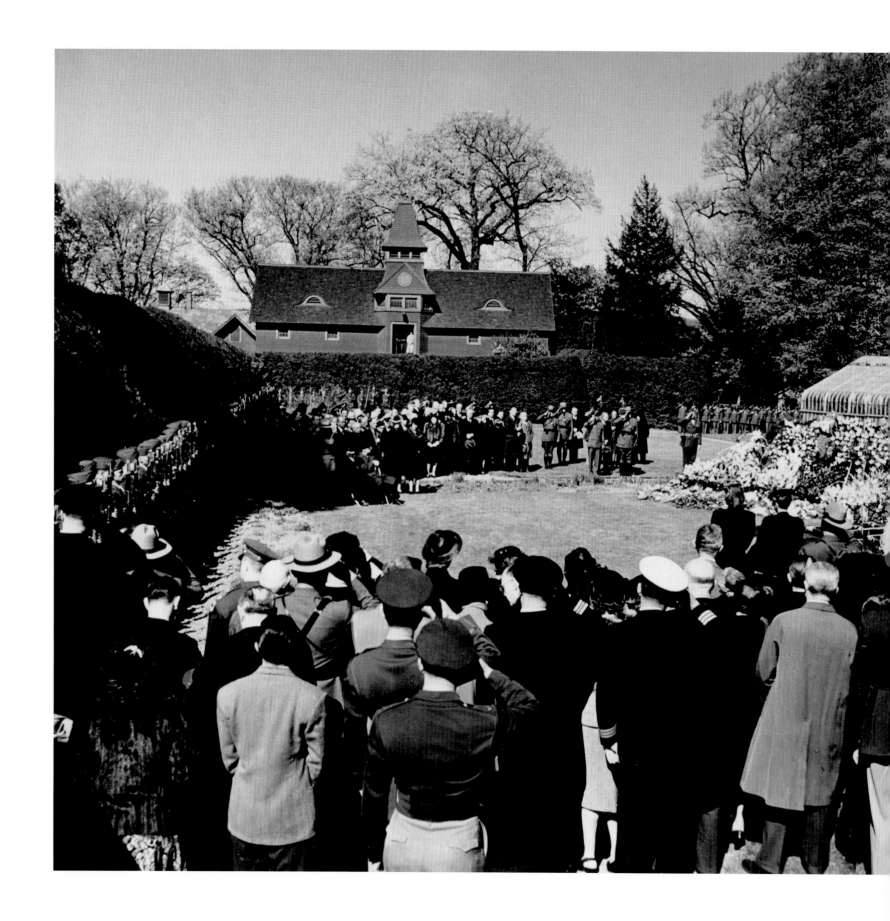

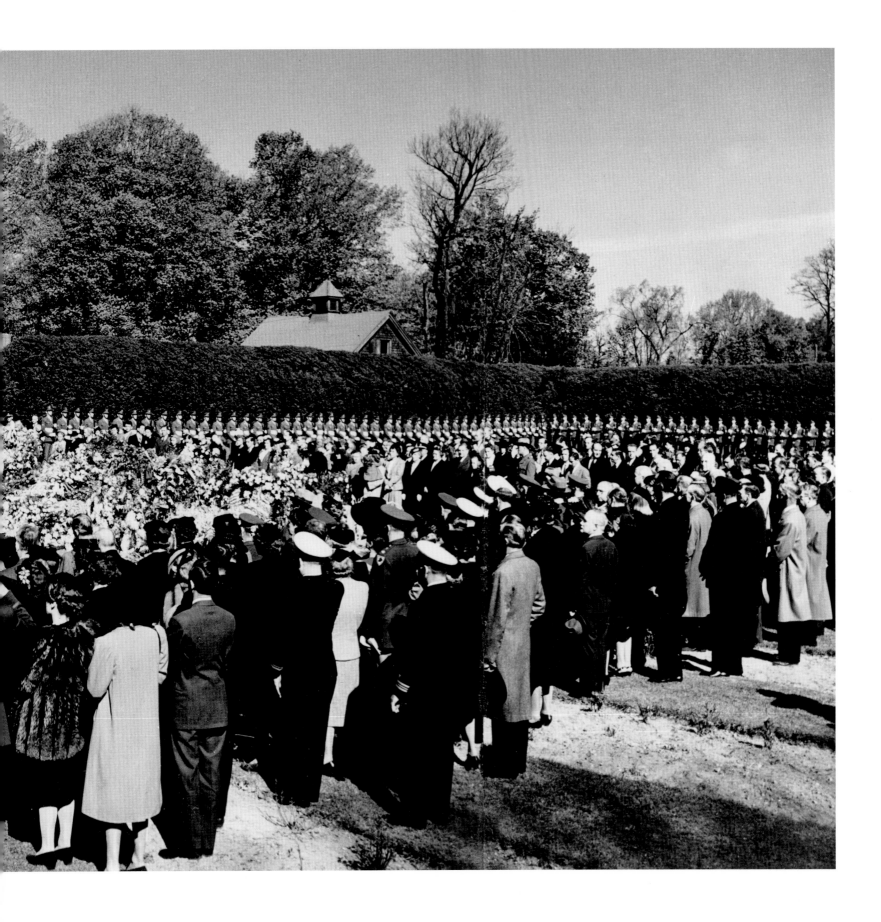

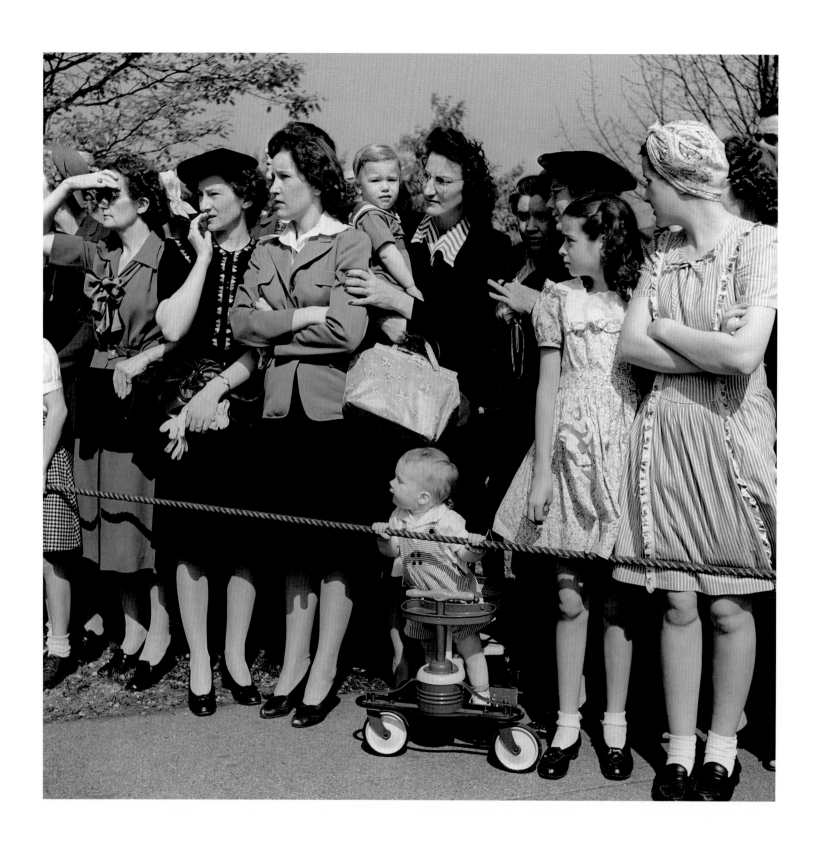

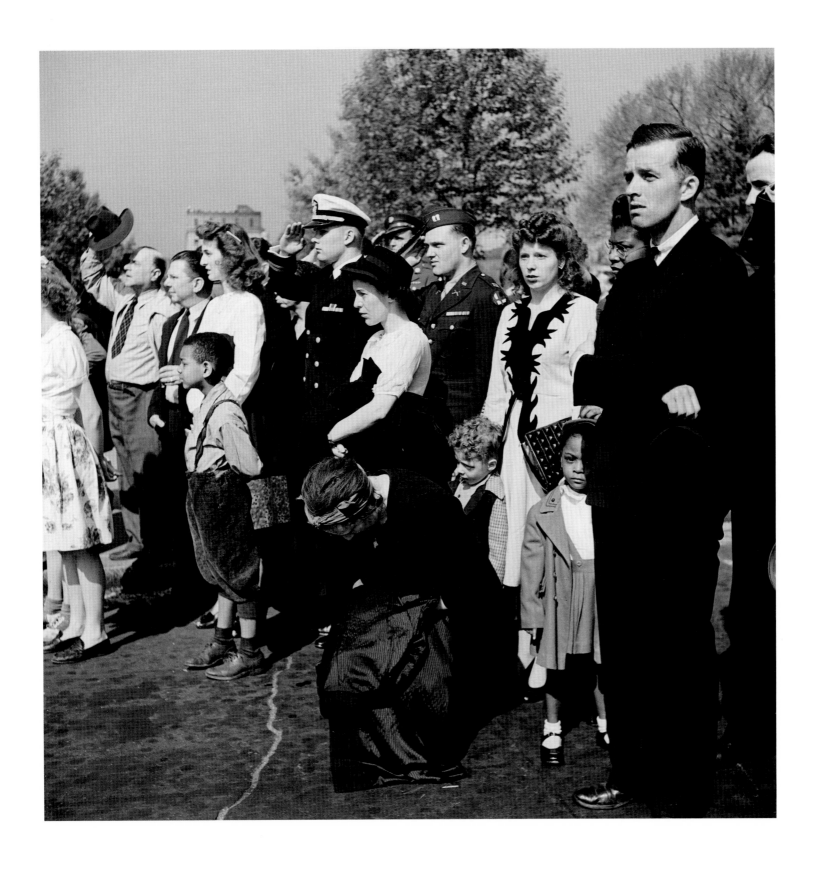

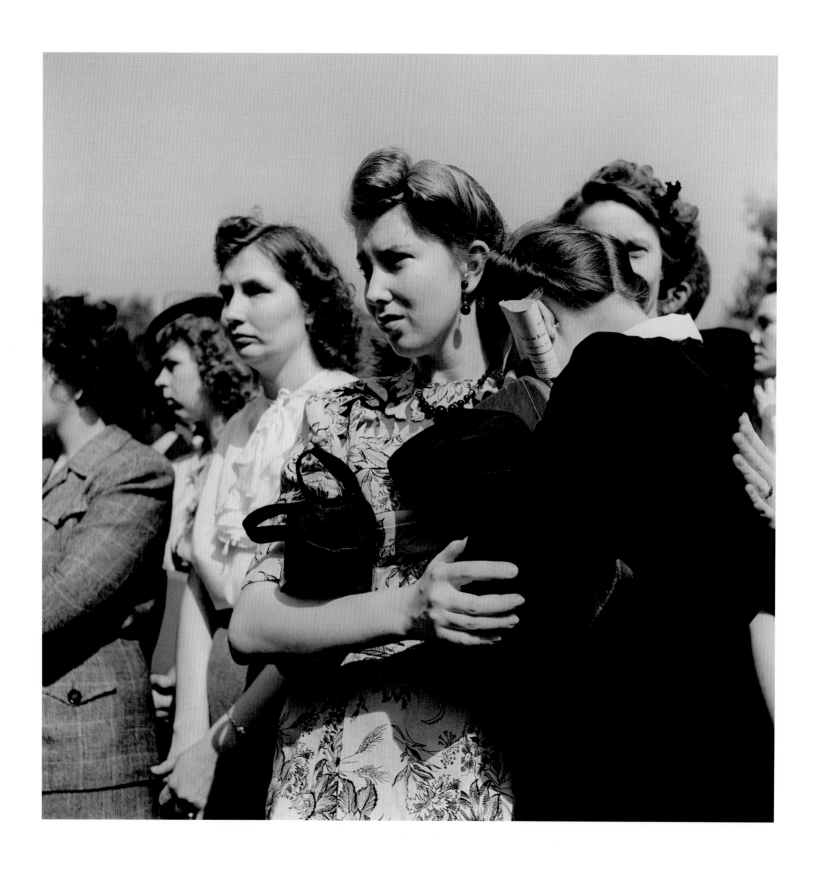

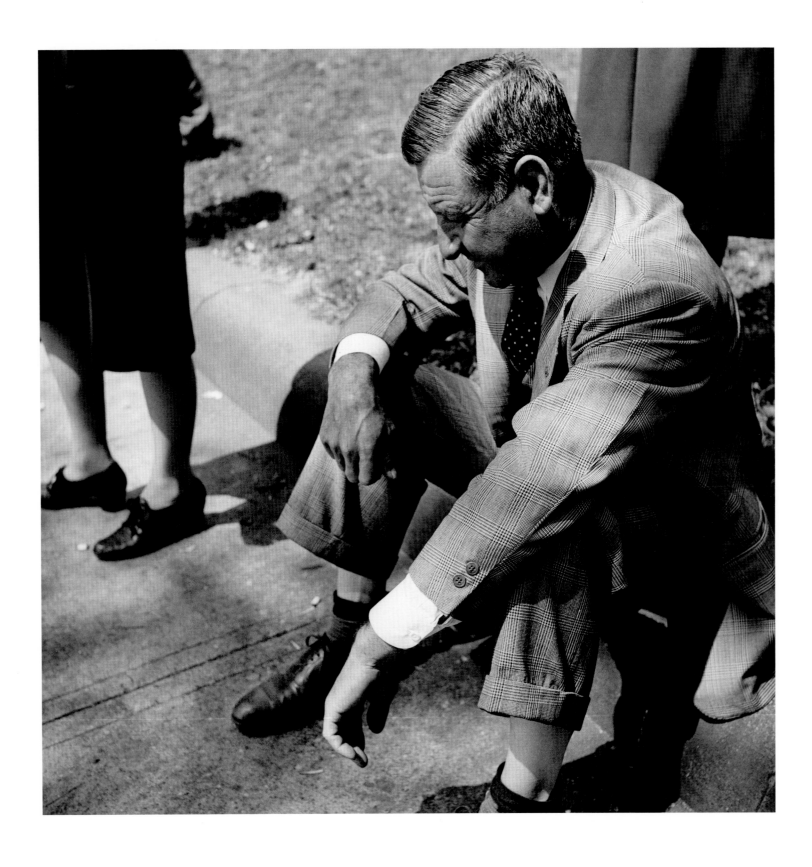

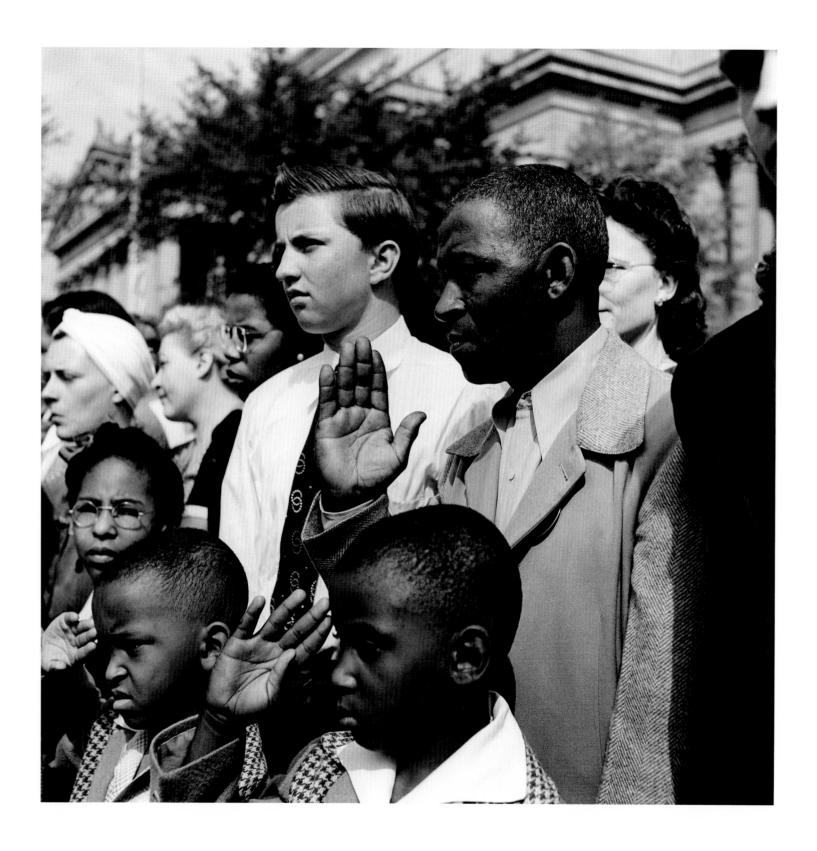

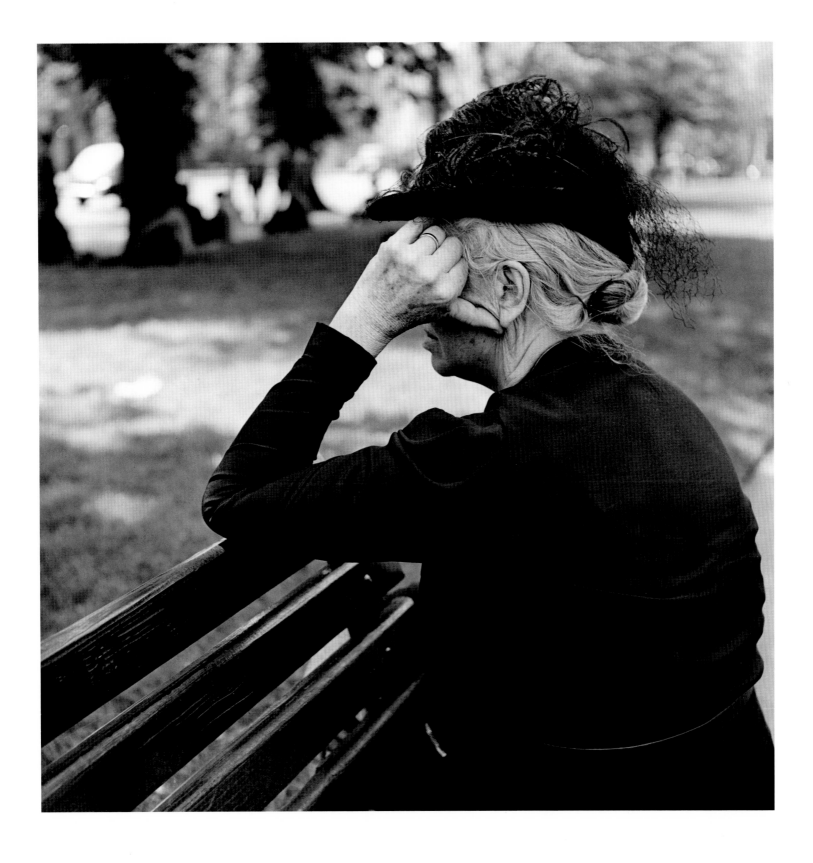

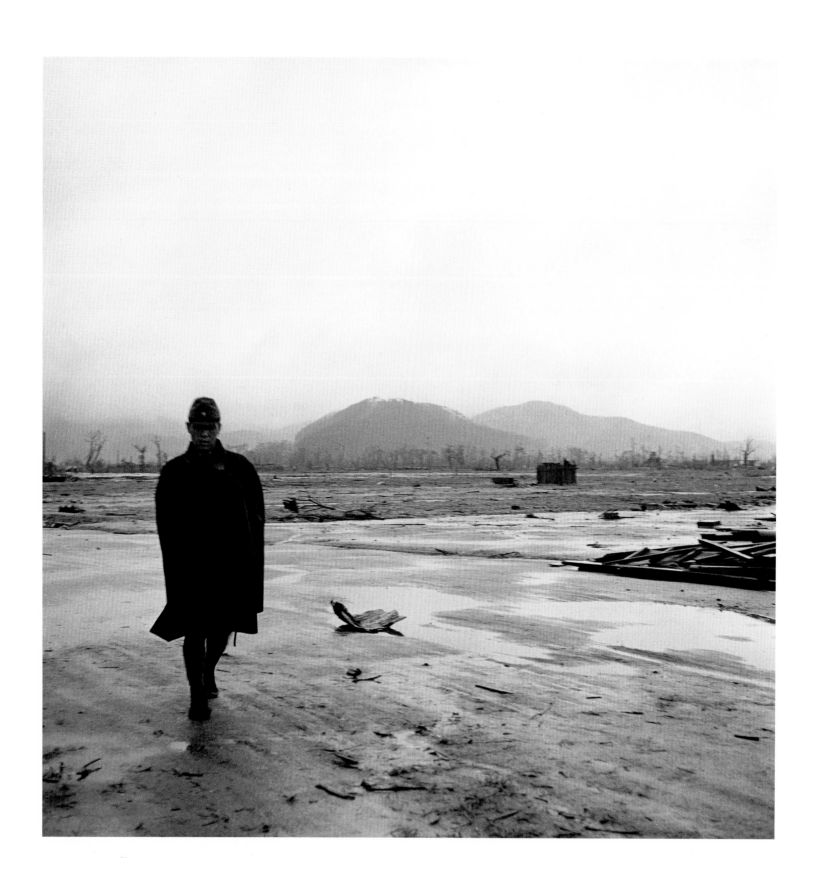

Hiroshima

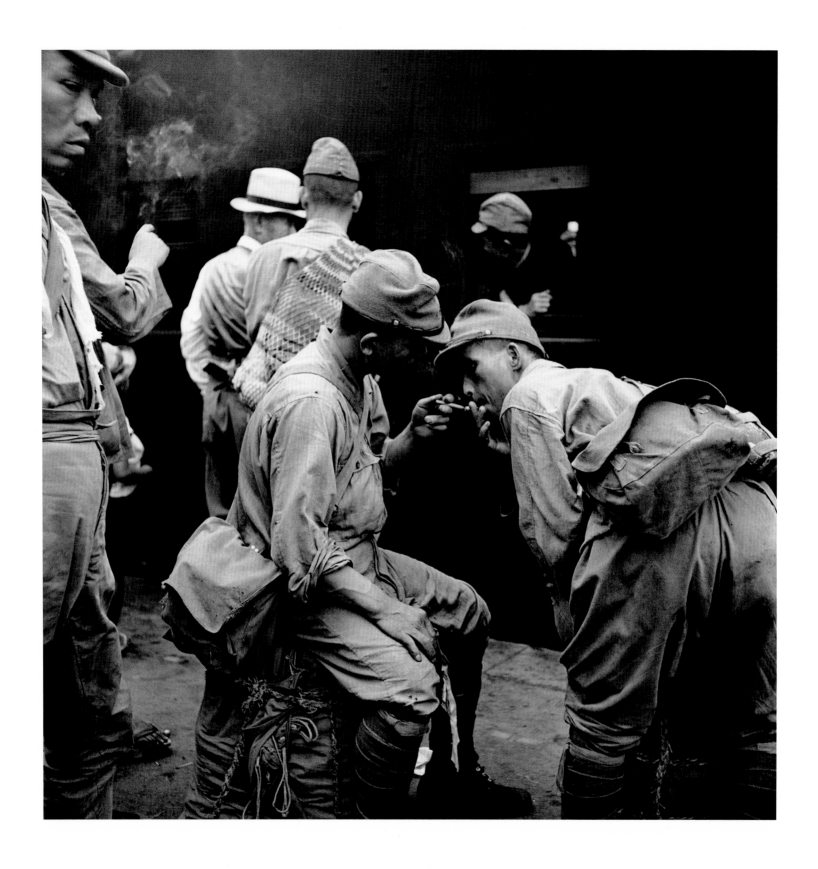

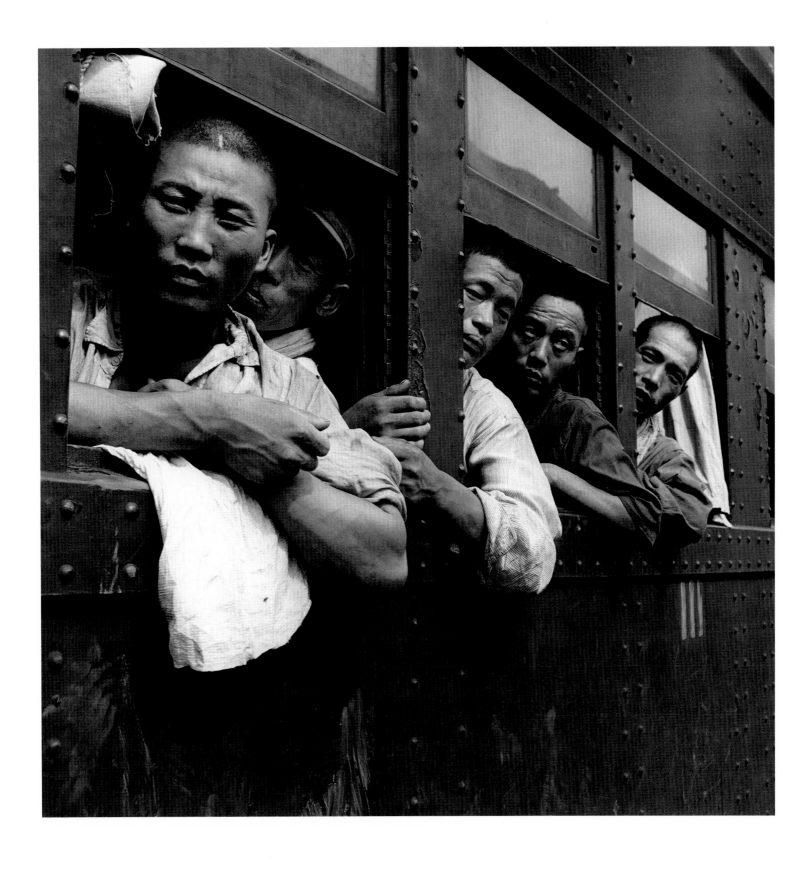

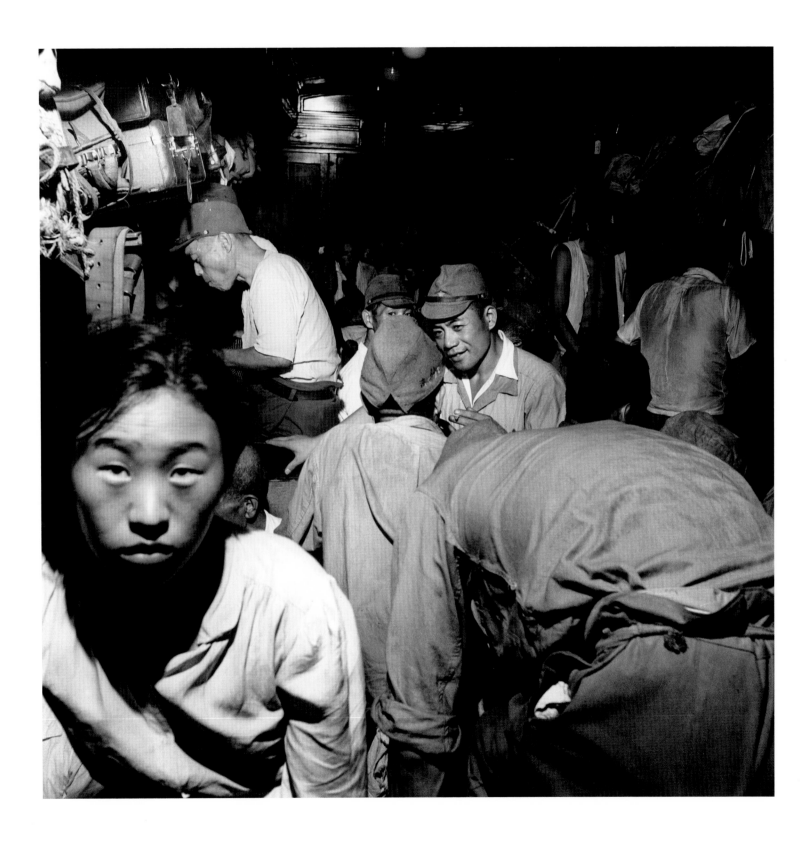

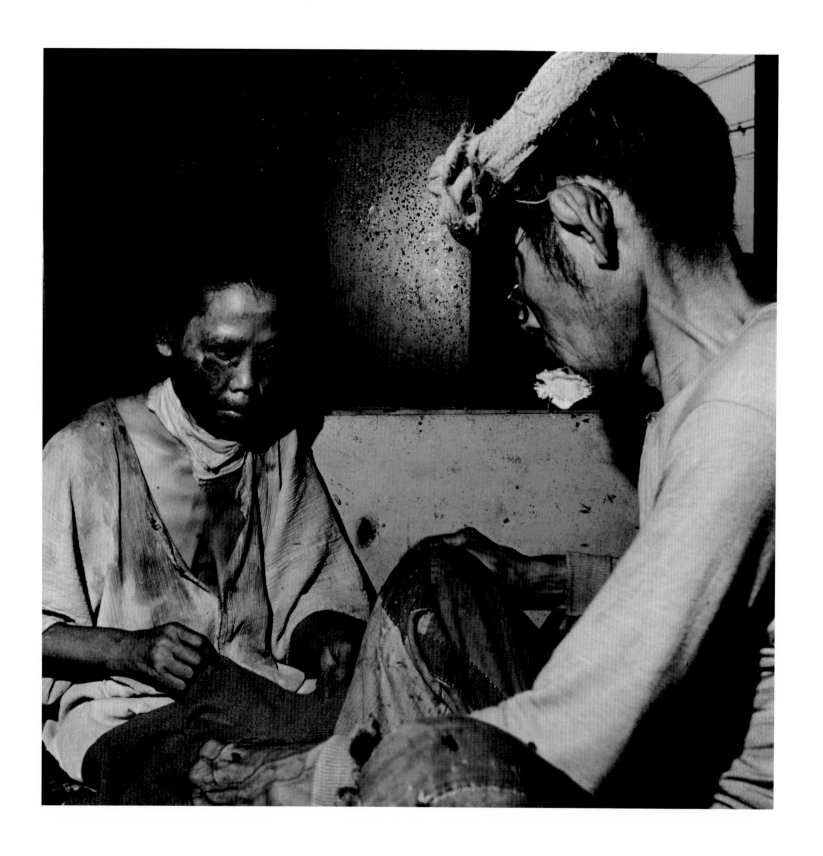

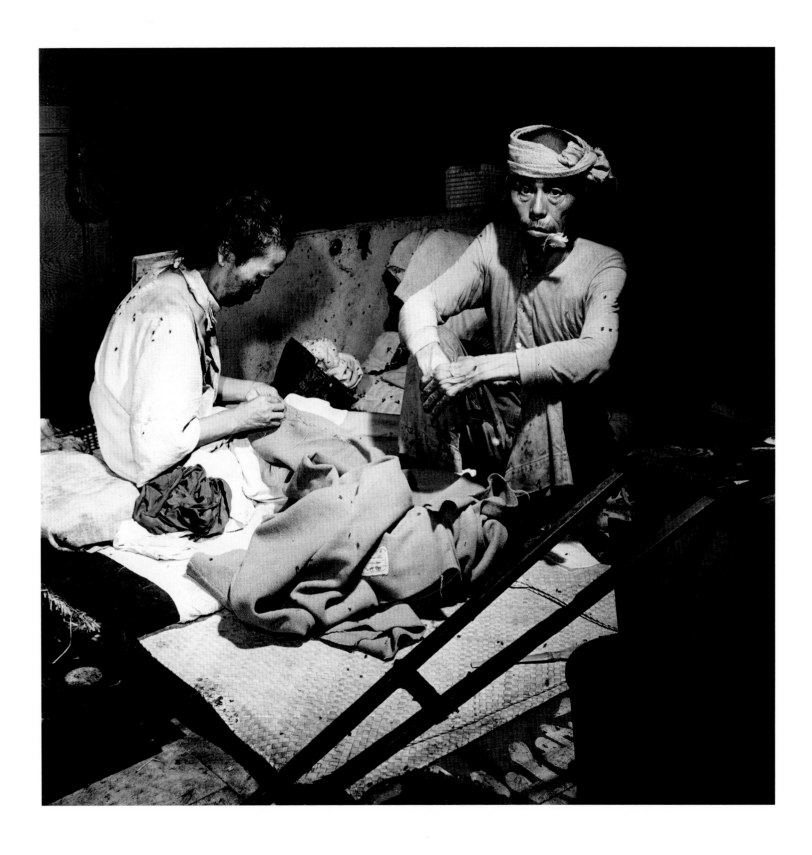

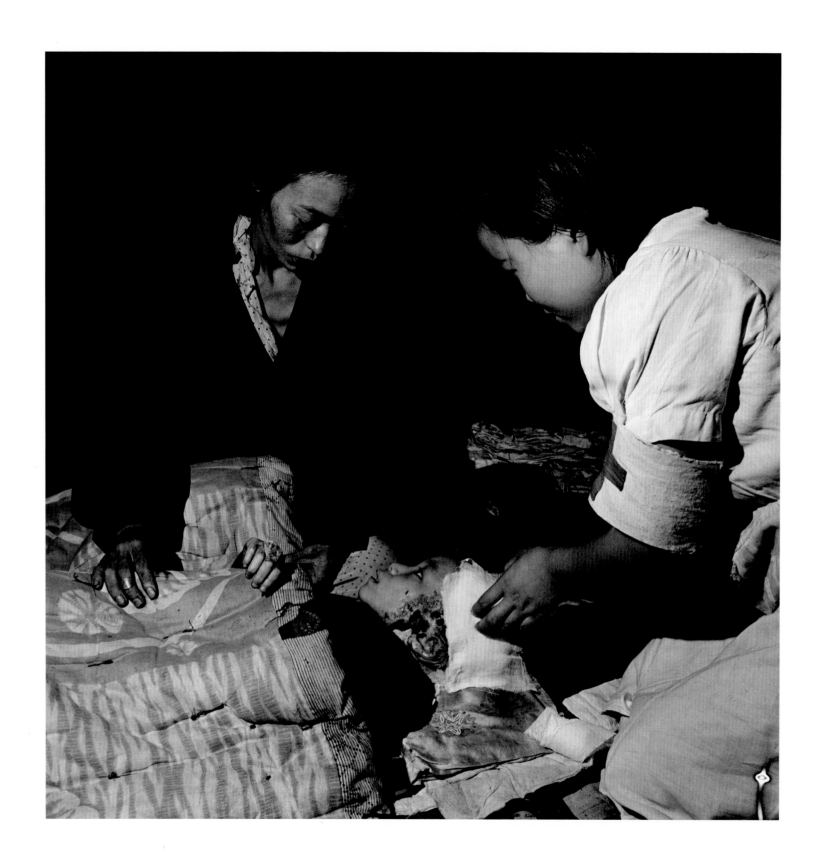

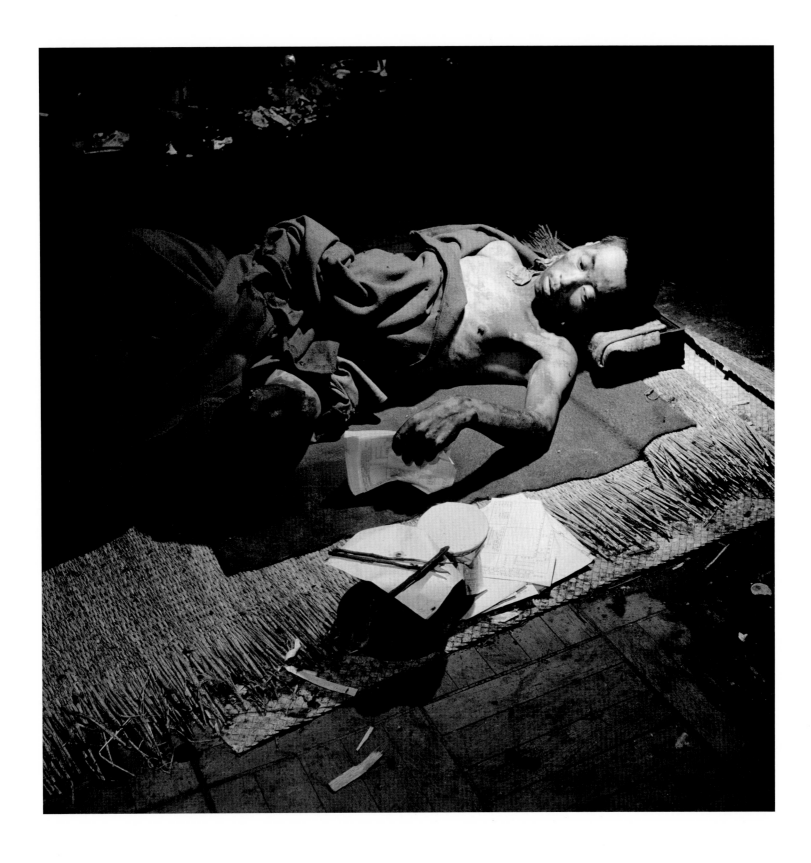

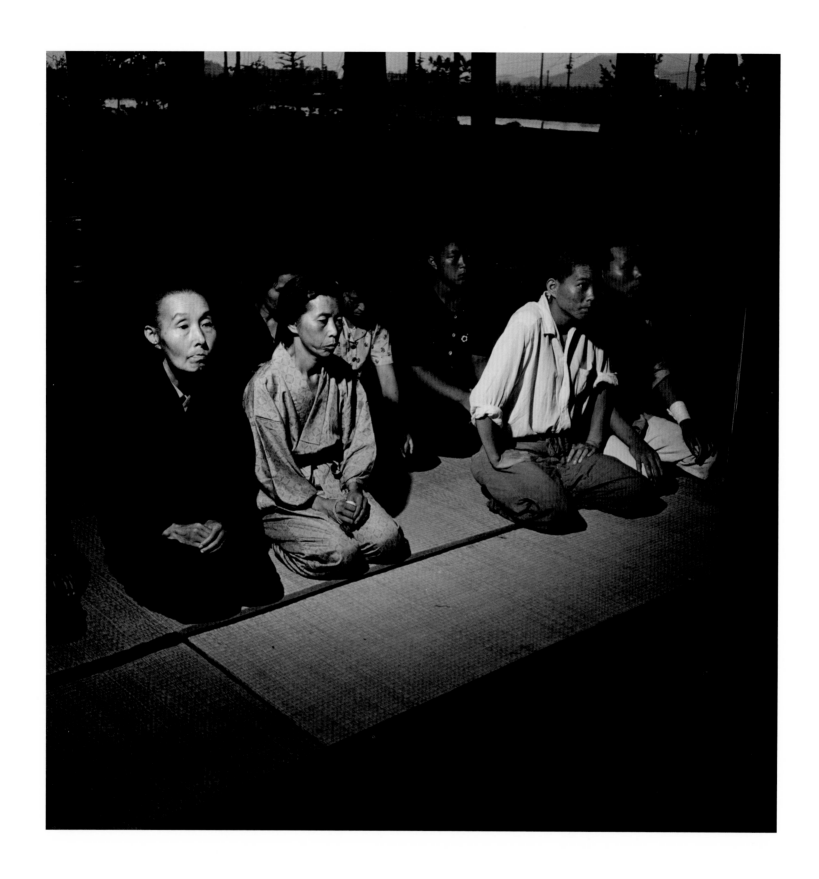

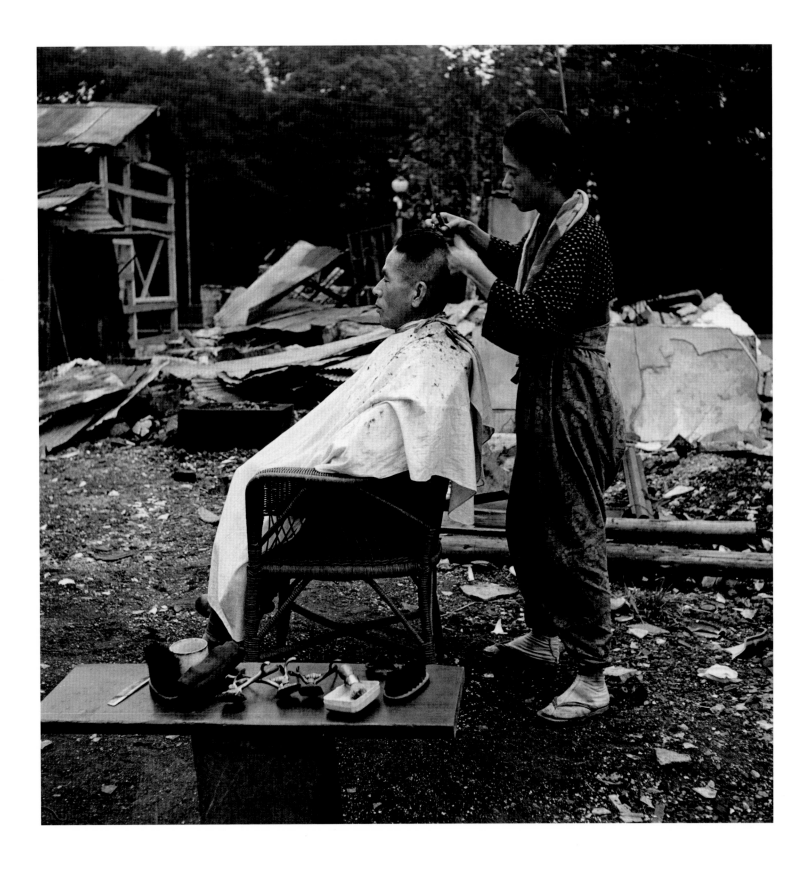

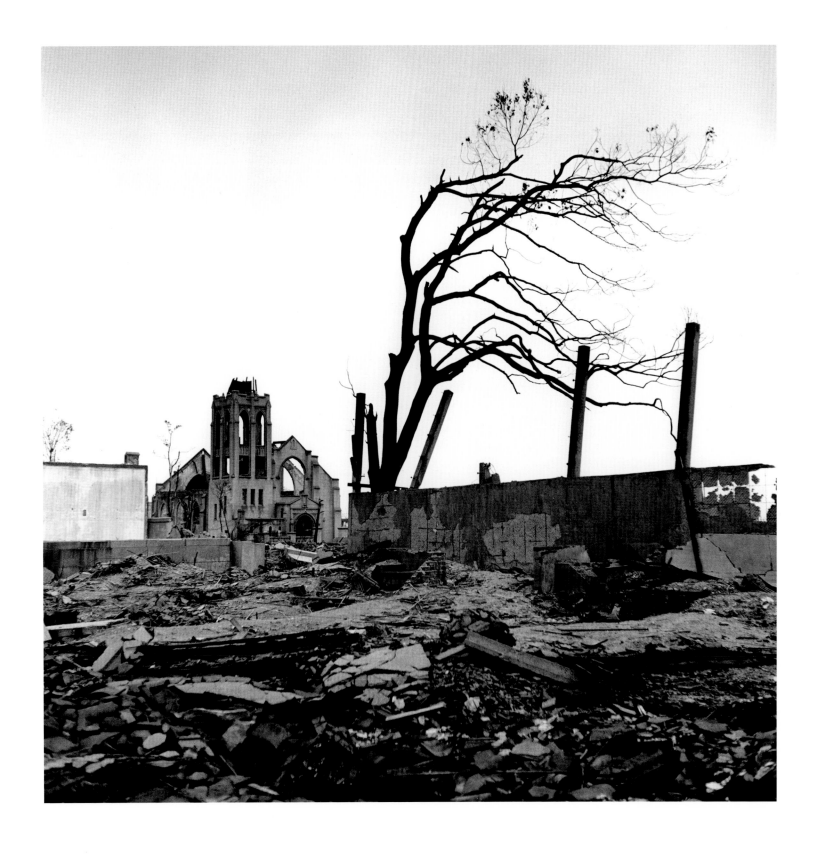

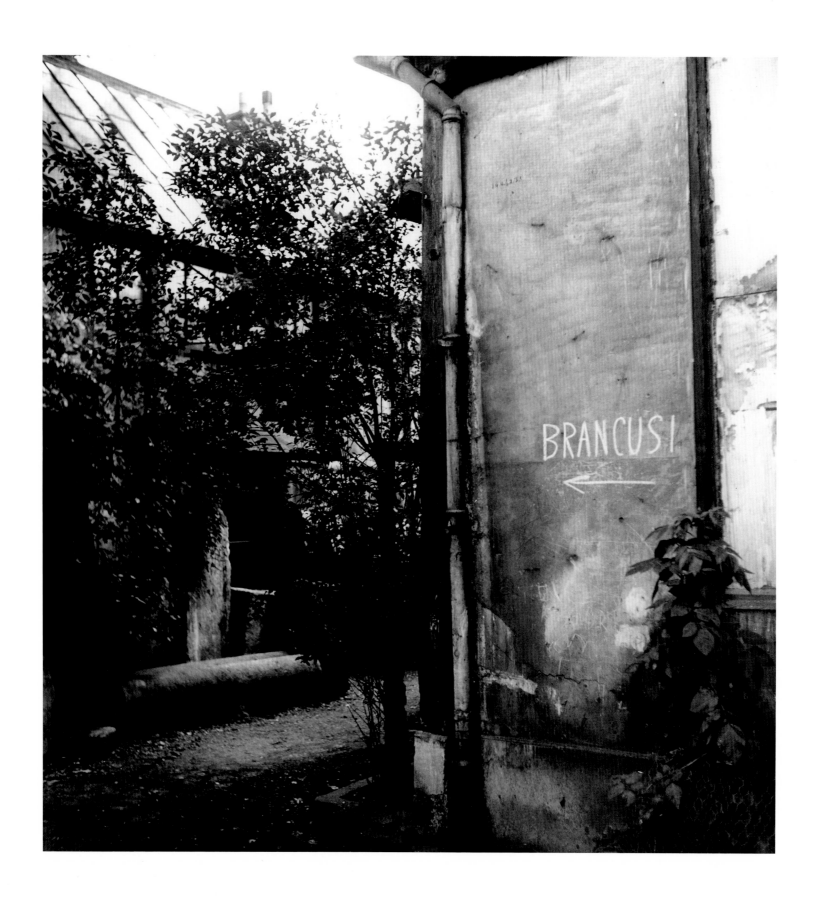

Brancusi

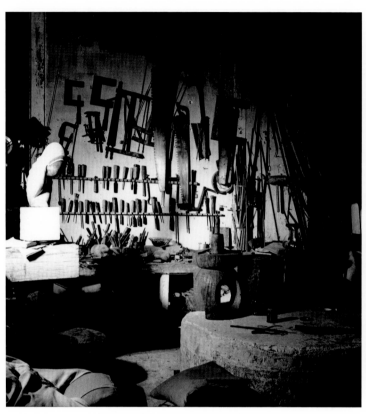 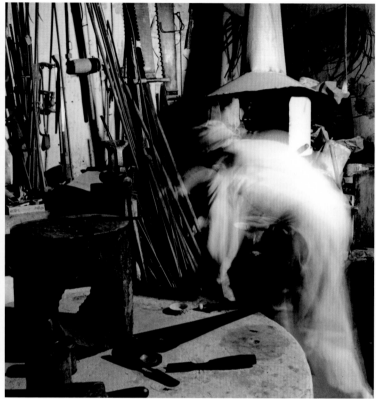

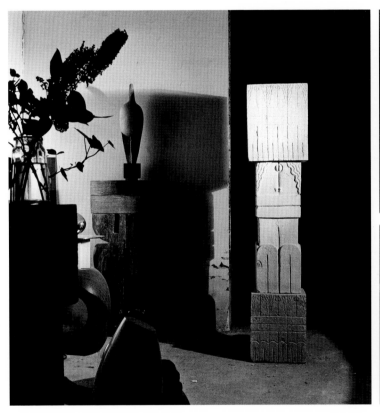
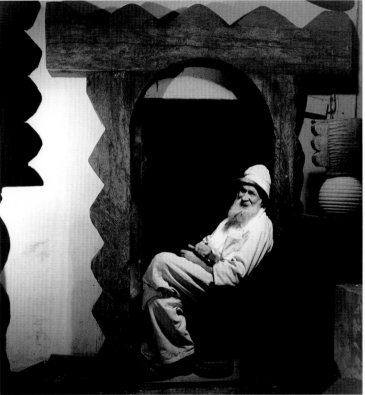

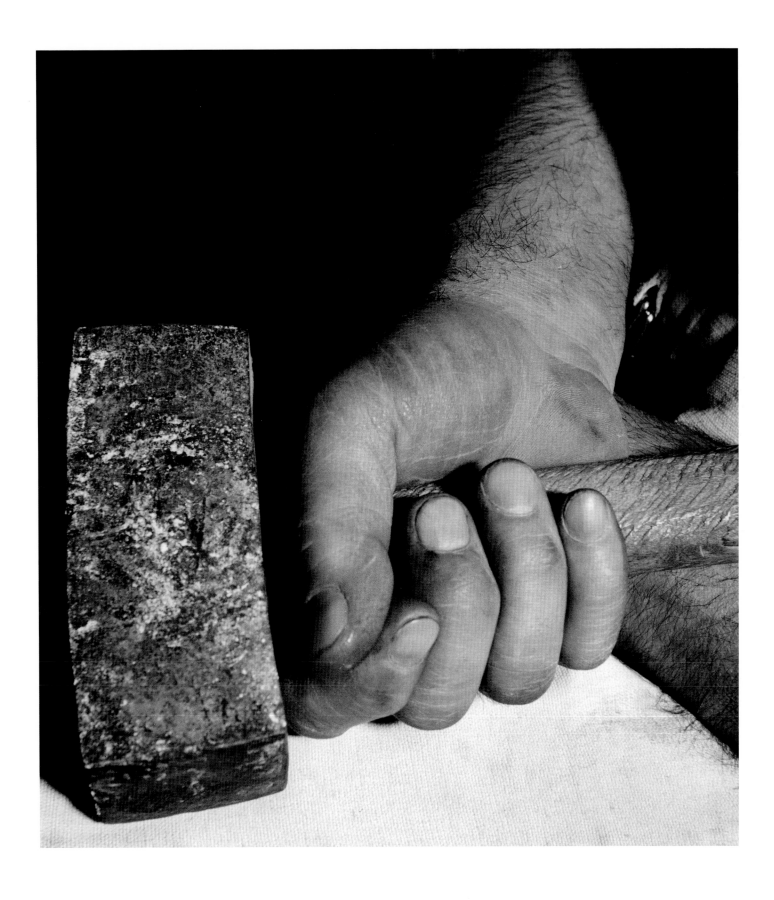

MIDWEST 1946–49

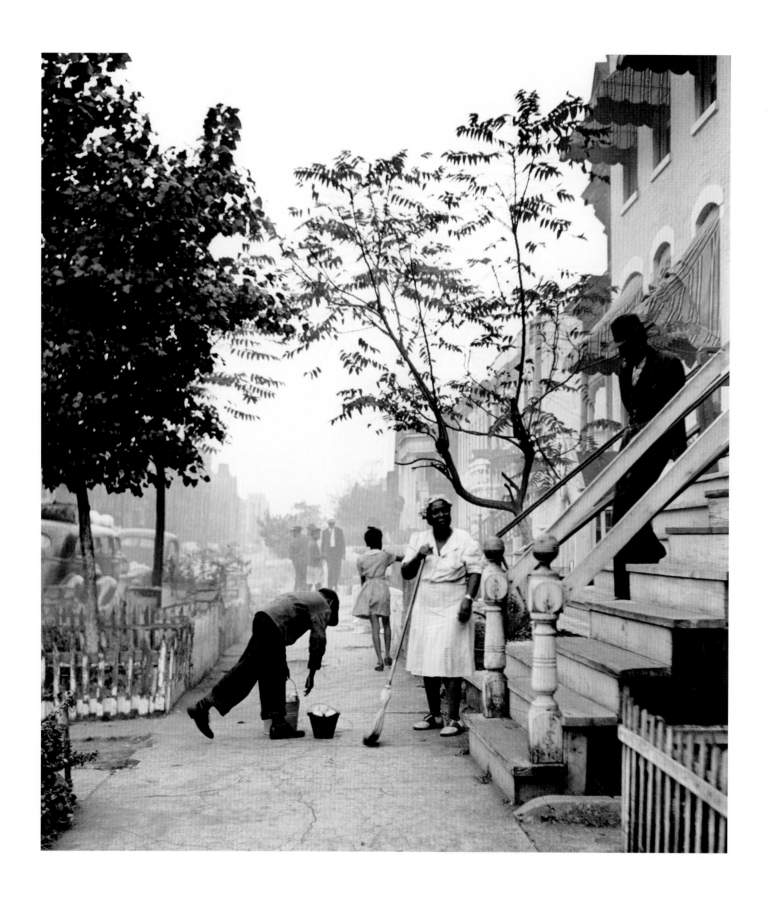

The Way of Life
of the Northern Negro

I was born a black boy inside a black world. So, like moments rising out of my unfathomed past, many of Wayne Miller's images slice through me like a razor. And I'm left remembering hunks of my time being murdered away as I suffered blistering hot summers or ate the salt of equally cruel winters. For me those crowded kitchenettes, the loneliness of rented bedrooms, and the praying in leftover churches remain an ongoing memory. Here, far from the Kansas prairies where I was spawned, I just couldn't melt into the ghetto's torturous ways—unlike so many others who, after a hard day's work, numbed the misery with booze and soothing music. "Hello blues. Blues, how do you do?"

New York's Harlem, Chicago's South Side—both cities of blackness crammed inside larger cities of whiteness—offered mostly hunger, frustration, and anger to their tenement dwellers. And those same tenements that imprisoned thousands are still there, refusing to crumble. I recall swarms of slow-moving people passing the chili shacks, rib joints, storefront churches, and funeral parlors—all with the same skin coloring but rarely speaking to one another. When you left your door you walked among strangers. Now there are a few new buildings going up to look smugly down at the old ones. Good music, laughter, and prayers are still in the air, but for many young blacks, music, laughter, and prayers offer at most an uneasy peace.

At times I became disgruntled with this social imprisonment, even became angry with myself for not finding a way out. But eventually that anger grew tired of hanging out with me day and night, and little by little it left me alone. And for a long time I remained alone—still desperately searching for bread in the rubbish. That search was awful. I was constantly reaching for something denied me, or perhaps longing for something lost along the way.

Slowly the shadow of hope had spread its presence. Anger had fled—running as though it were escaping the violence festering inside me. Then gradually the light that avoided so many other hearts began falling on mine. But be free of doubt. Wayne Miller shows us what I remember most—those garbaged alleys and wintry streets where snowflakes fell like tears, those numberless wooden firetraps called home, the homeless gathered around flaming trash cans to escape the hawk of winter, those crudely worded signs—COAL 50 cents, WOOD 25 cents—those old men reclining in forgotten chairs left at curbside for moving vans that never showed up. There where funerals had become a habit and hardship never seemed to be out of order.

How feeble the uncertainty! Wayne's camera appears to be inexhaustible as it goes from life to life—abruptly leaving one door to arrive at another. Then somewhere, perhaps a short distance away in a pool hall or restaurant, he finds brothers and sisters of the soul muddling through the grime and sipping Fox Head beer. Yet to some of their fortunate kinfolk that was a small thing. Having swum through the dust, they were now in tuxedos and ball gowns, dancing to the strains of Ellington's uptown music in a softly lit ballroom. "Hug me, sugar, and let the good times roll."

Where, one might ask, does Wayne Miller fit into this chaos that plagued my youth? A good question. Did he possess an insatiable curiosity that had to be fed, or was he perhaps treading the path of any competent photographic journalist? A close acquaintance with him for many years gives shape to my own answer. He was simply speaking for people who found it hard to speak for themselves. And that trait takes full measure of any journalist who is worth his salt. Once when a reporter wrapped that question around his neck, he answered unhesitatingly, and rather bluntly, "I am interested in expressing my subjects. I won't turn a nice guy into a son-of-a-bitch or a son-of-a-bitch into a nice guy. There are people who make pictures and people who take them. I take them. At times I have been so busy capturing what I was seeing that it was impossible to cry and work at the same time. Good images emerge from good dreaming. And, to me, dreaming is so important."

Wayne went to wherever his conscience called him, and his camera's eye baptized whatever confronted him. Earthbound and free of any shadowy miscellany, he made contact with the roots. And as no one can stop the waters flowing, neither can one eliminate his powerful images from our past. They will still be here with us, even if those tenements crumble in time, exhausted.

Gordon Parks, Photographer
2000

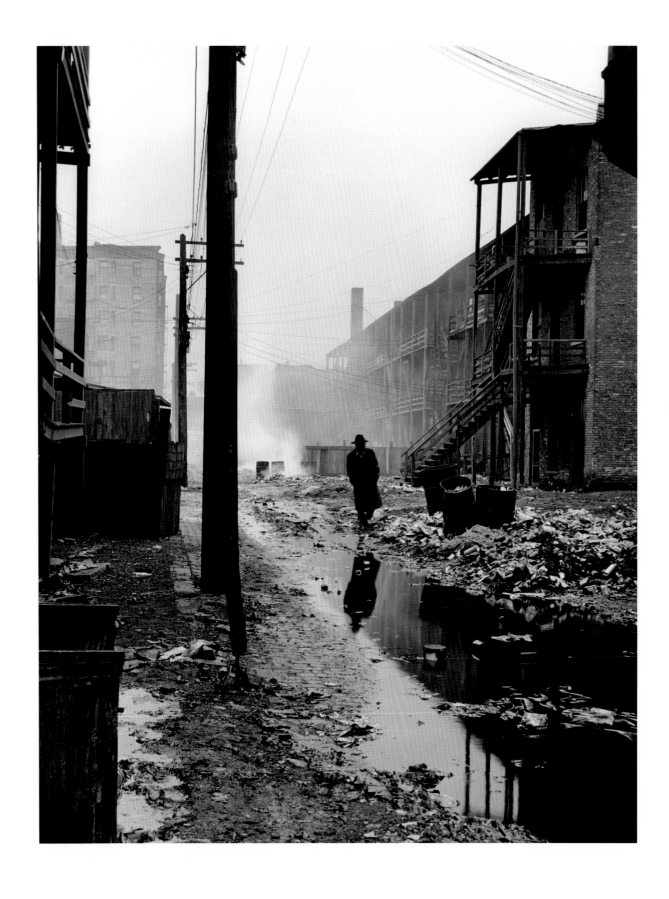

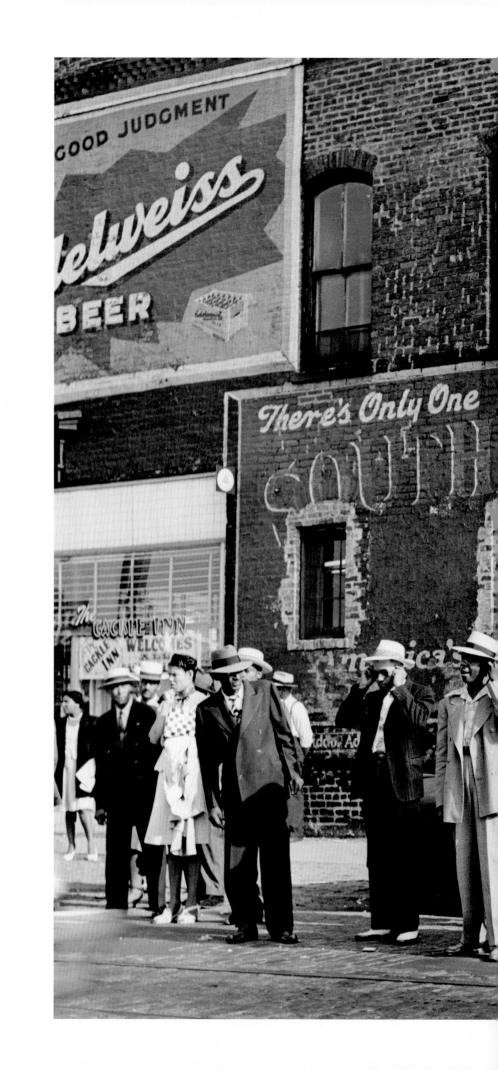

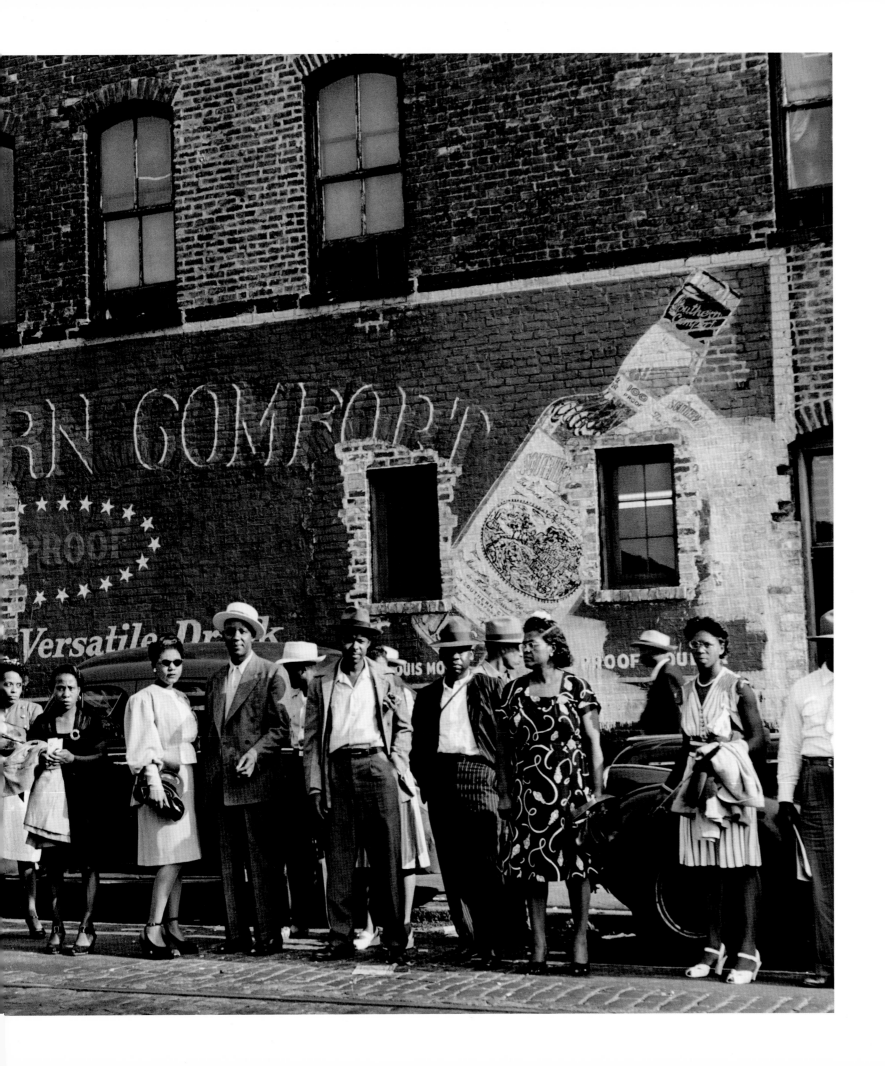

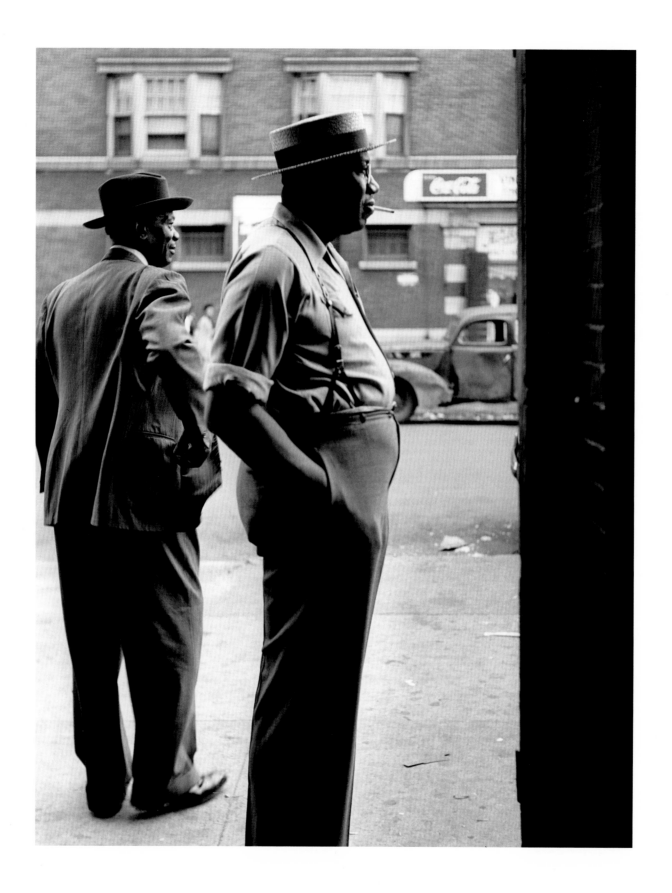

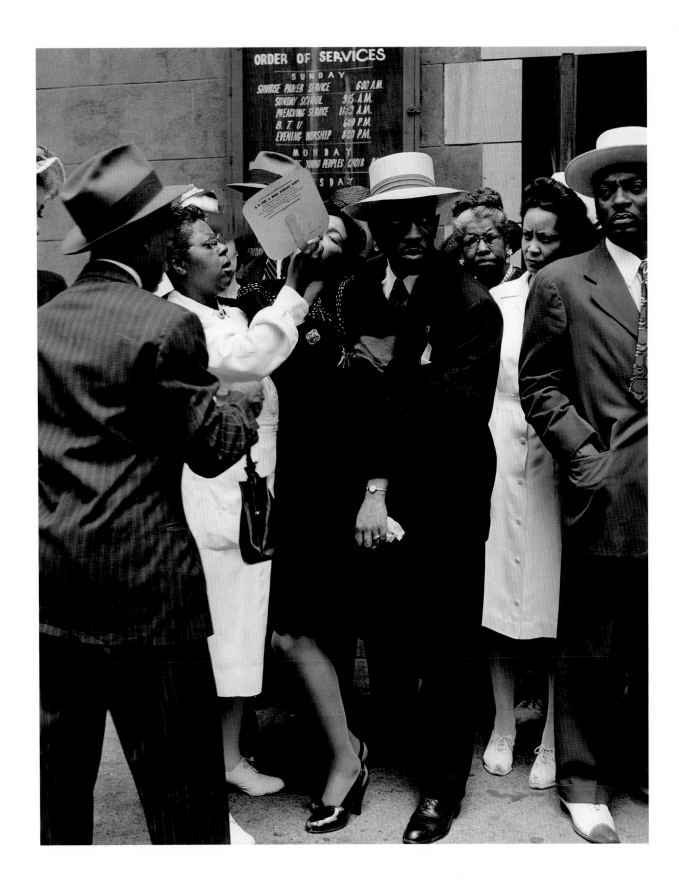

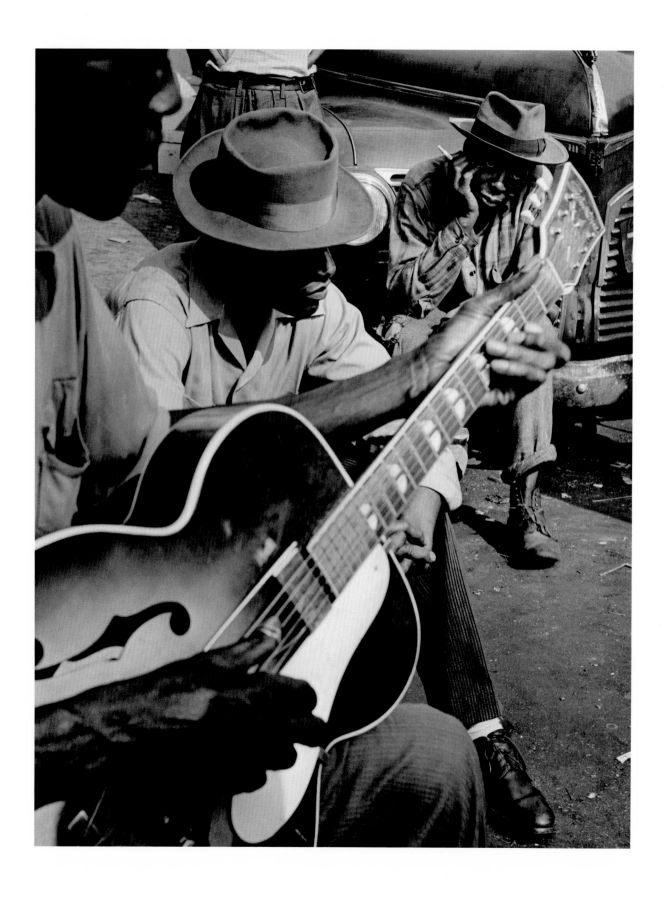

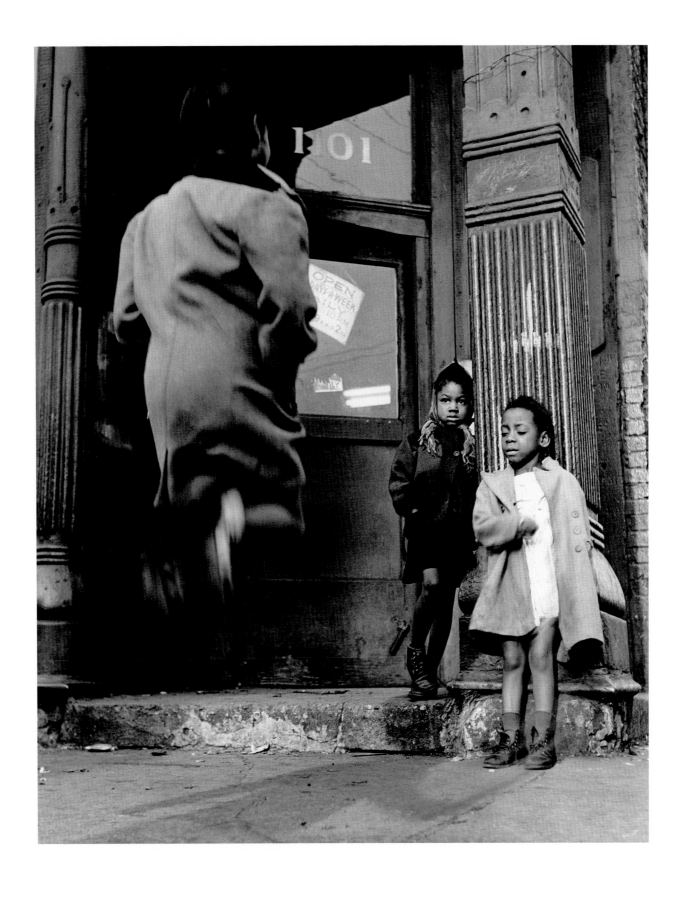

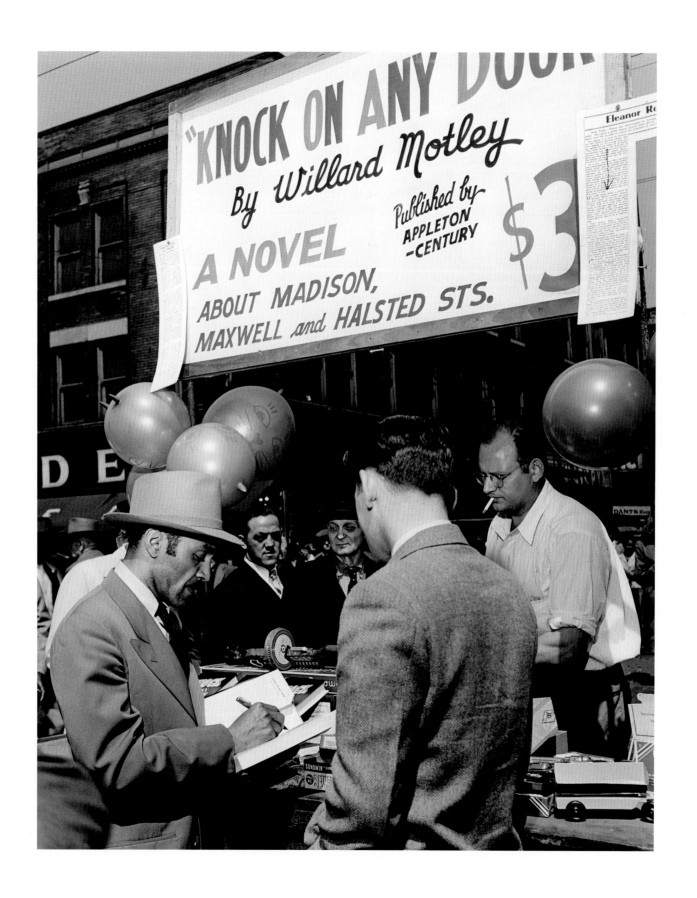

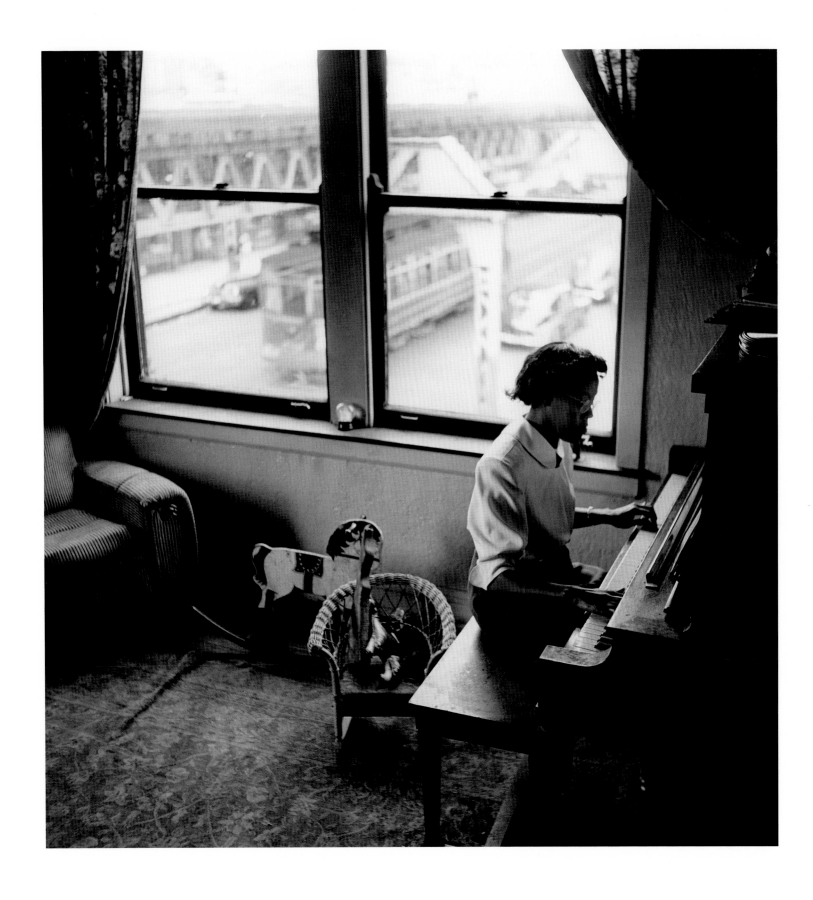

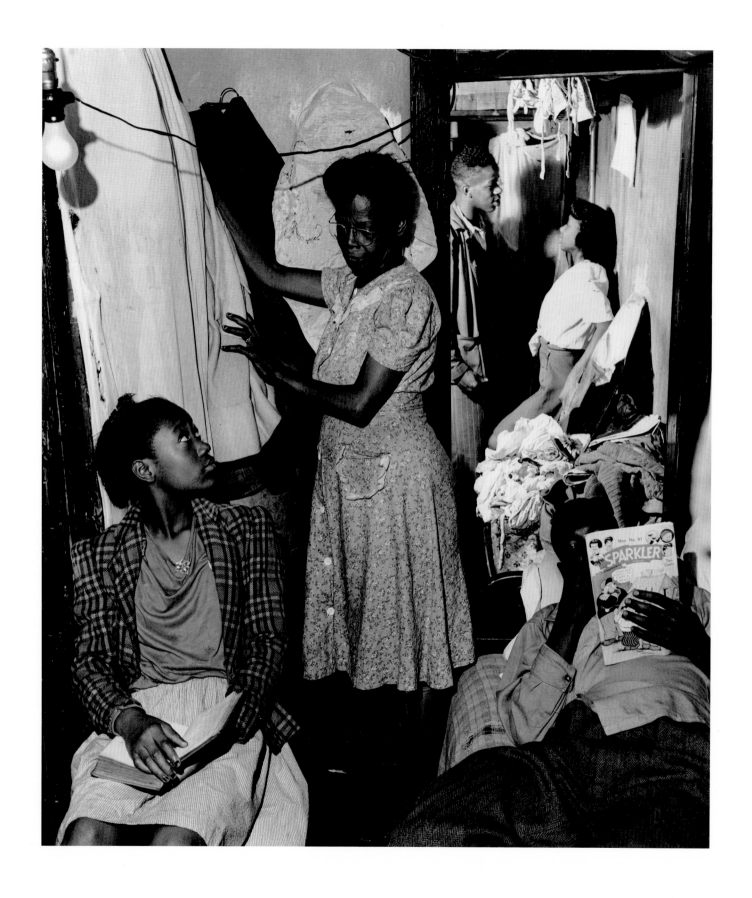

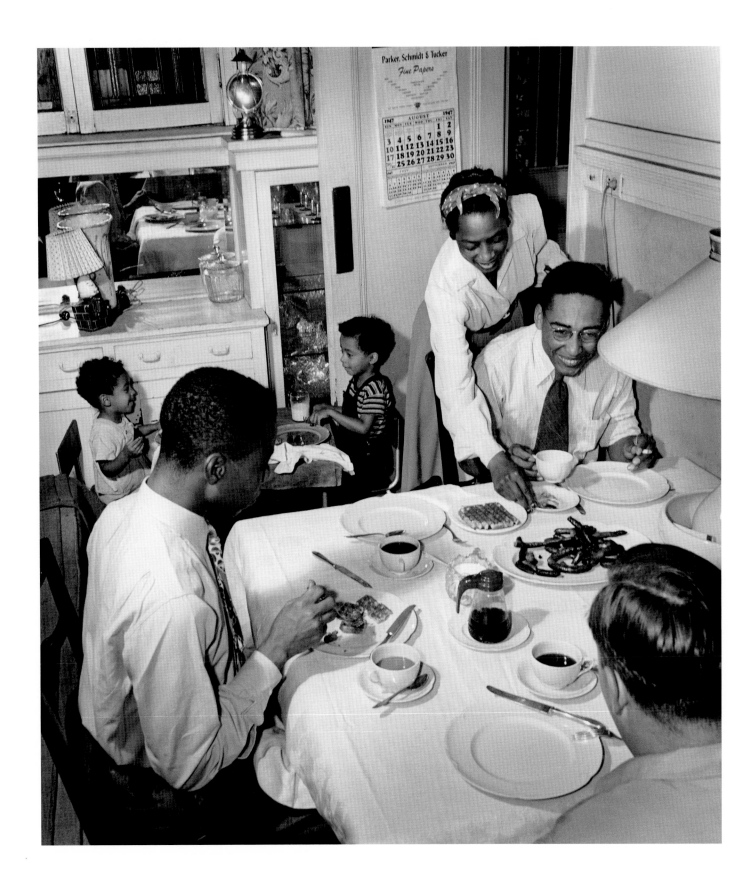

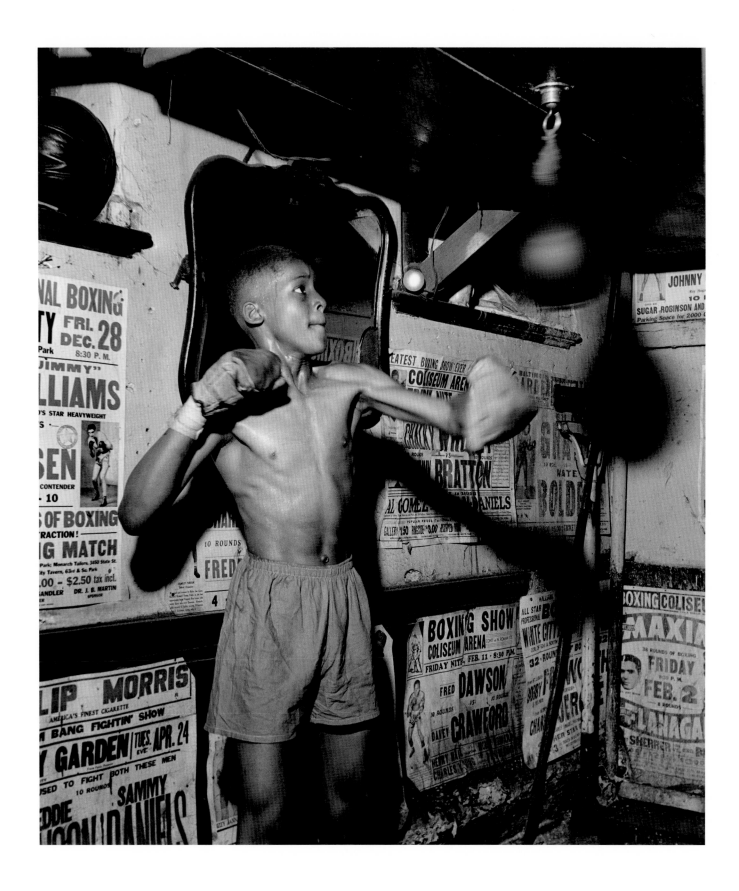

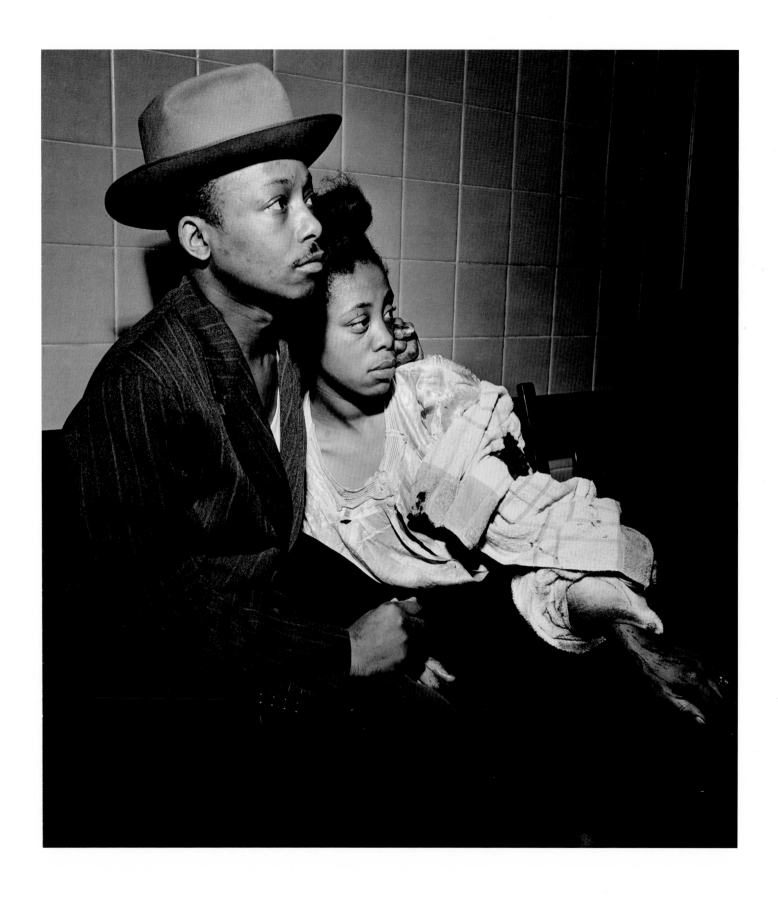

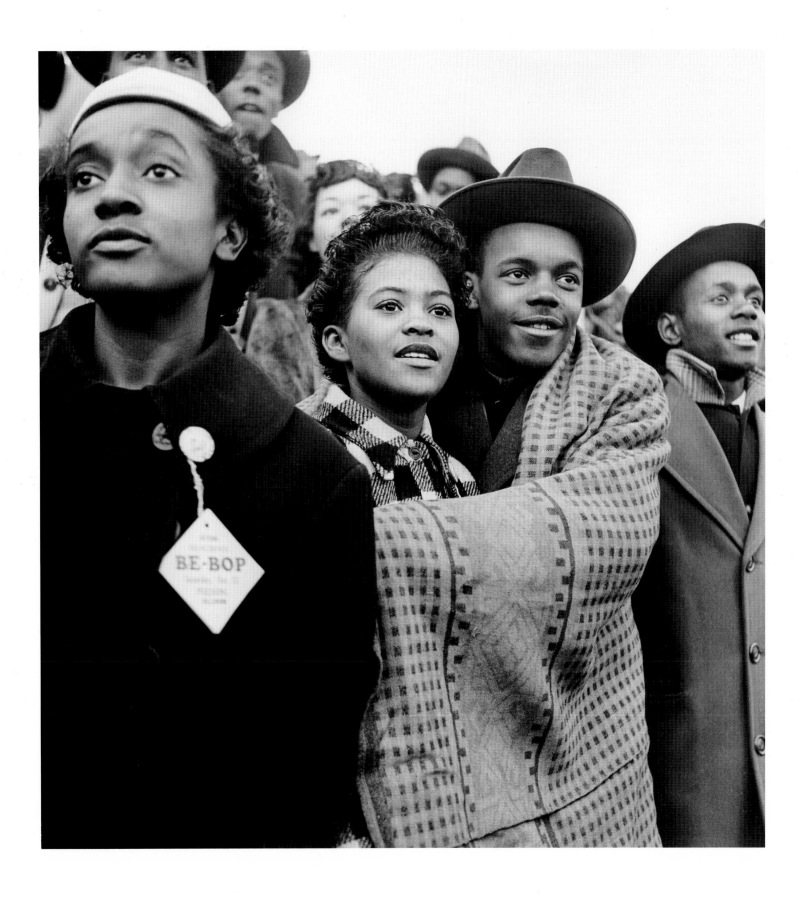

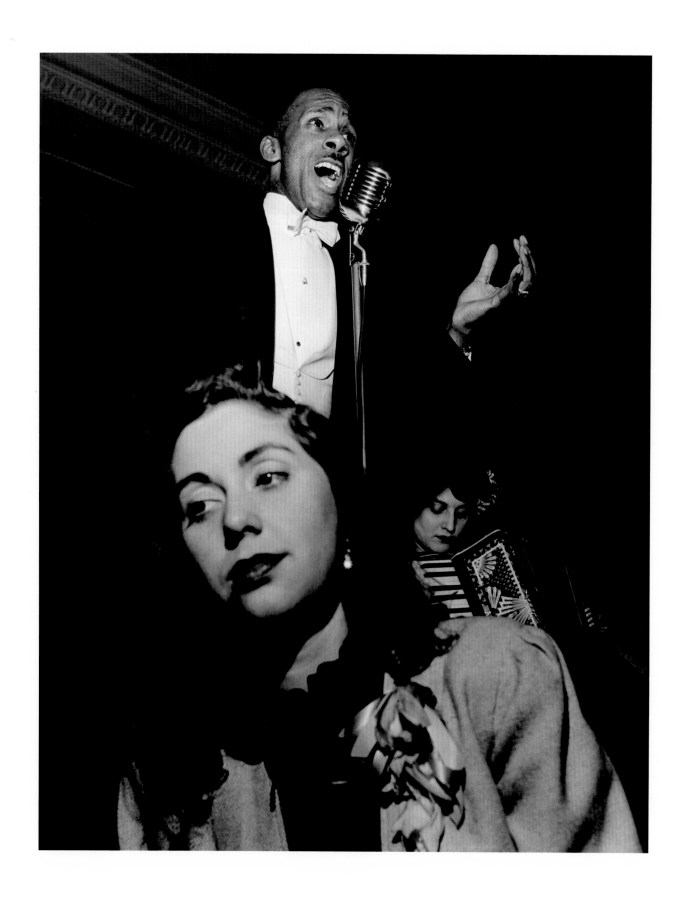

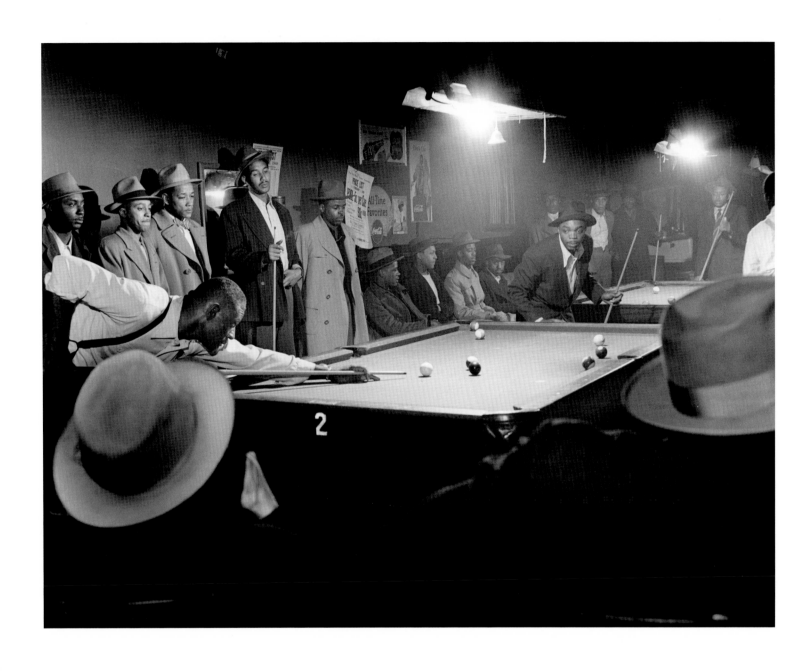

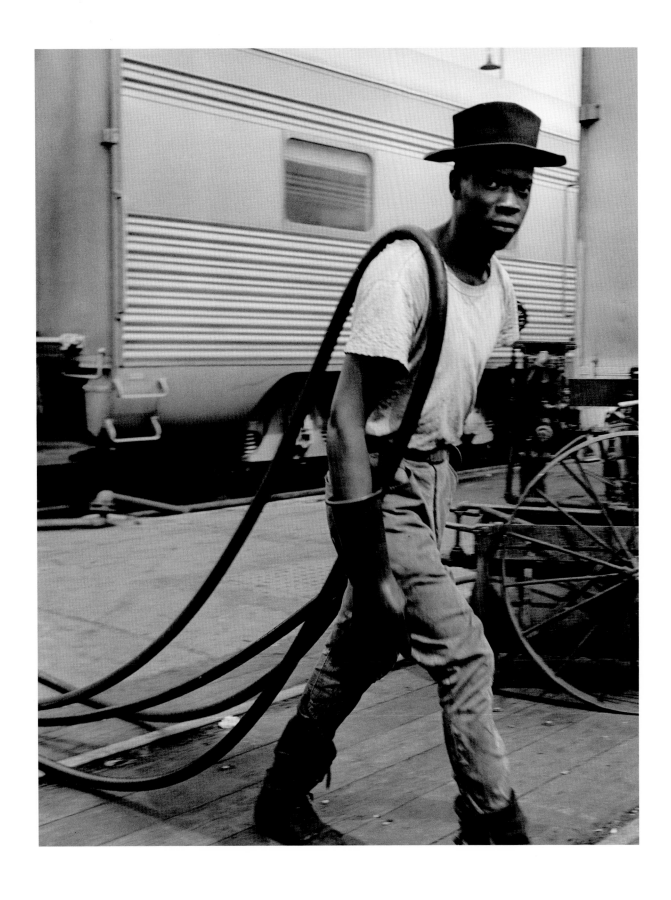

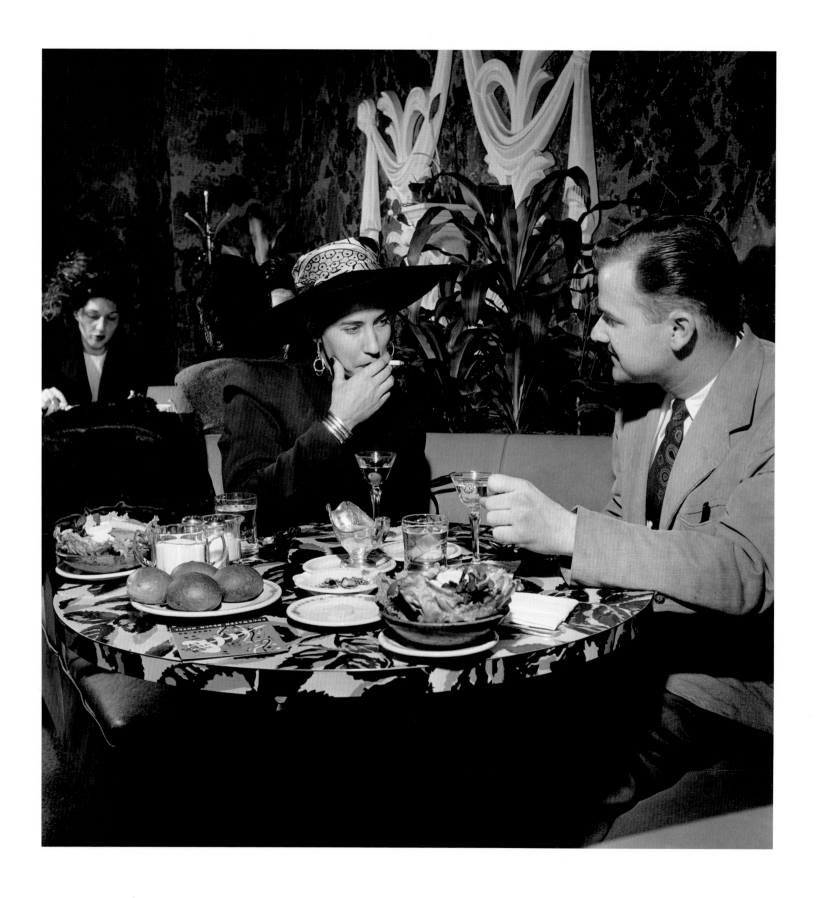

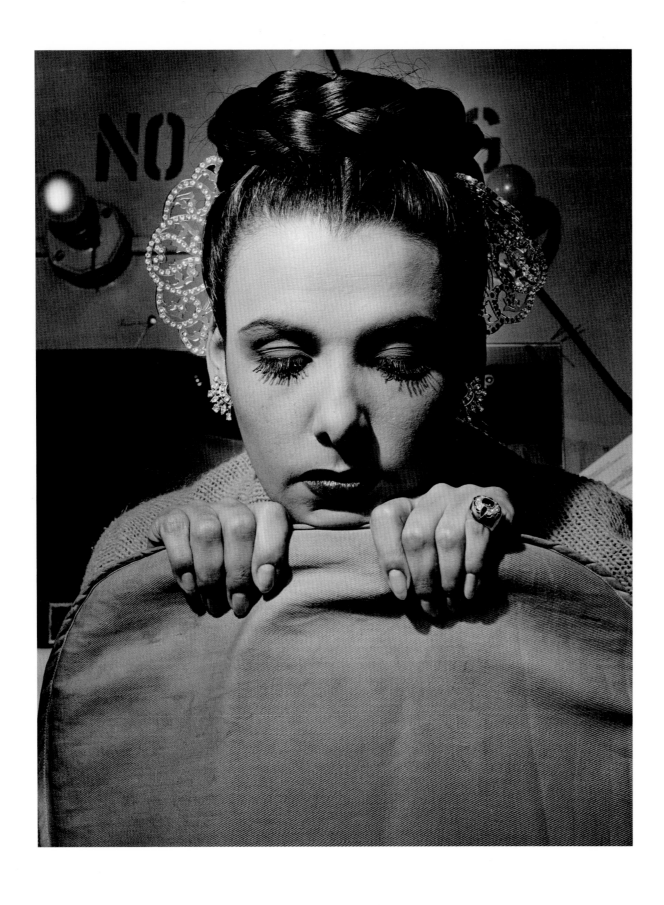

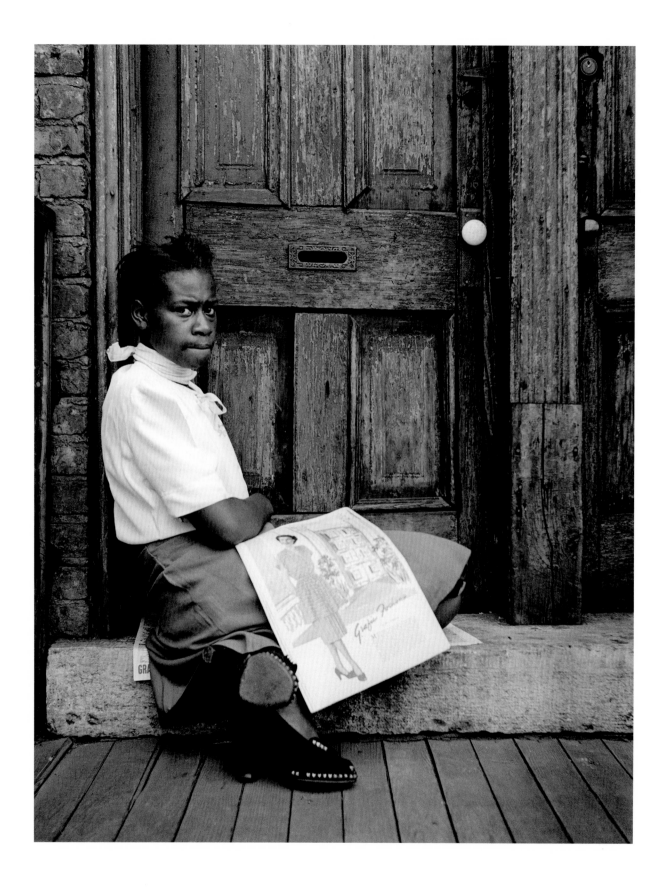

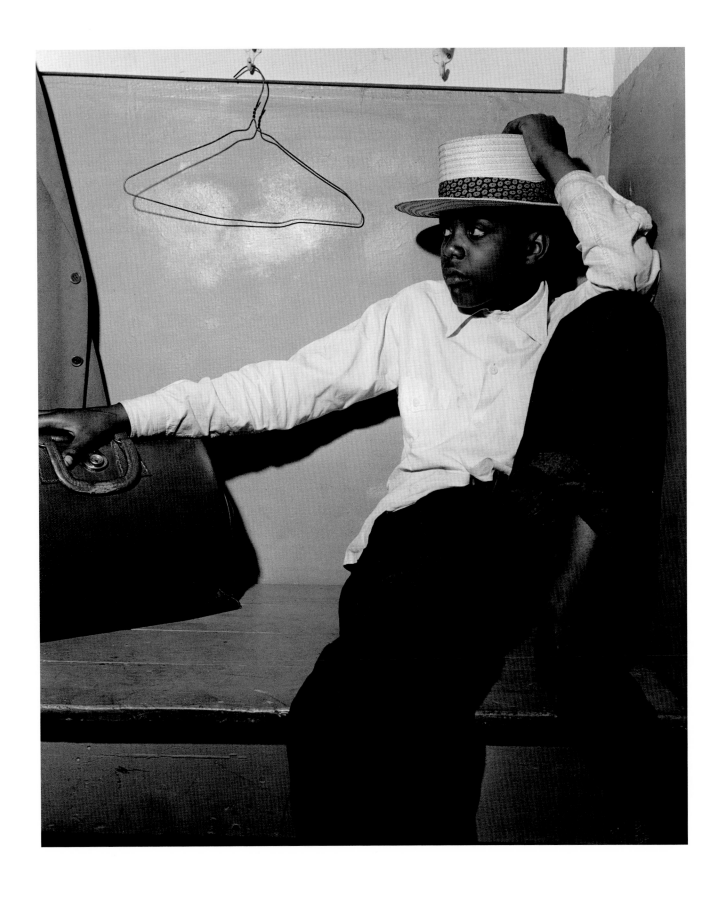

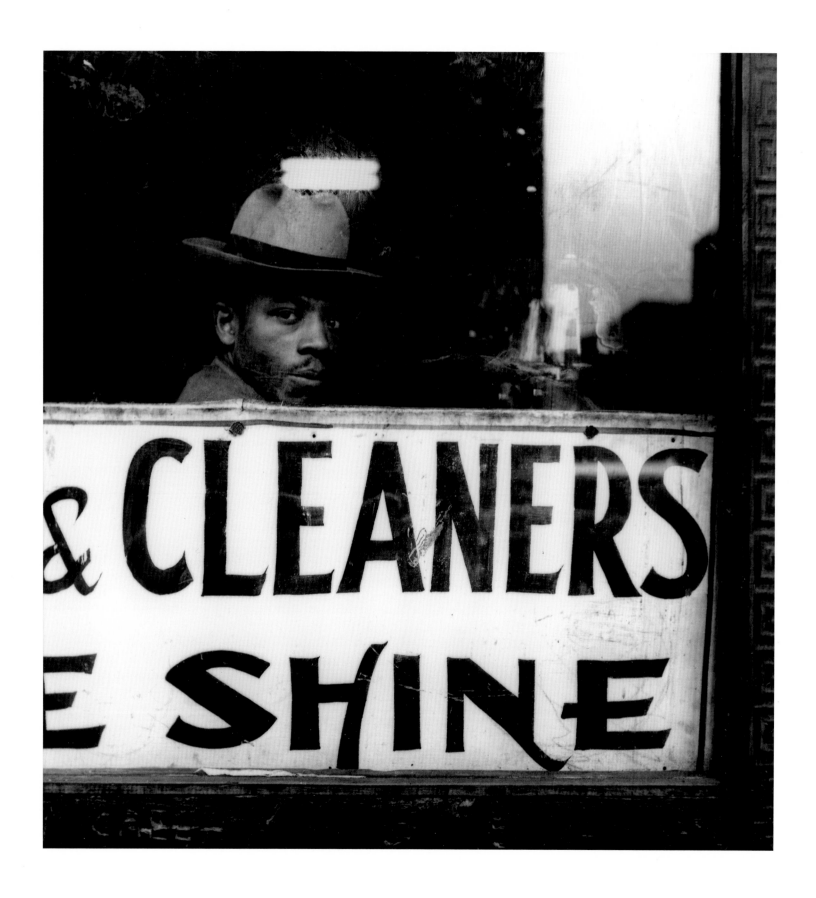

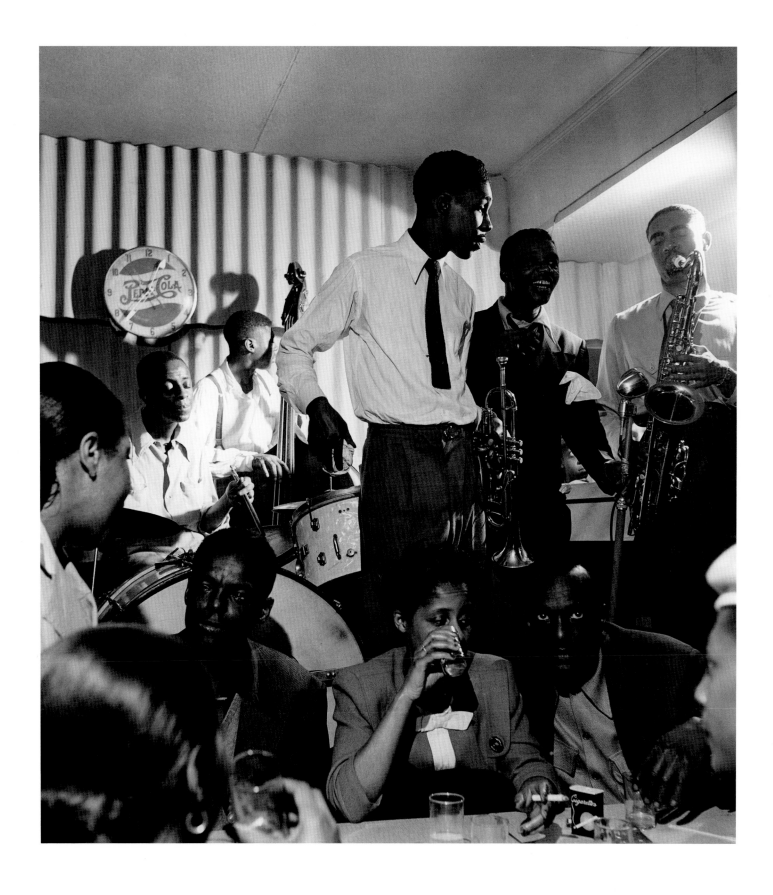

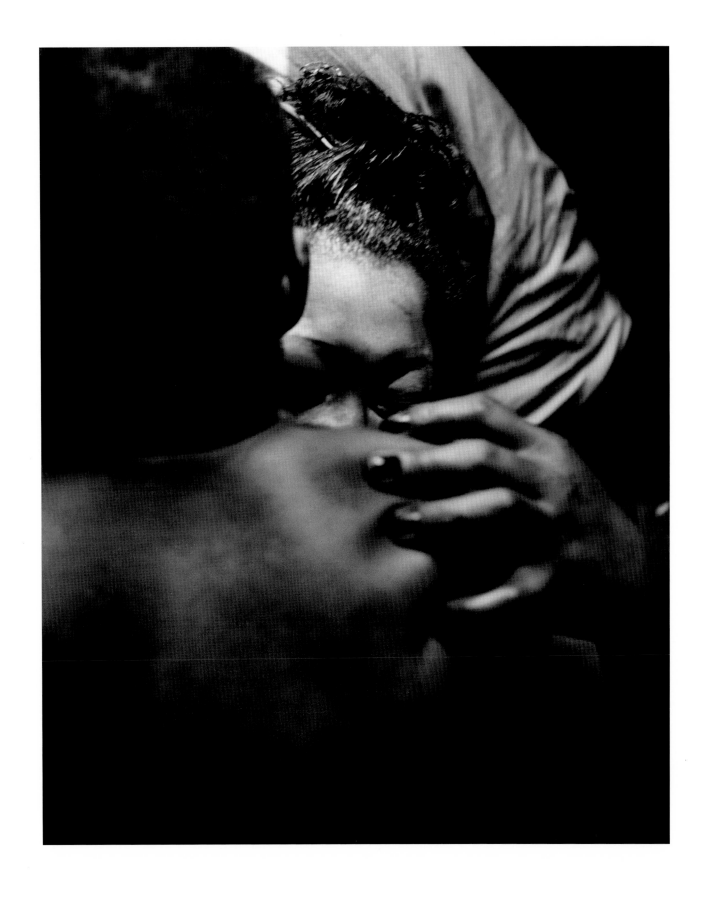

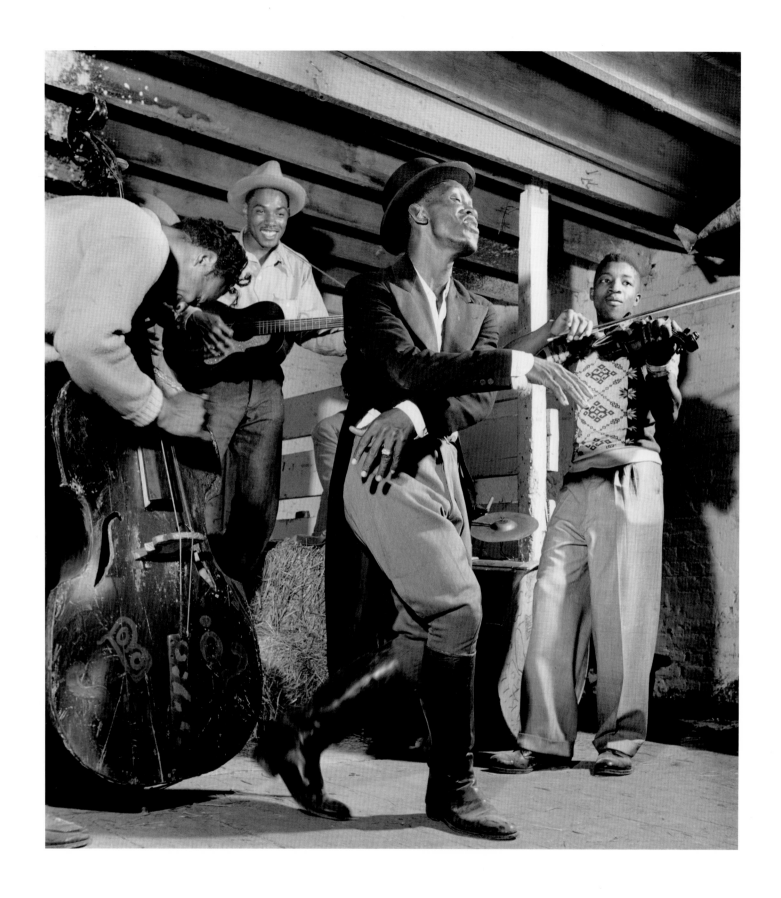

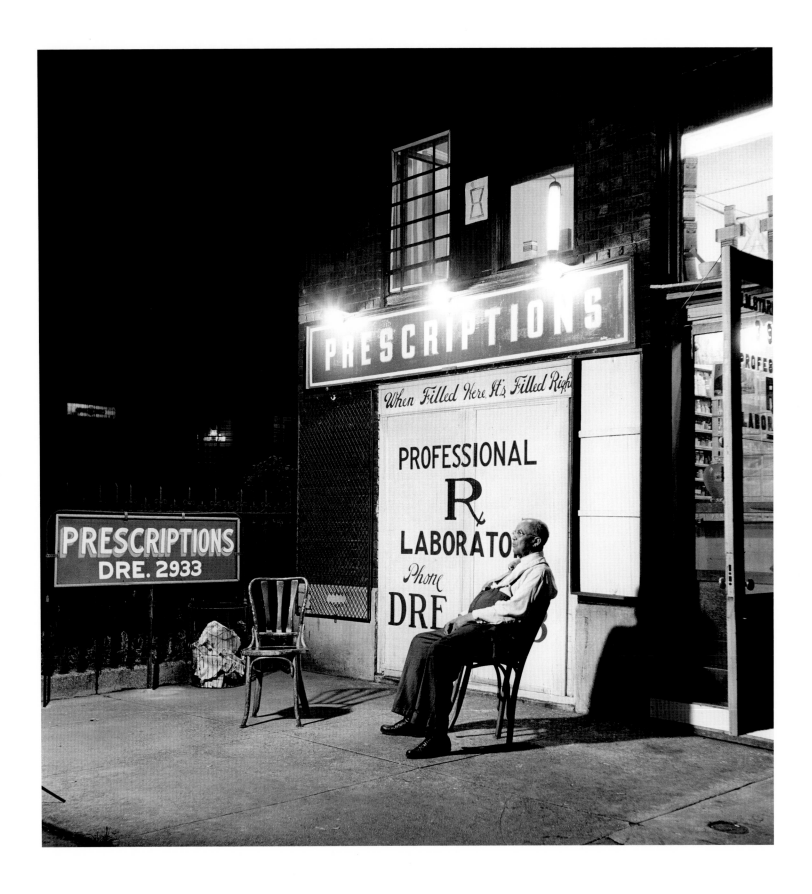

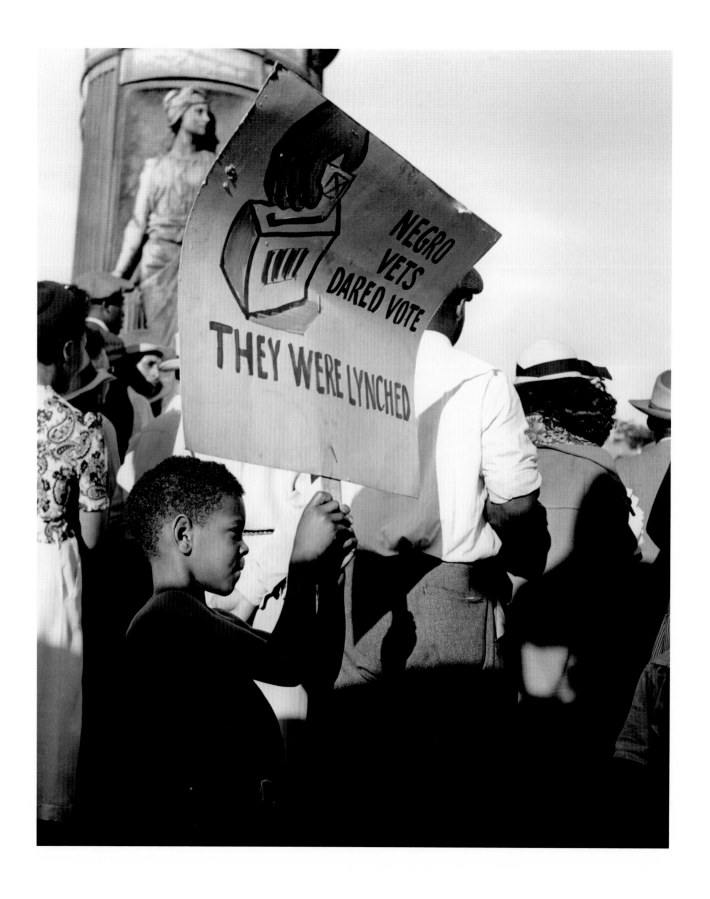

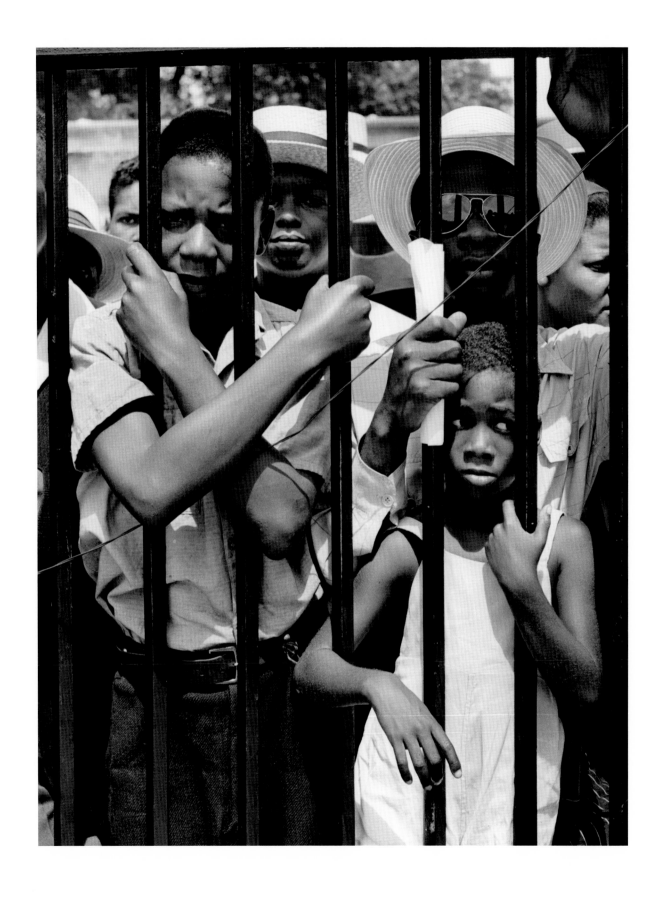

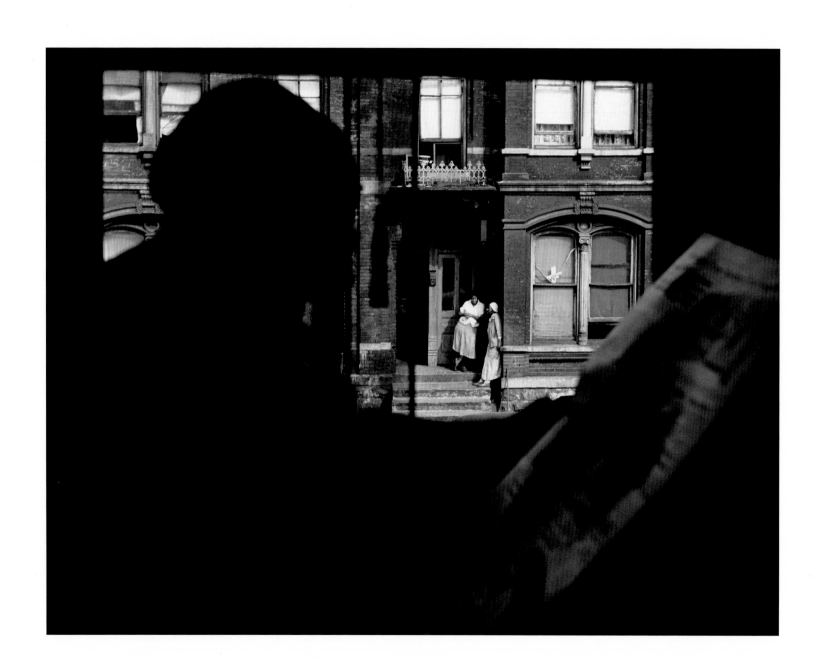

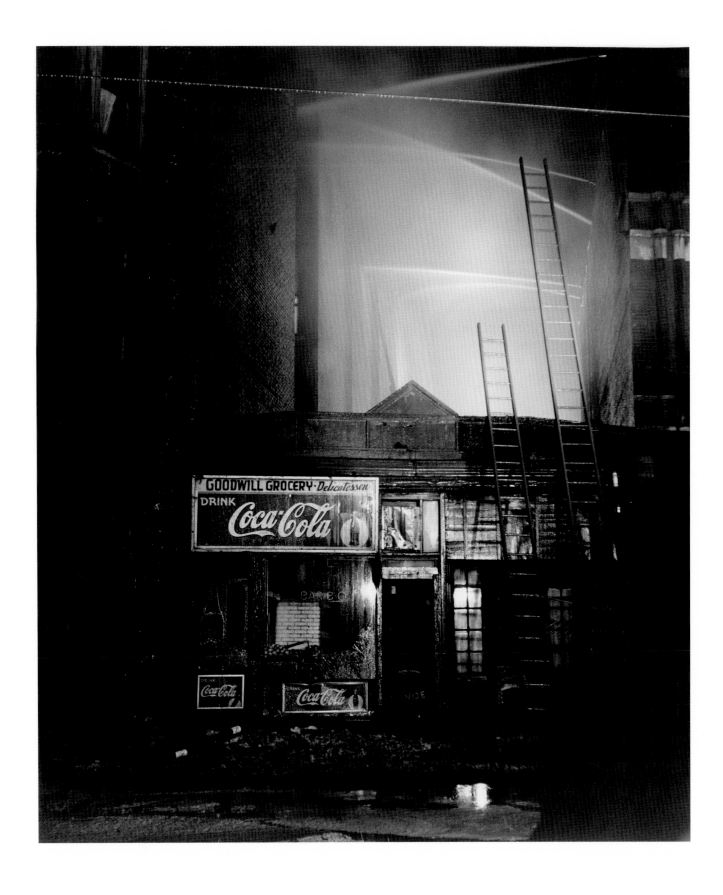

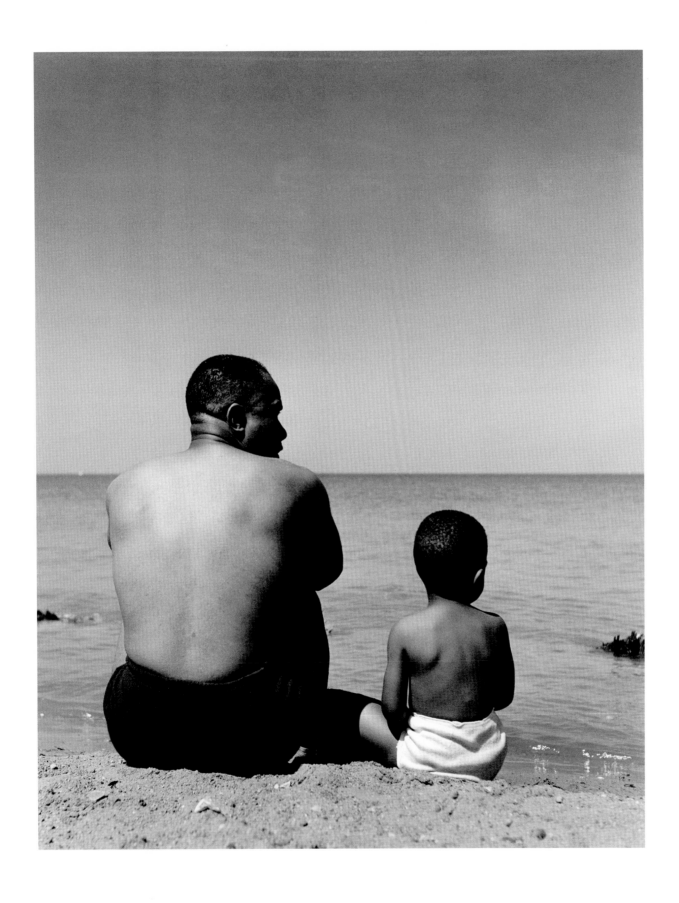

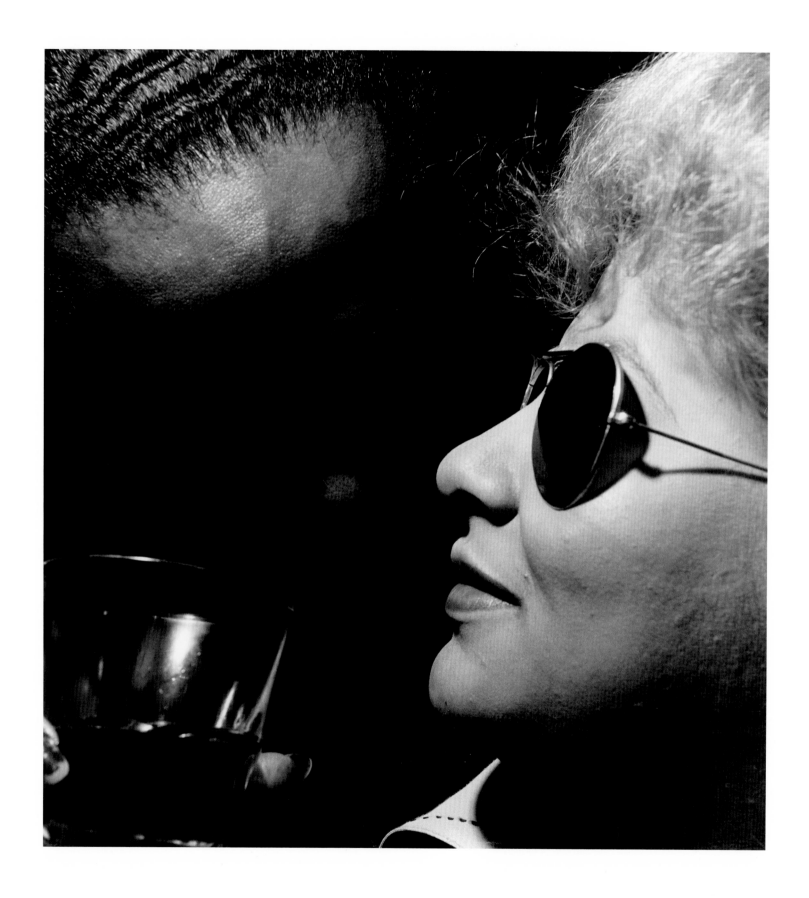

Reefer Party, Chicago

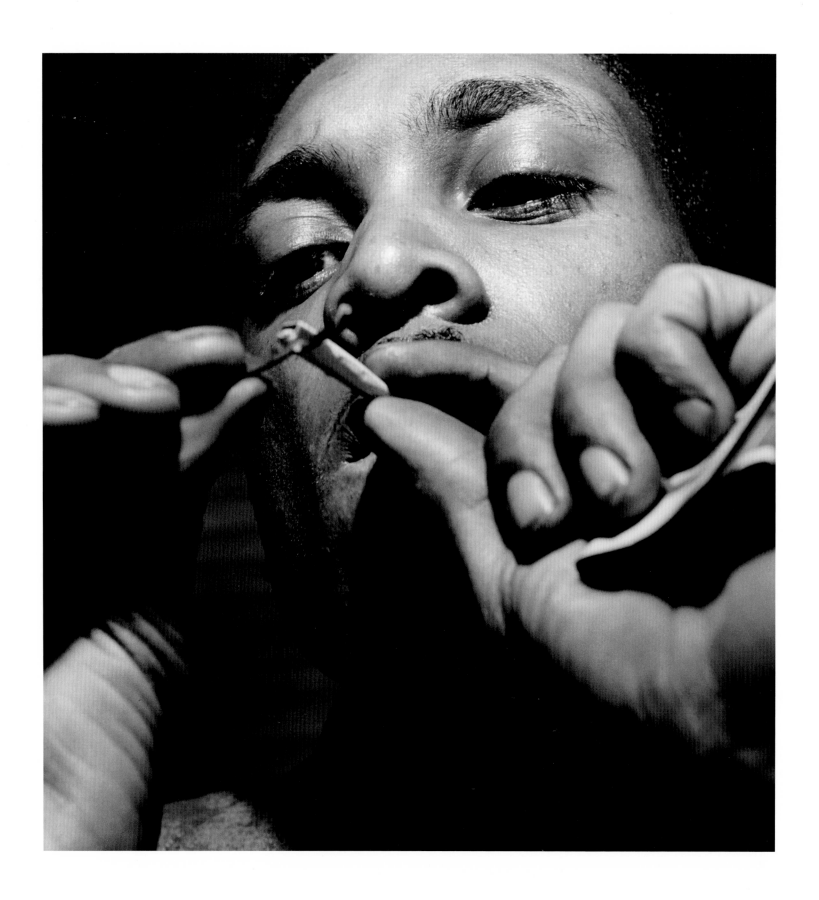

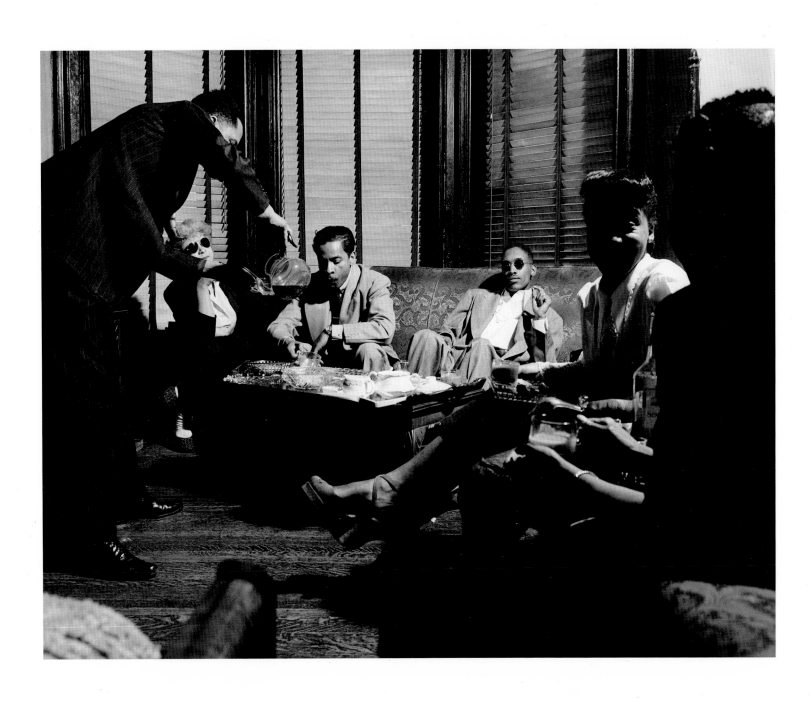

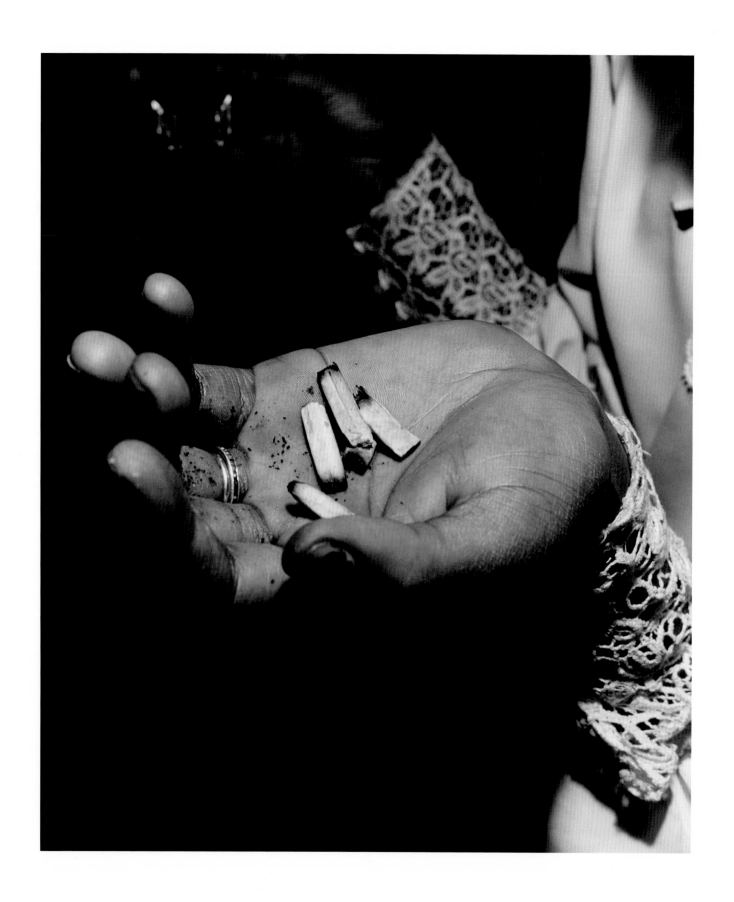

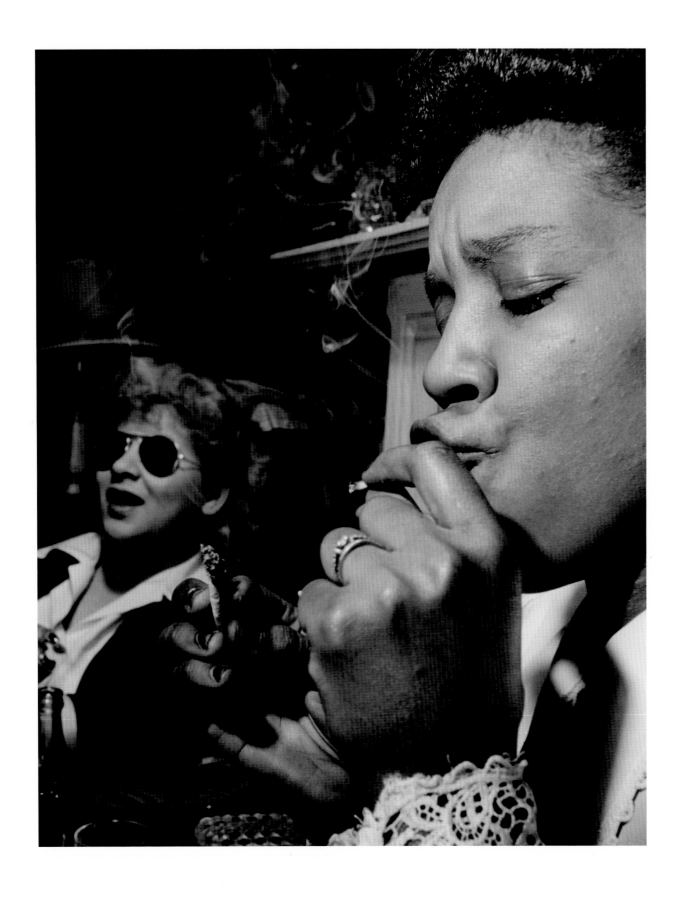

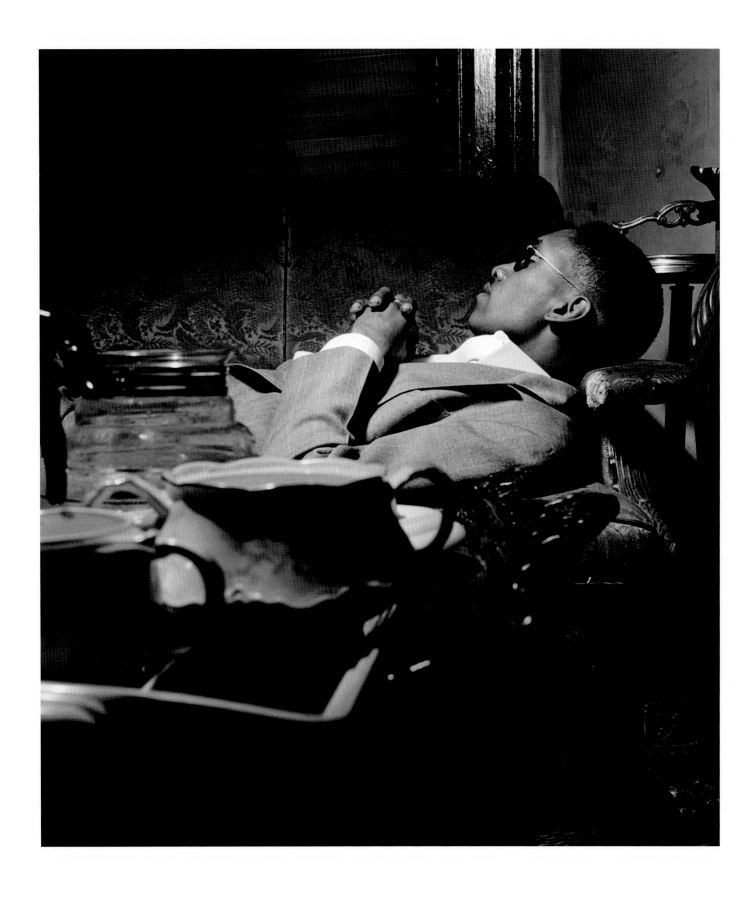

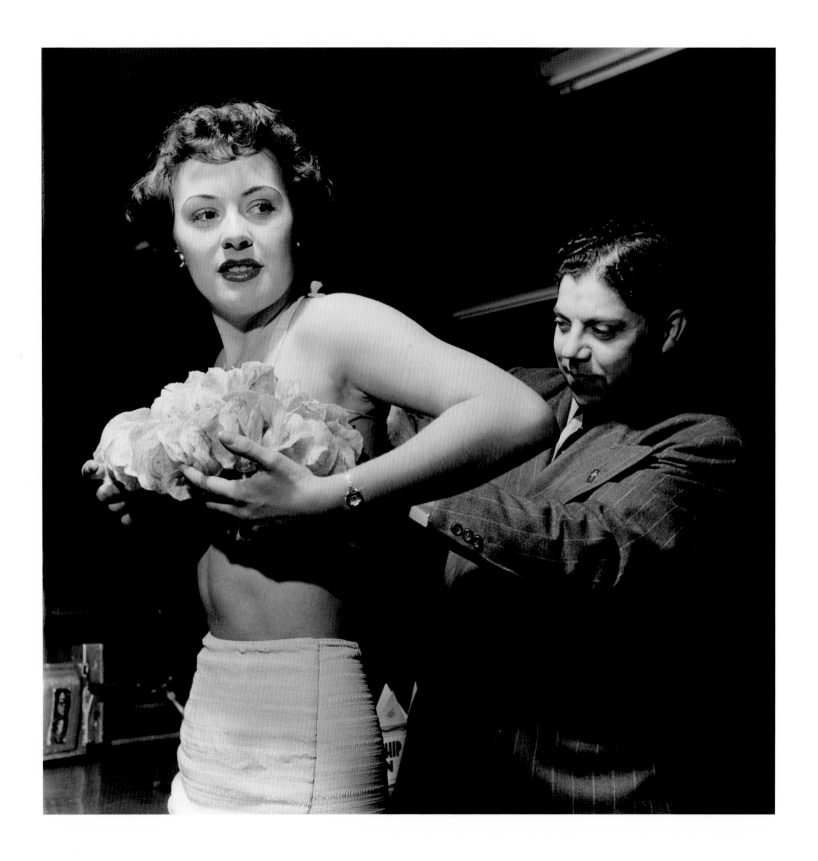

Potato Chip Convention

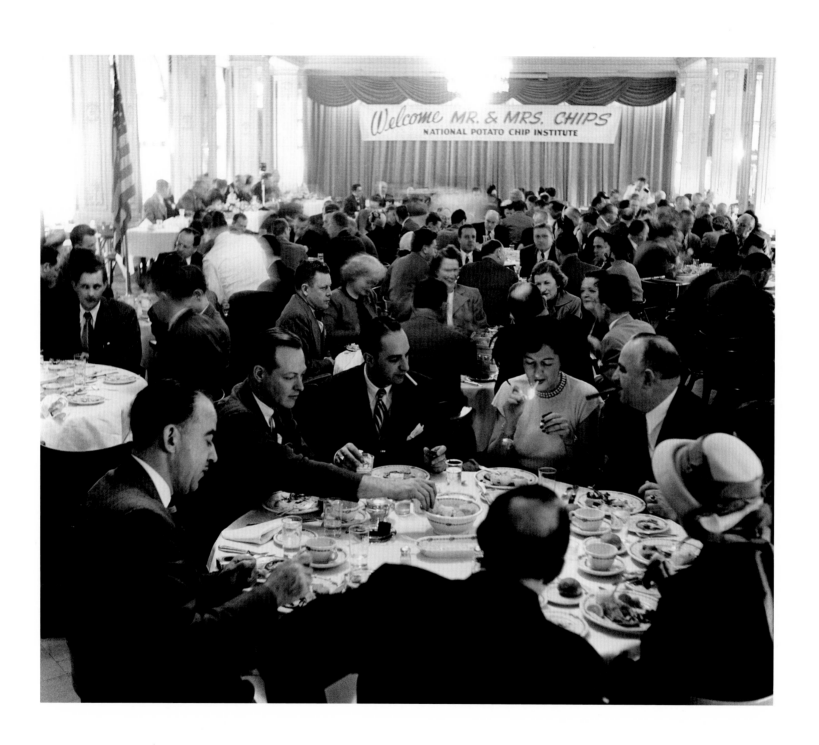

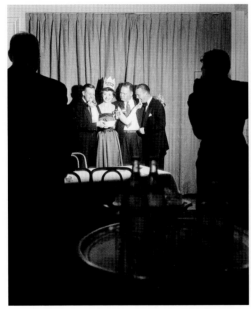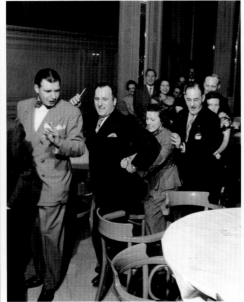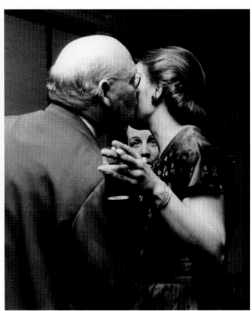

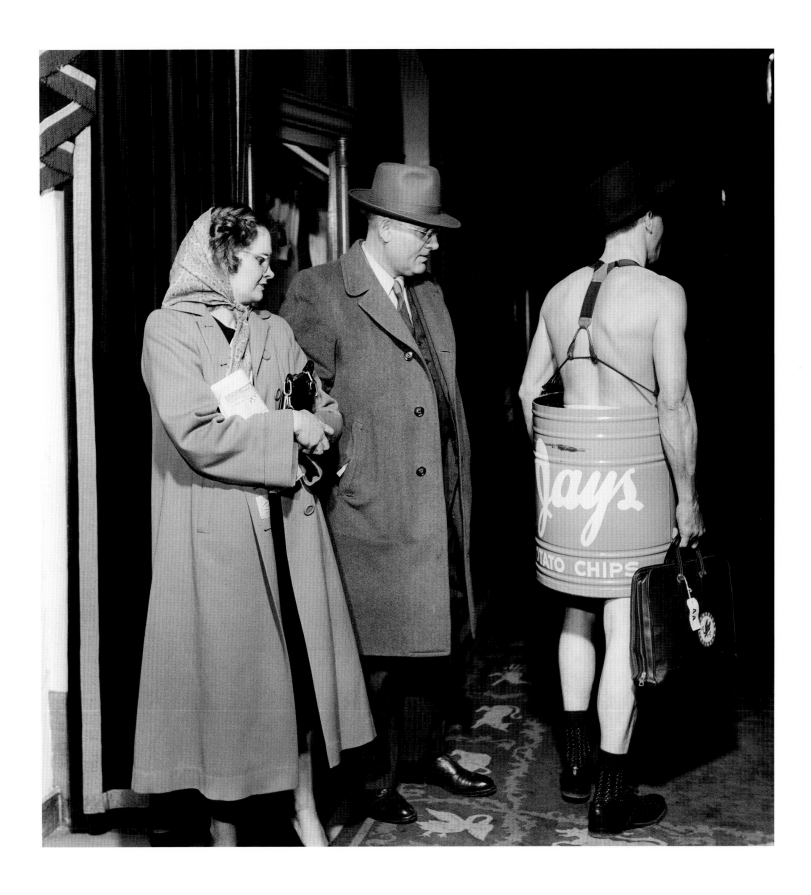

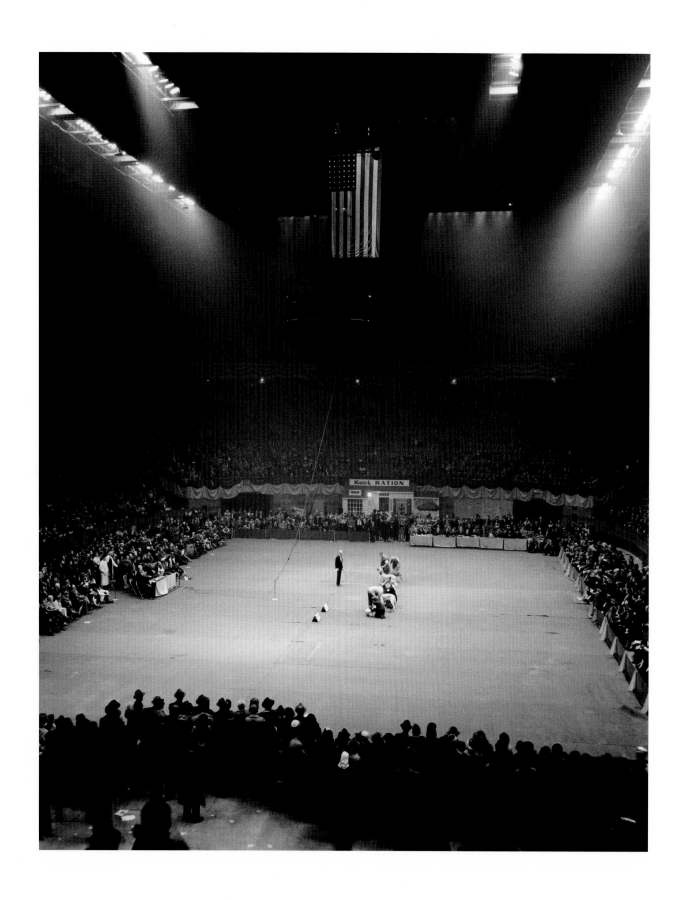

Dog Show

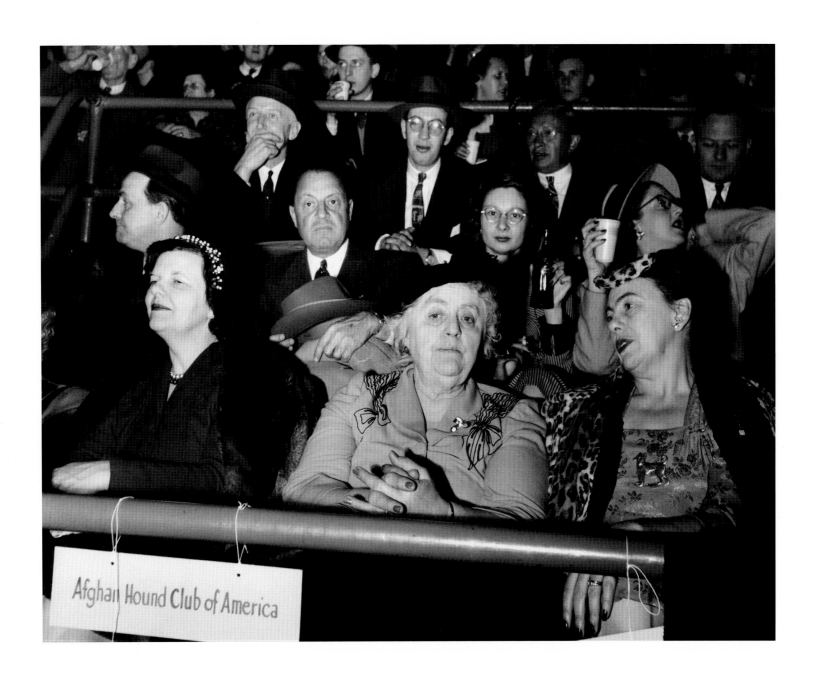

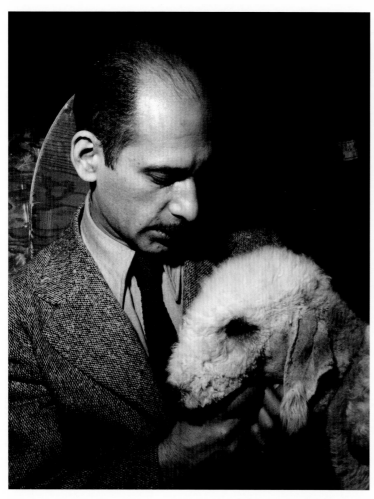

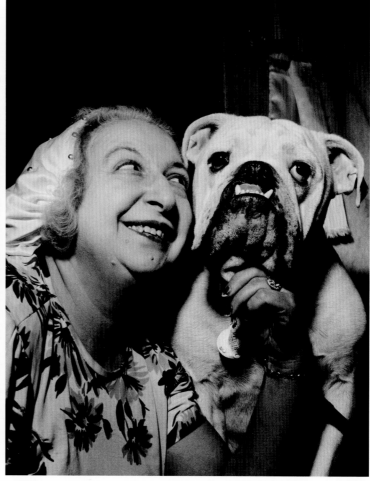

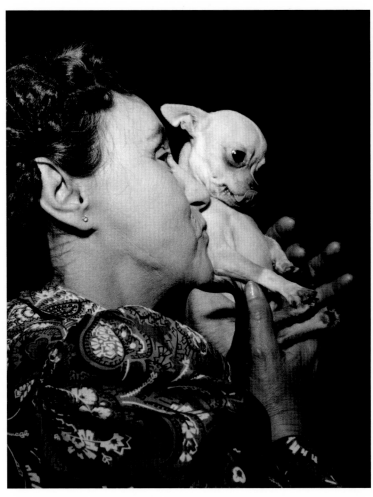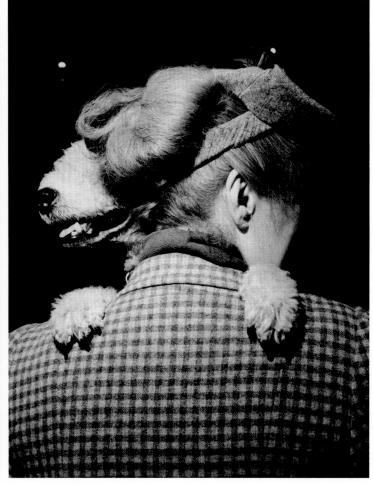

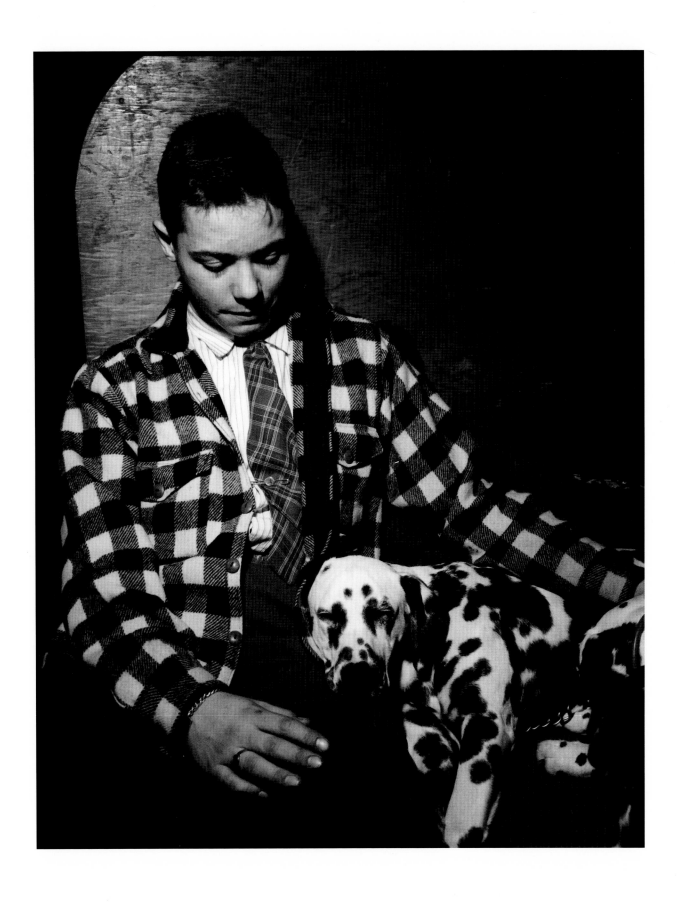

CALIFORNIA 1947–1953

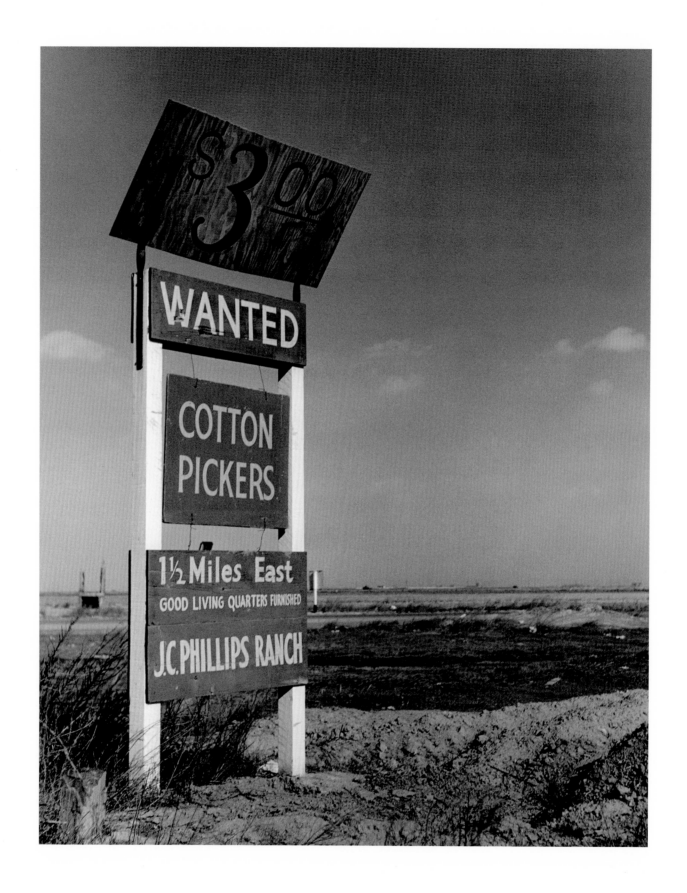

Migrant Workers

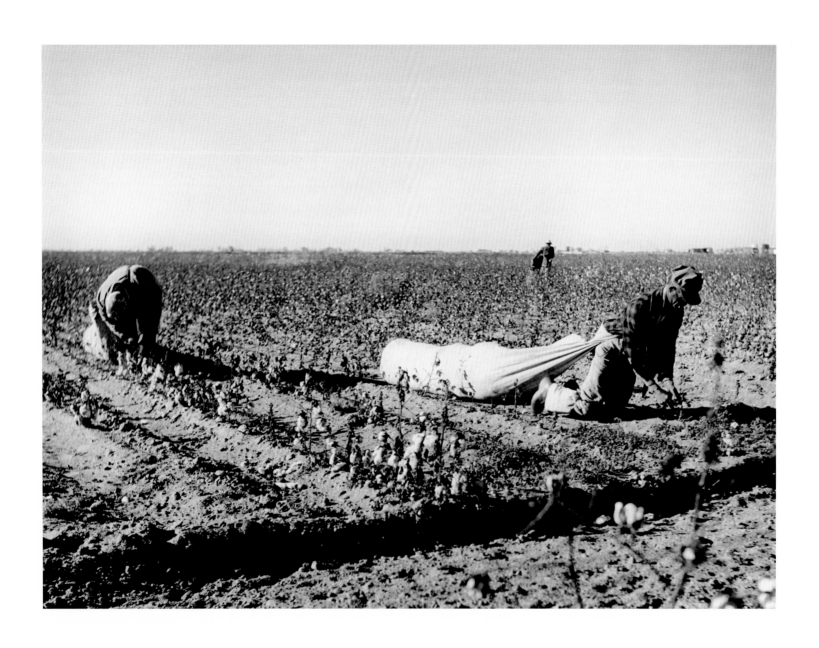

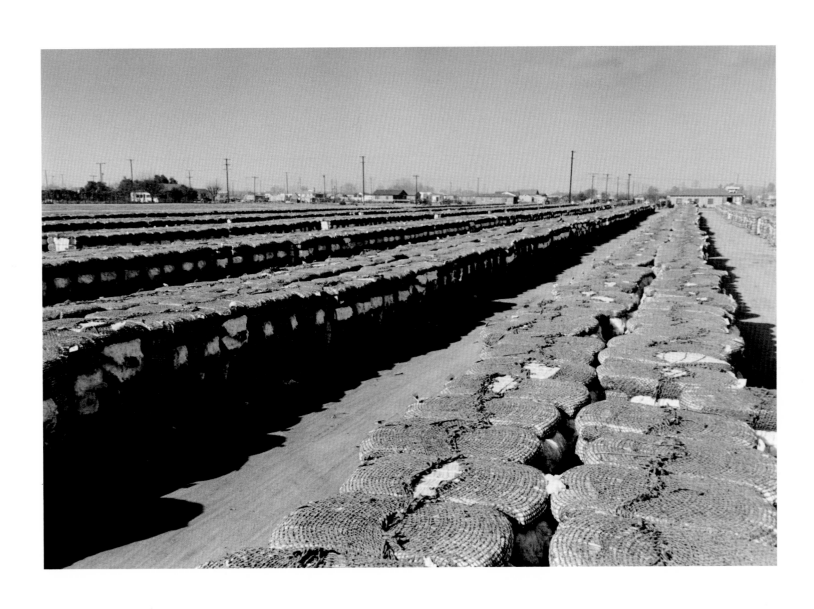

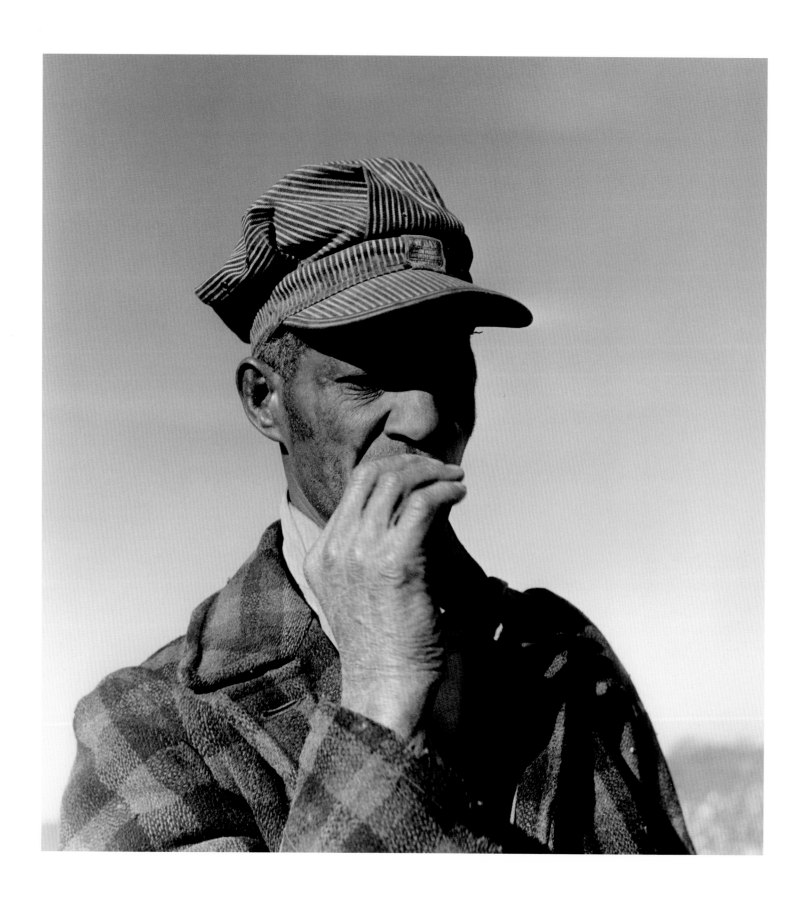

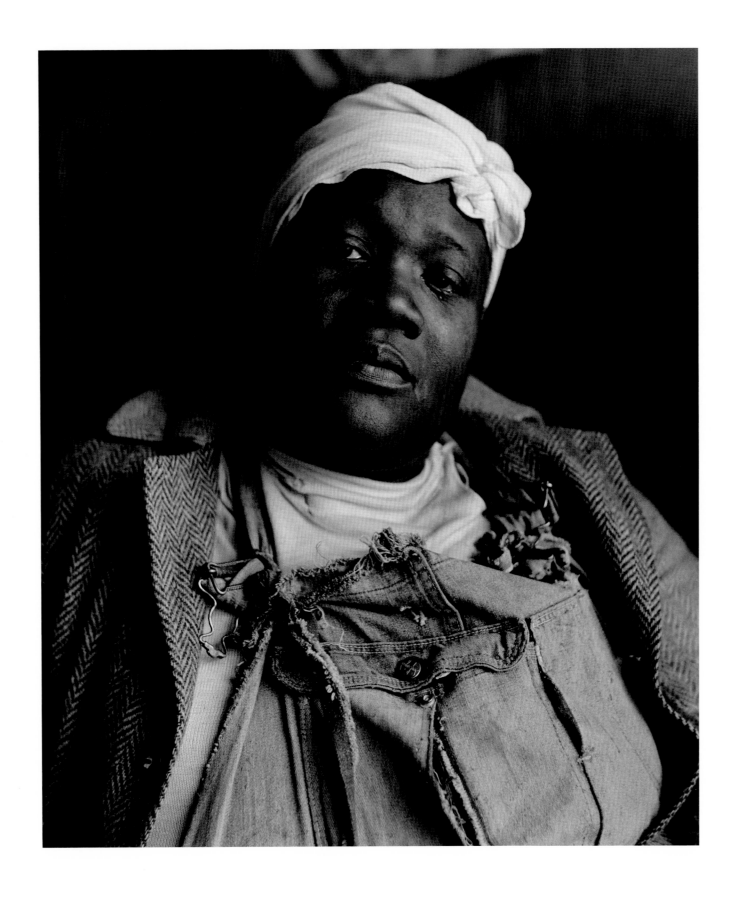

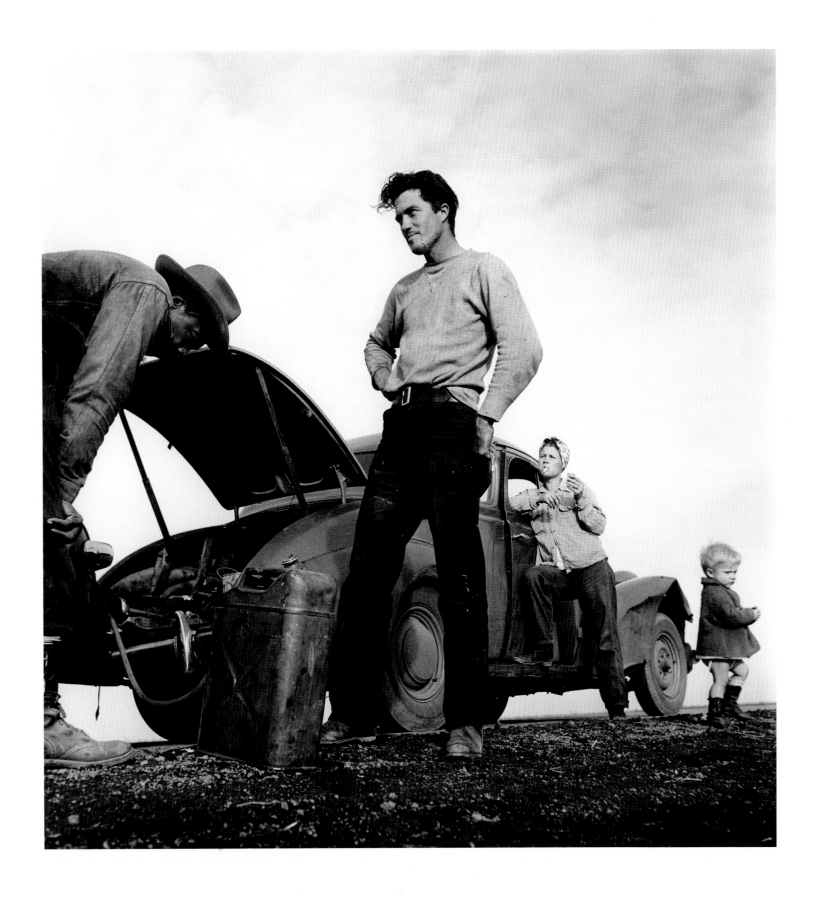

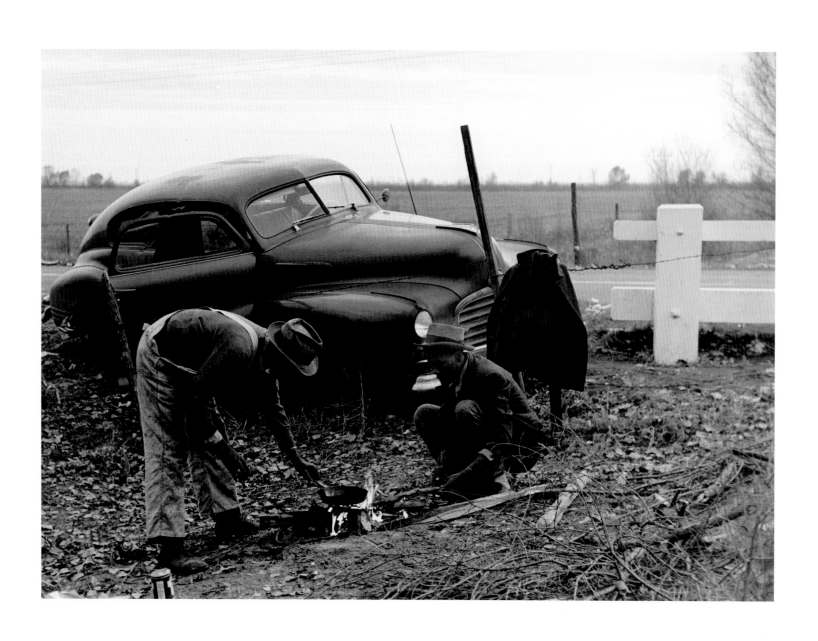

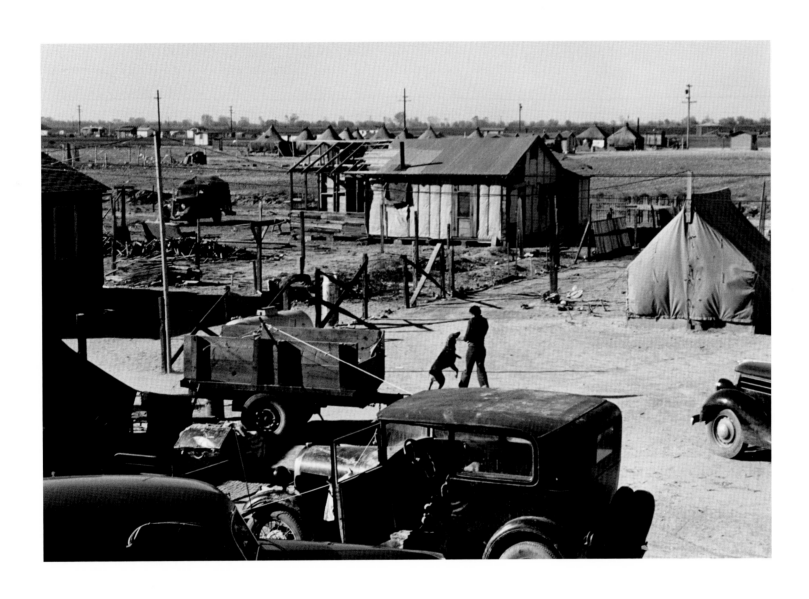

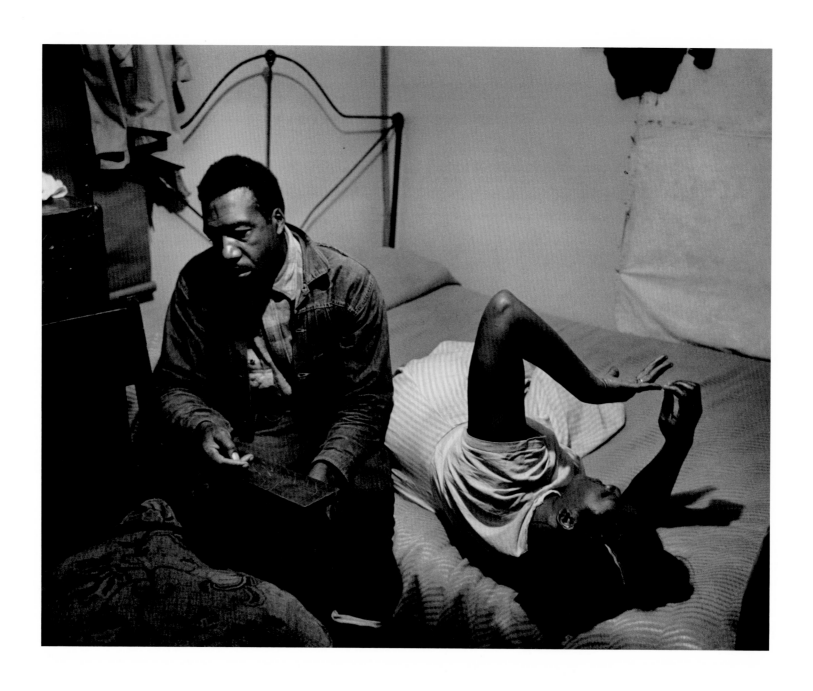

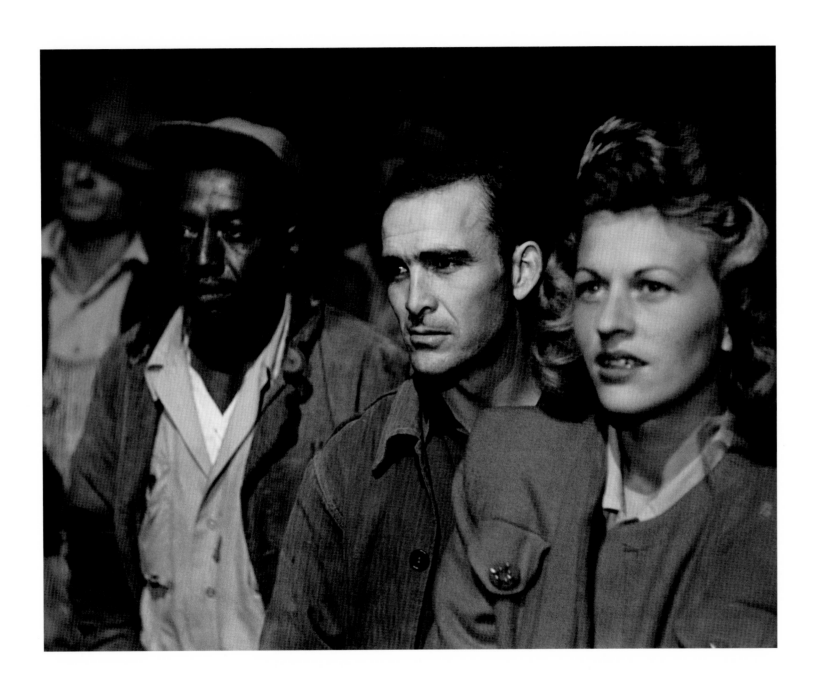

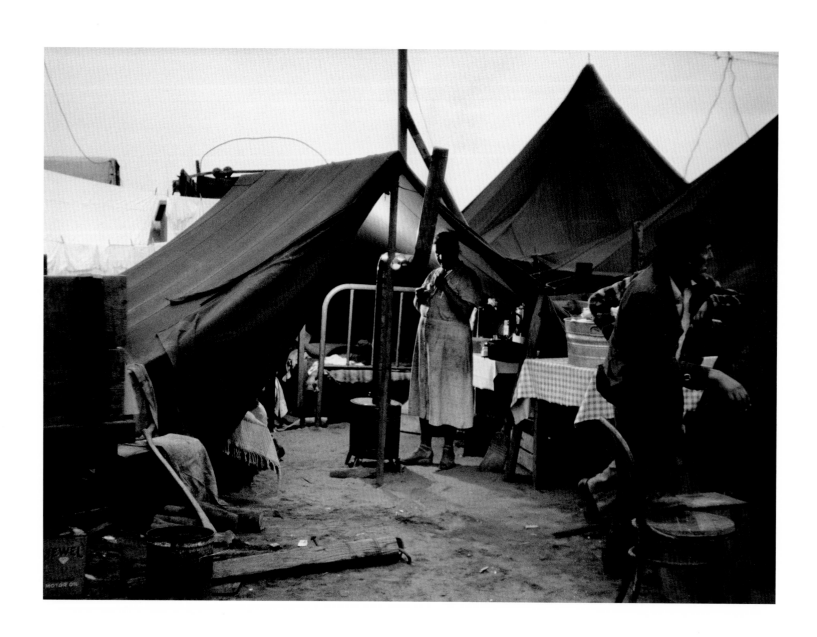

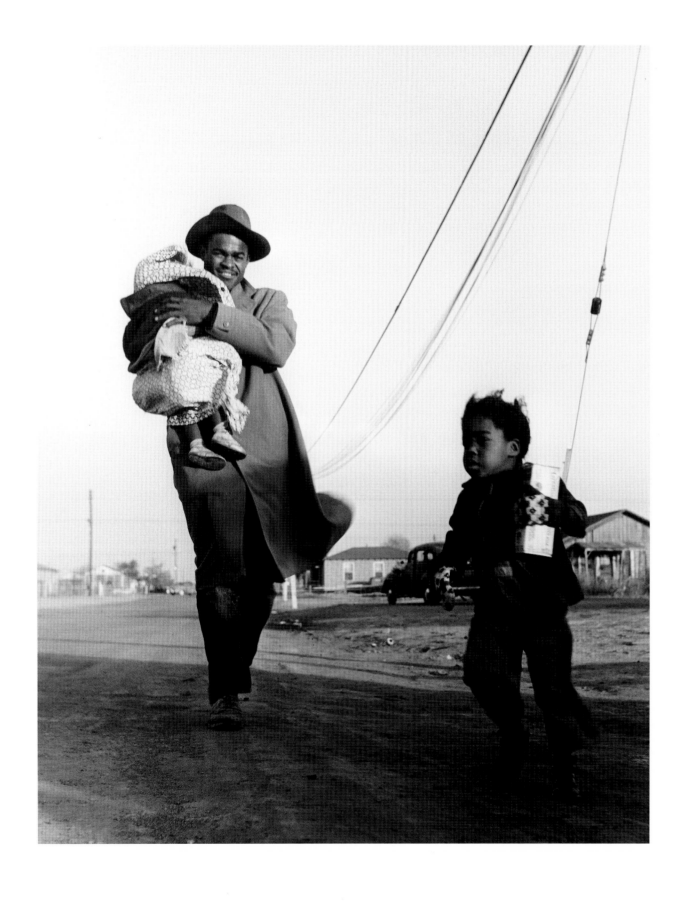

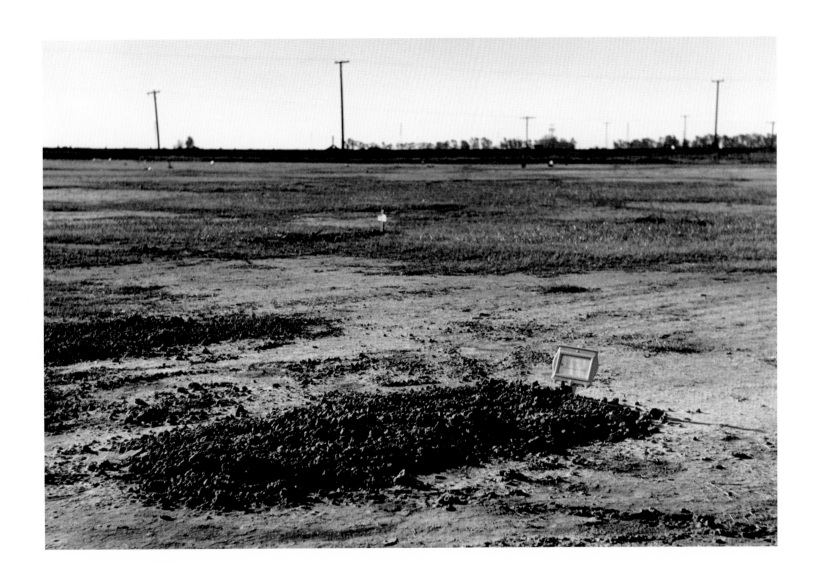

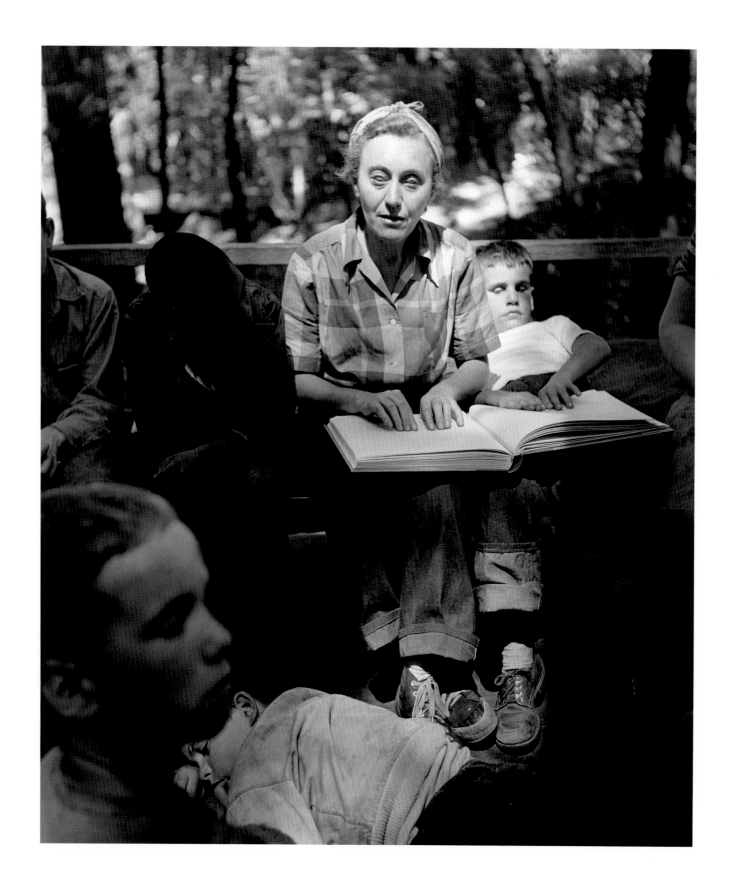

Enchanted Hills
Camp For the Blind

In 1950, while photographing at Enchanted Hills camp for the blind in Napa Valley, Wayne Miller also assisted the children who were eager to take pictures of things they would never see. He had no answers, however, for their inevitable questions and was frankly quite baffled when they asked what a photograph is. He asked Rose Resnick, the director, what she thought a photograph was like. Later that day she approached Miller with the following:

I know that a photograph attempts to lend permanence to what is originally a transitory visual experience. A photograph is a reproduction of something actually seen.

I know that photographs are flat, printed on paper and completely intangible.

I know that light and shadow are imprinted in the form of lines, curves and circle-outlines which by visual association translate into an infinite variety of shapes and forms.

In my mind, a picture of my collie-shepherd, Toddy, would be an outlining of her outermost layer, from nose to tail-tip. Obviously, the main line would curve in and out to allow for ears, fur collar, paws and tail. These offshoot curves would be relaxed or taut, depending on what expression we caught in the picture. I'm not sure what happens about the eyes.

I know that clarity, mood, degree of animation, subtlety of detail, vary with the skill, technique, and discernment of the photographer.

Since I have not been able to see since I was two years old, I have virtually no visual recollection.

Rose Resnick

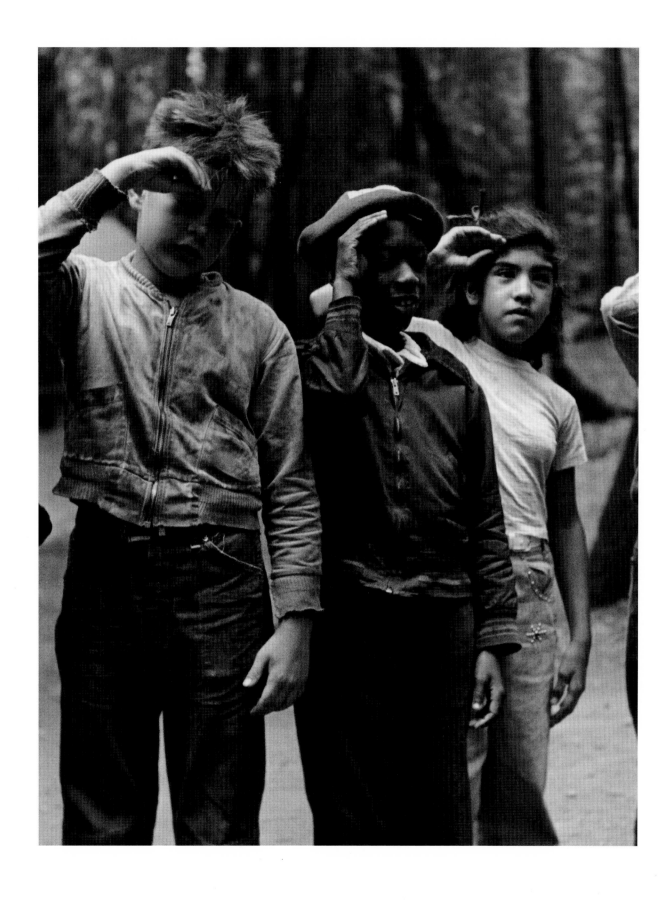

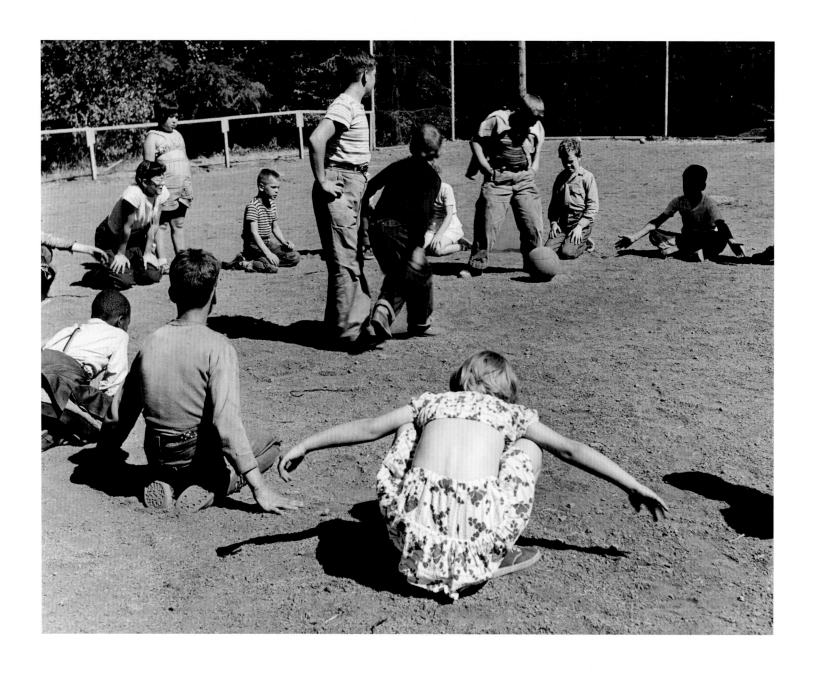

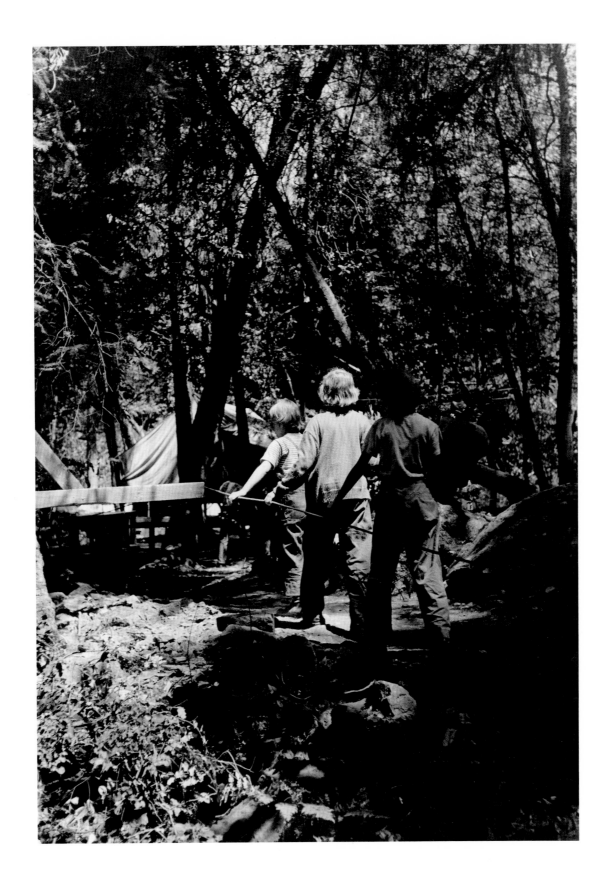

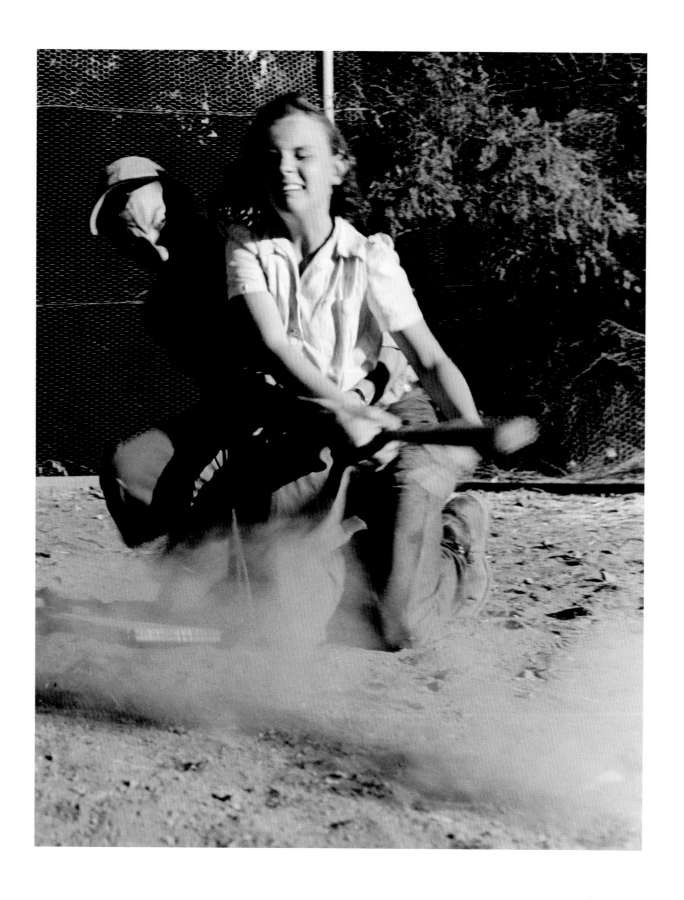

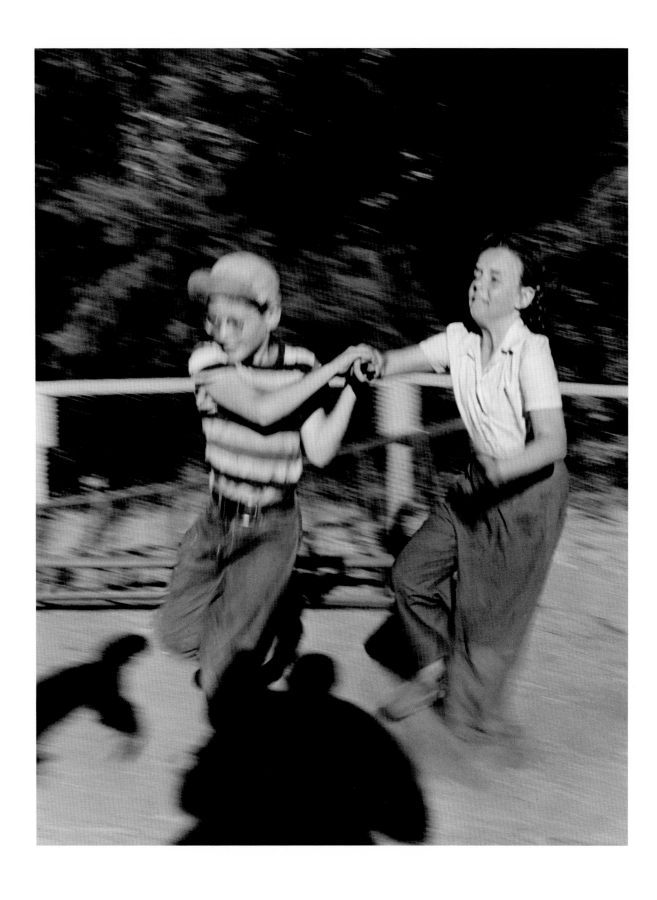

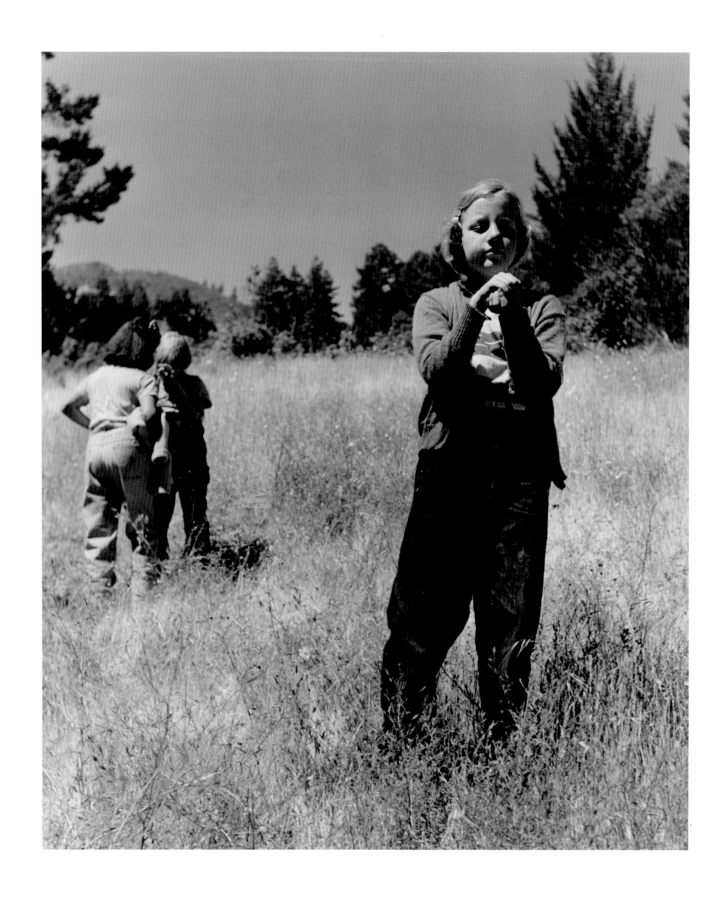

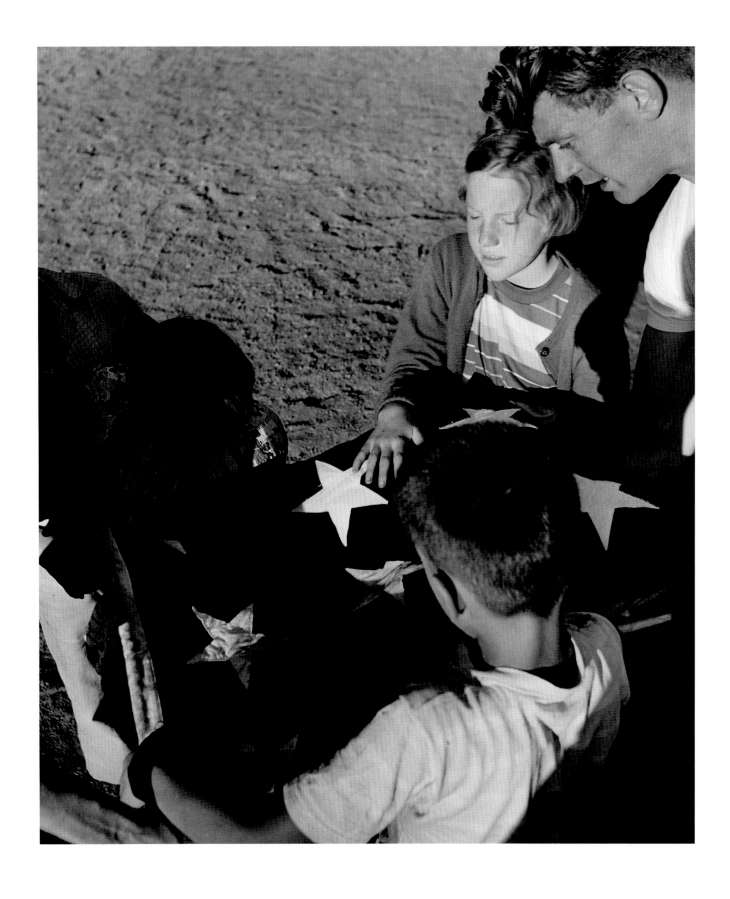

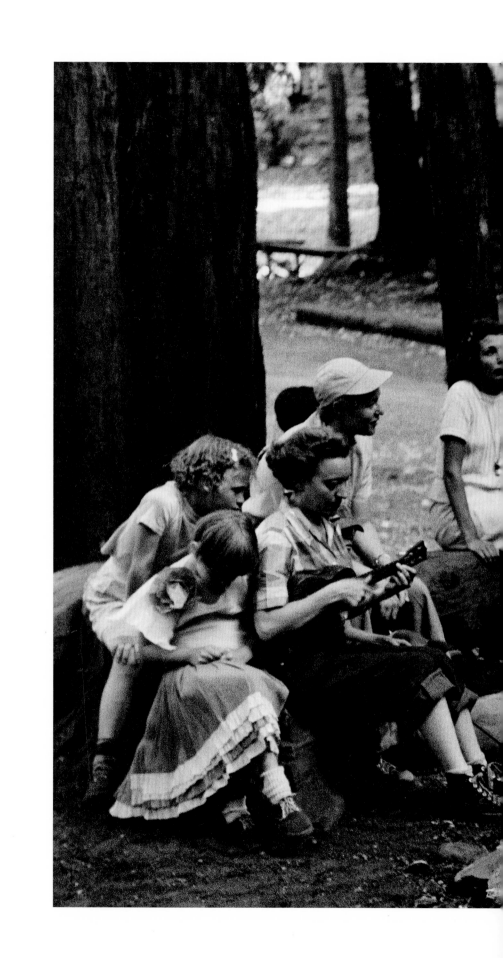

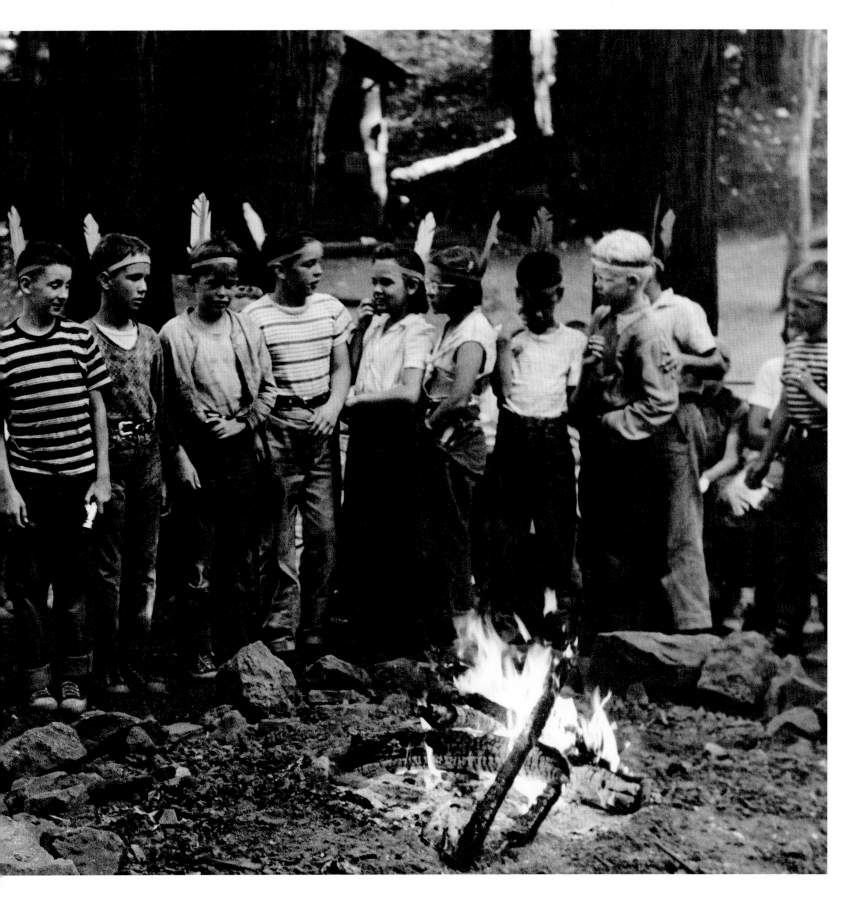

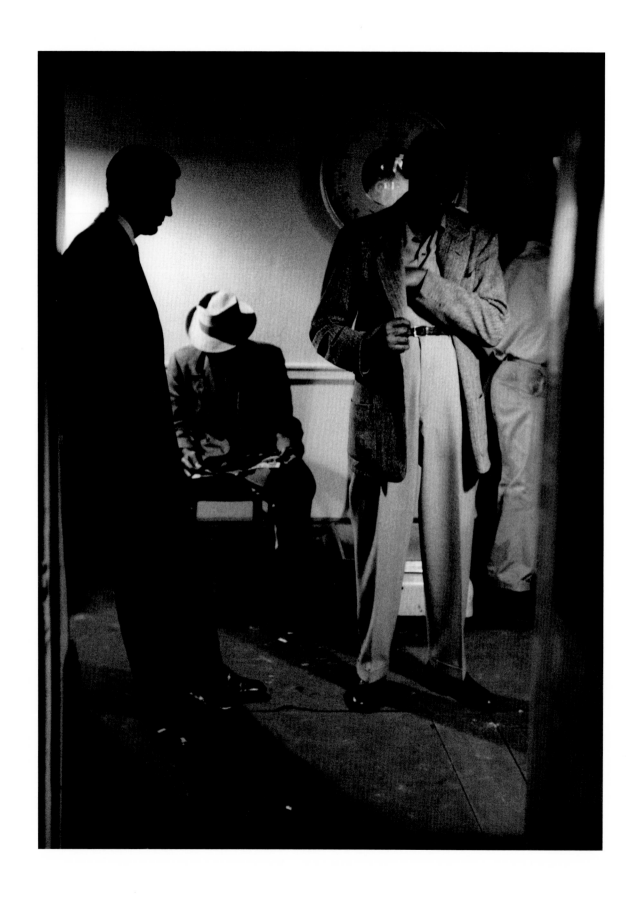

San Francisco Police
"Flying Squad"

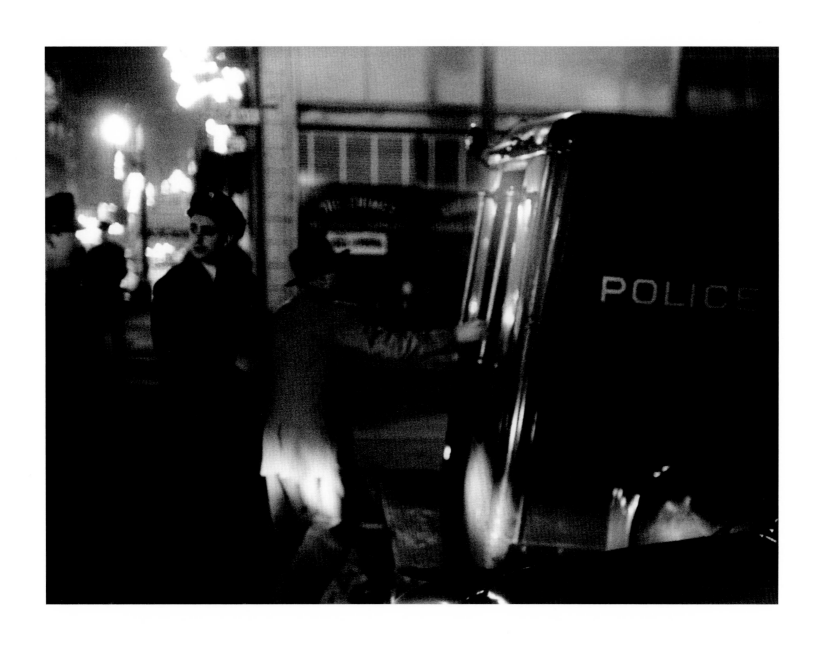

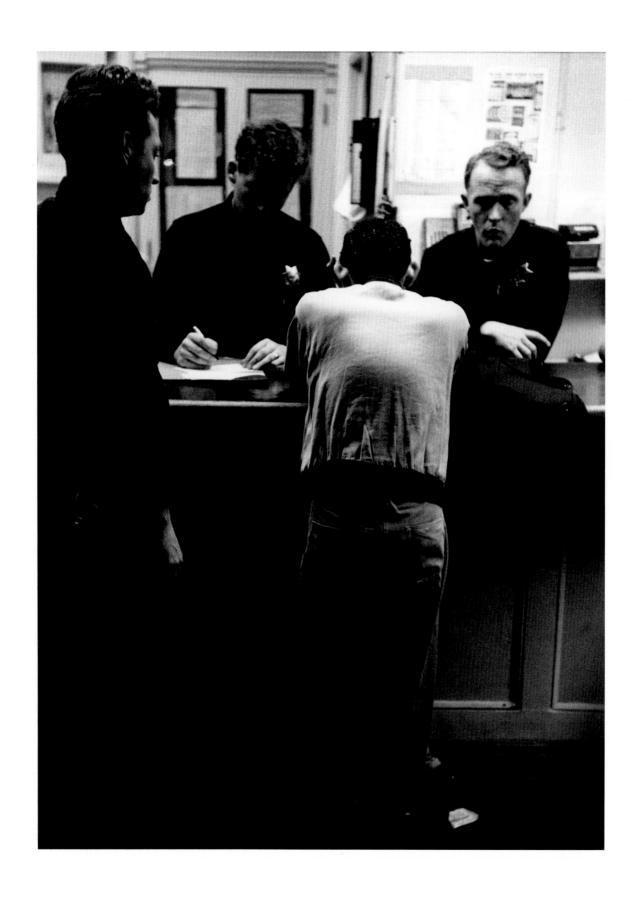

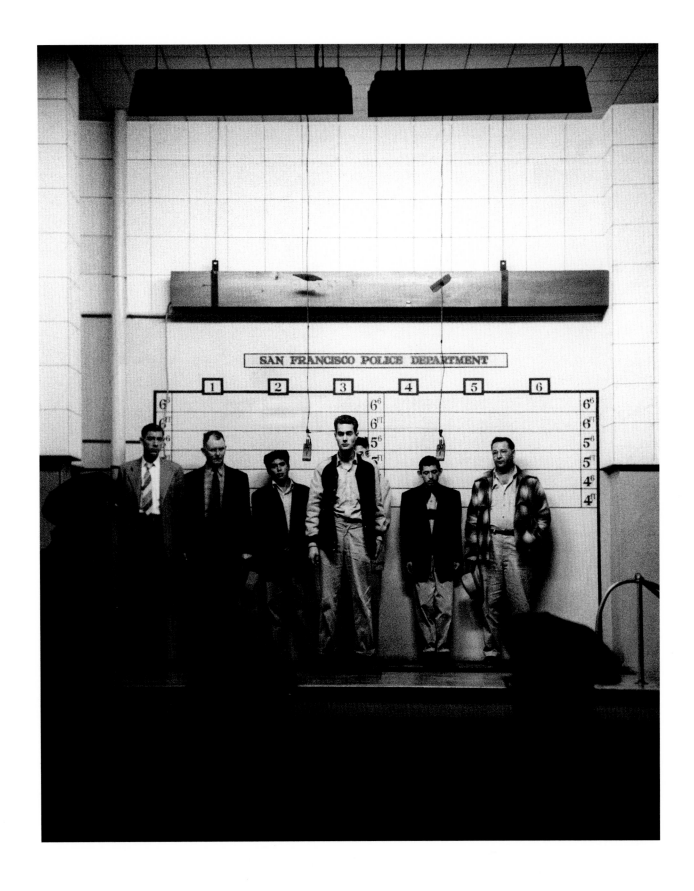

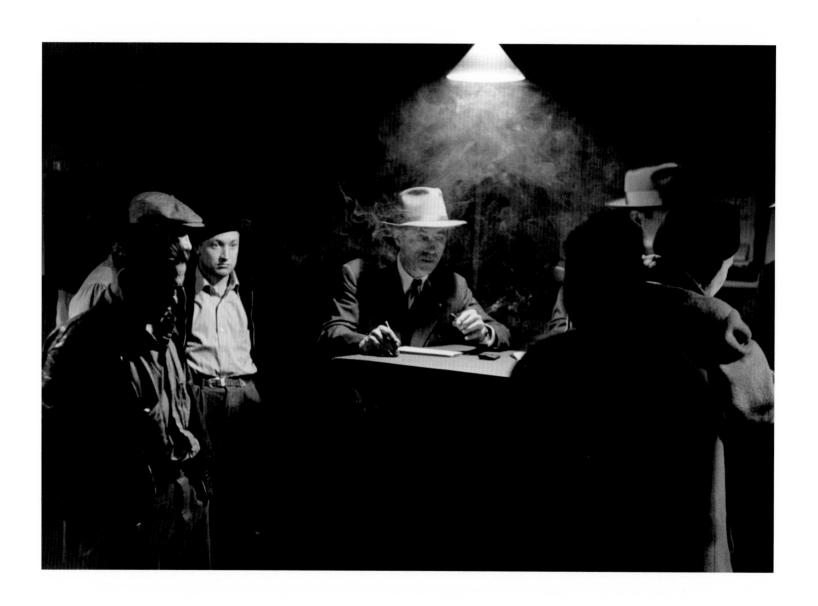

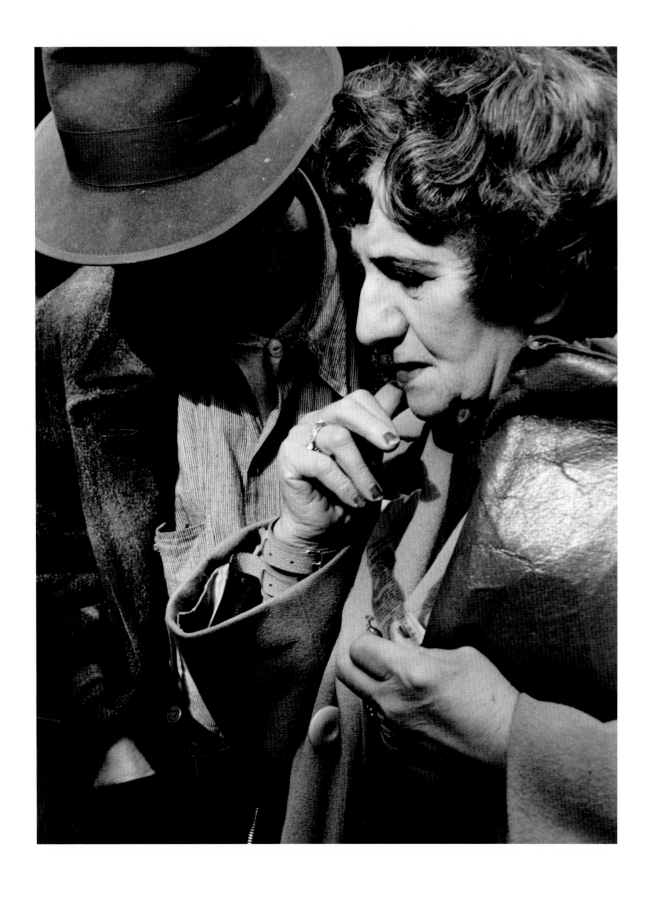

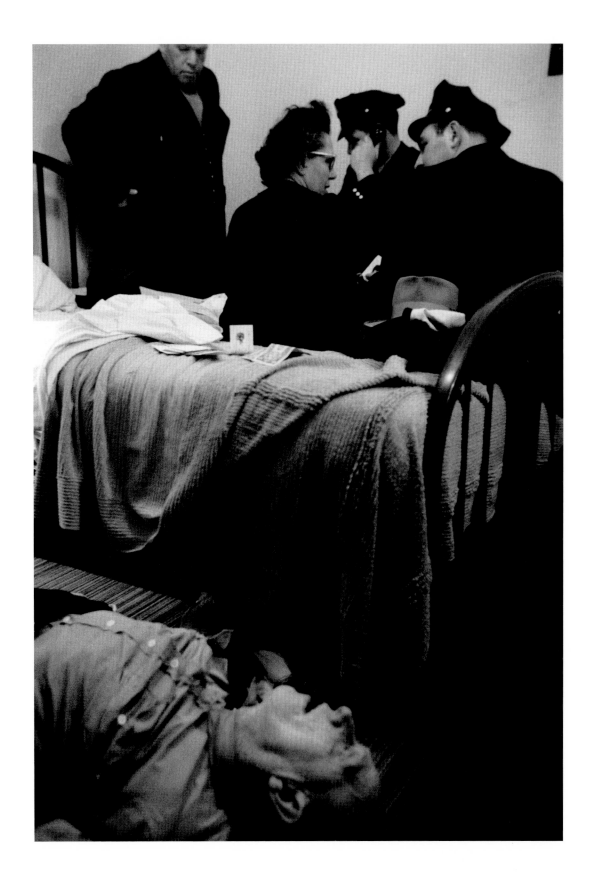

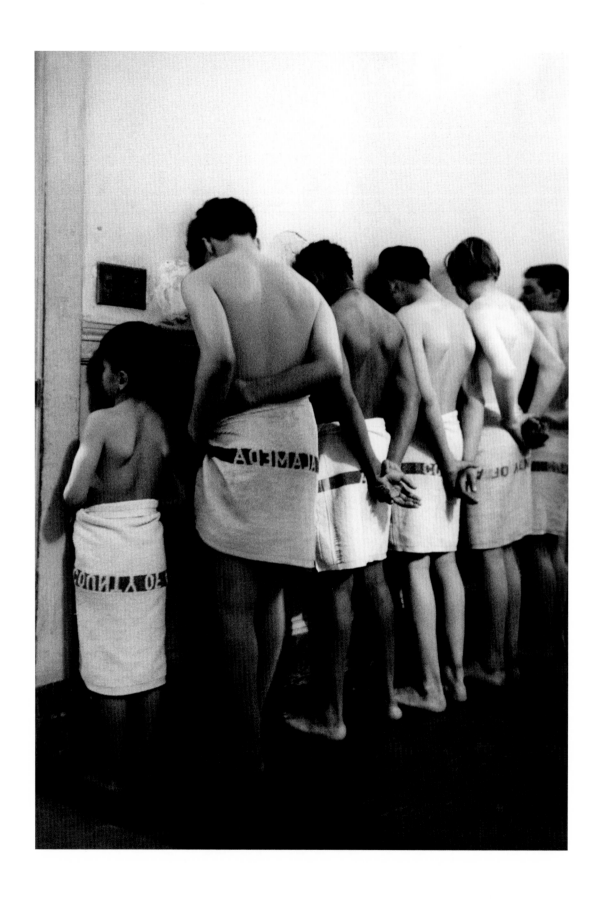

Juvenile Detention
Alameda, Oakland

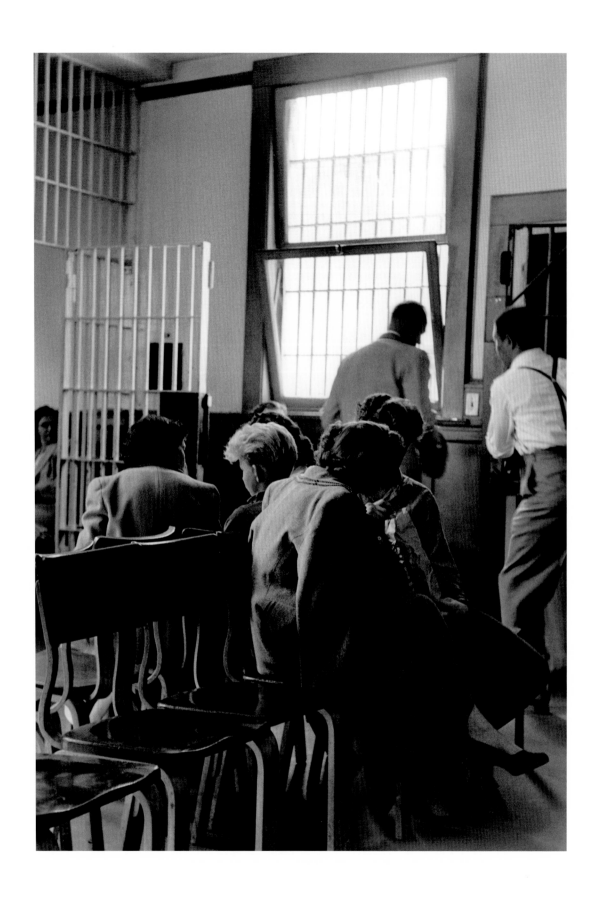

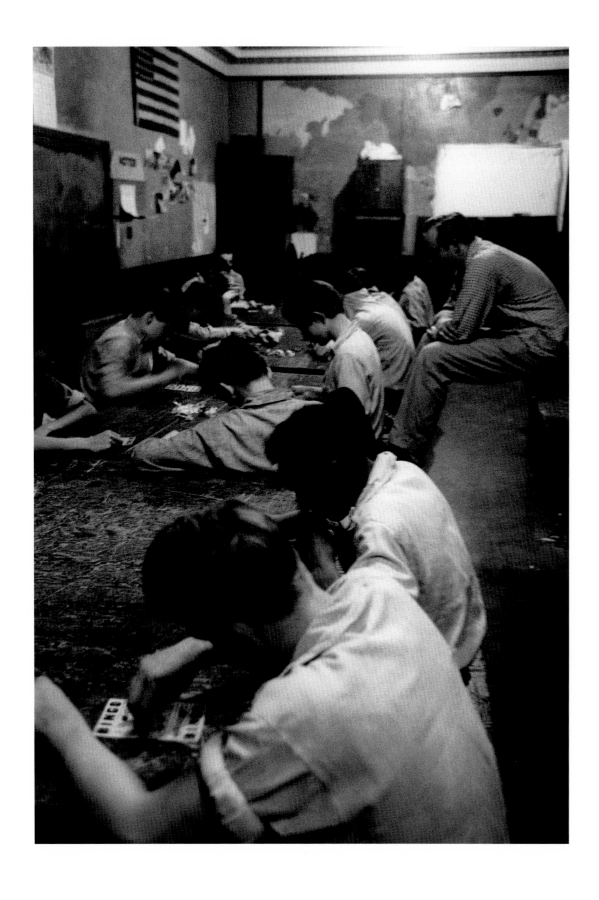

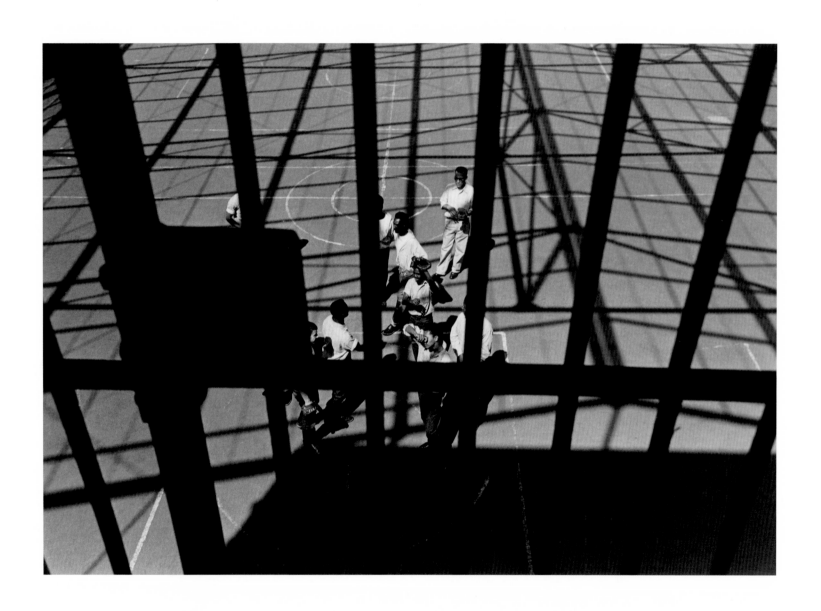

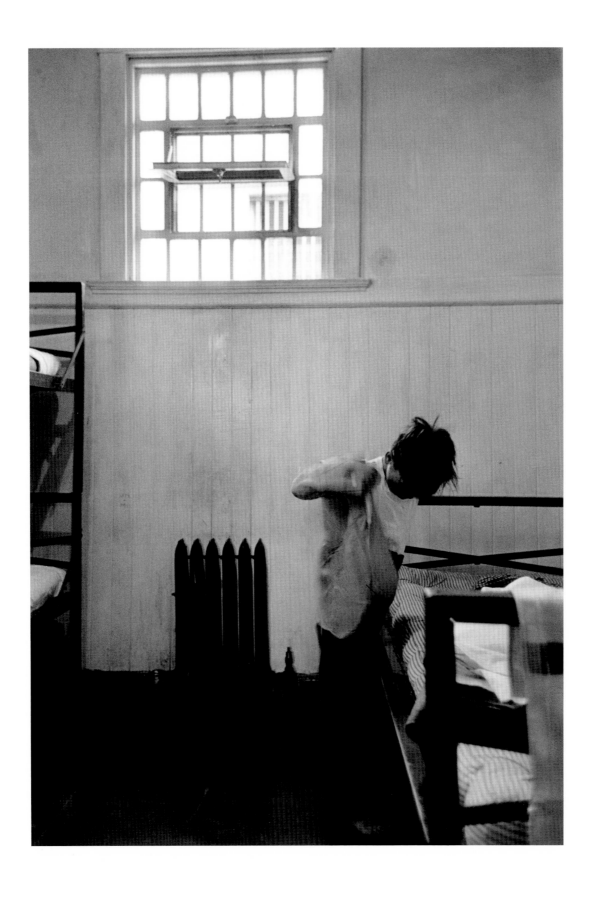

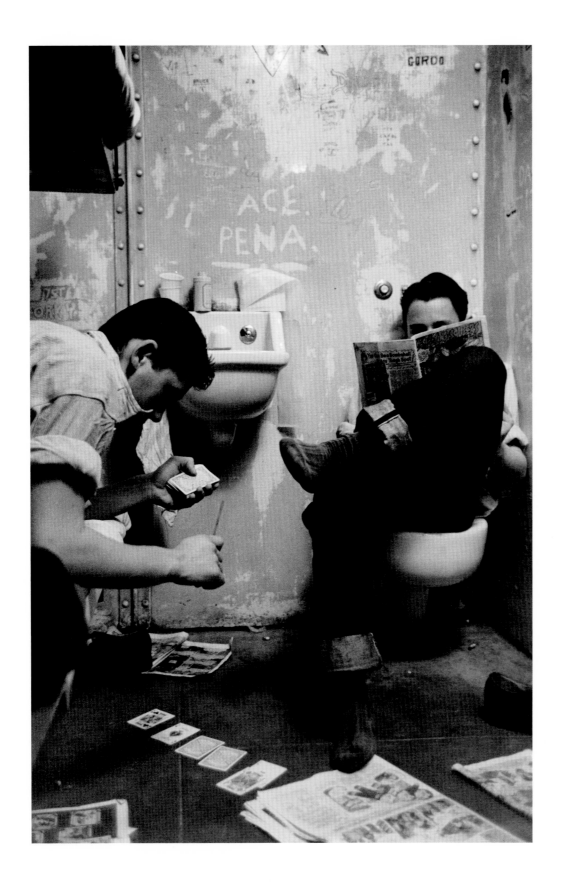

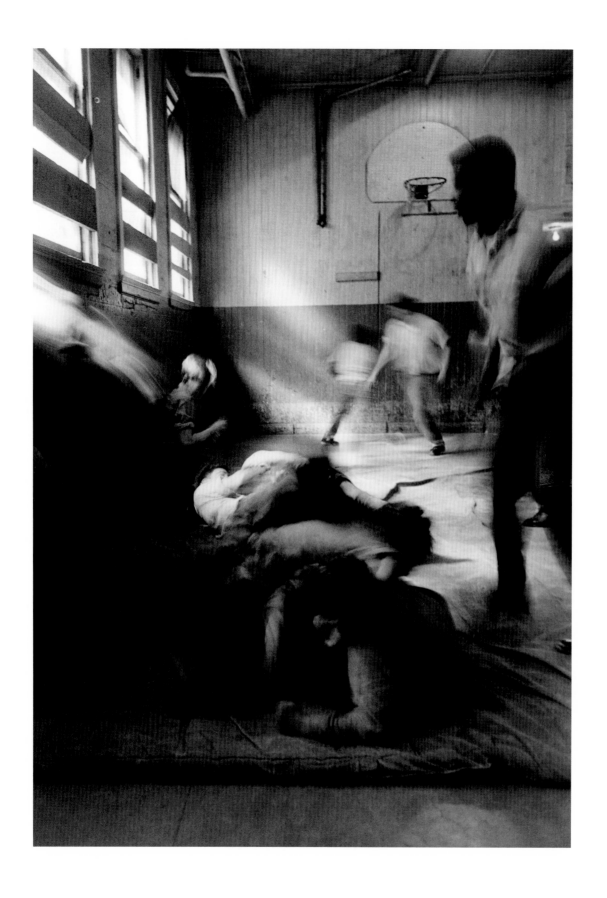

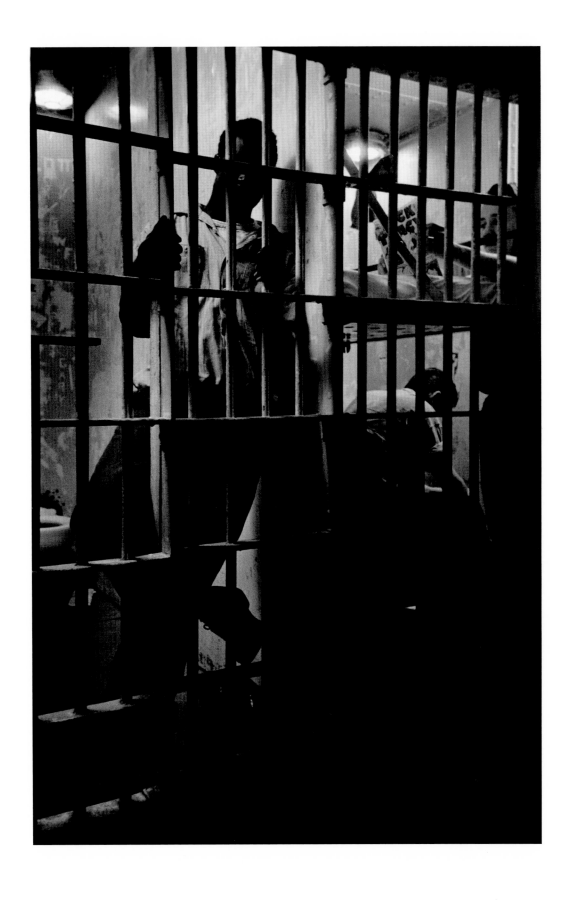

When We Were Young

It was the best of times, after the worst of times. It was the time of the baby boom and hula hoops and Dr. Spock and tupperware parties and *Leave it to Beaver*: the 1950s. It was the moment that inspired Wayne F. Miller to title his own photographic work *The World Is Young*. To many Americans, the world indeed seemed young—reawakened and redeemed after the nightmare of World War II and the unthinkable horrors of the Holocaust and Hiroshima. It was a time of rebirth after annihilation unprecedented in human history. And at the very heart of this vision lay the home—a warm place occupied by a loving family, a haven from the Cold War.

Like others who returned from the front, flush in the victory over fascism, to marry, buy a house, and have a family, Wayne F. Miller literally came home—turning his camera on his own private life to project the dreams of his generation. His focus shifted from the vast horizon of the Pacific to the home front: black Chicago, Franklin Delano Roosevelt's funeral, California's pastures of plenty, the lives of the blind, the fate of the deviant, finally resting on the delivery bed where his wife Joan gave birth to his children, and the tender sight of his own family. "I had begun a photographic exploration of the world of childhood," Miller wrote in 1958. It was an intensely interior perspective, a domestic point of view, which gained international display in the intimate portraits Miller contributed to Edward Steichen's landmark photography exhibit, *The Family of Man*. Miller's work brilliantly bears witness to the cultural paradox so pointed in this era: the public rendering of the private as a universal experience.

With peacetime conversion, therefore, came the camera's shifting perspective, as Miller's photography captured the idylls of the home and the innocence of children. Instead of the bloodied hand resting on a helmet (p. 51)—a gesture appearing terribly casual, with the hand seemingly disembodied because the soldier sits mainly outside the picture's frame—the vision was now of a child looking down at his own hand poised to touch a butterfly flittering on his sleeve (p. 232). So from death Miller turned to life, exploring the Eden of the young—"the child we were," as he said—in a world haunted by the atomic bomb and the fateful rivalry of democracy and communism.

Yet this new point of view emerged in the very midst of what Miller saw as the "blind futility of war," and for him that perception arose just after Hiroshima, which he considered the "ultimate denial of sanity," as he and his shipmates envisioned the coming of peace. They dreamed of a peace based on understanding, he recalled, that would transform foes and strangers into friends and neighbors, "on the other side of the world—and on the other side of town." After the war, therefore, he set out to offer new insight with his camera: "to document the things that make this human race of ours a family...look at what we all have in common—dreams, laughter, tears. Pride, the comfort of home, the hunger for love." He searched to "photograph these universal truths...for a project that would embody these universal truths."

It was the peacetime search for universal truths that led Miller's generation to dwell on the family. At first, the photographer found embodiments of these truths in the streets, bars, kitchens, and pool halls of his hometown, on Chicago's black South Side, but then finally turned his camera lens inside his own home, with his wife and children, in a new San Francisco suburb not unlike others springing up across the country and populated by GIs and their families. "Most of us are new settlers who arrived after World War II," wrote Miller. "It is a new community without tradition…. We all have some young ones and might have some more." Dreams, joy, sorrow, pride, home, love—here were the common truths lost sight of in wartime but found anew on the suburban frontier in peacetime by the camera.

While political leaders of the 1950s gloried in the American Century and vowed to fight the Cold War against the spread of totalitarianism, Wayne F. Miller documented his family and paid tribute to the "warmth of living for all of us," which he said was created by his wife. Her housework, he saw, constituted the heart of his home, assuring a world that could feel young. In pursuit of universal truths with his photography, he brought to the public the vision of his wife's most private labor in bearing their second child. And it was images of his four growing children that graced the pages not simply of his own book, *The World Is Young*, but also of Steichen's *The Family of Man* and Dr. Benjamin Spock's *A Baby's First Year*. Although he once considered a wider sweep in documenting the world of childhood, Miller chose to go home to lay bare the universality of the "child within."

Yet within a very few years, the world so candidly rendered in Miller's photography would burst apart as women's liberation and civil rights simultaneously arose. For the housewives who gave warmth to the home amidst the Cold War, reading Dr. Spock and making chiffon pie, began to wonder about their own destiny—"the problem that has no name." Meanwhile, on Chicago's South Side, in the very neighborhoods documented in Miller's work, the idylls of childhood were shattered when a casket stood open in 1955 to expose the body of Emmett Till, the black boy lynched in Mississippi for whistling at a white woman. And so Miller's compassionate vision of a world where all would be equally entitled to innocence crashed up against the old American dilemma of race. At that moment, the *Family of Man* exhibit was touring the globe, a beacon of universal humanity in a world fearful that the Cold War would end in atomic apocalypse.

But if the era of the 1950s is no more, the common truths of a common humanity portrayed in Miller's work endure. A half century after he set out with his camera to explore universal themes in experience as different as warfare and street life and home life, the remarkable insights alive in these photographs command attention.

Amy Dru Stanley
Associate Professor of History, University of Chicago

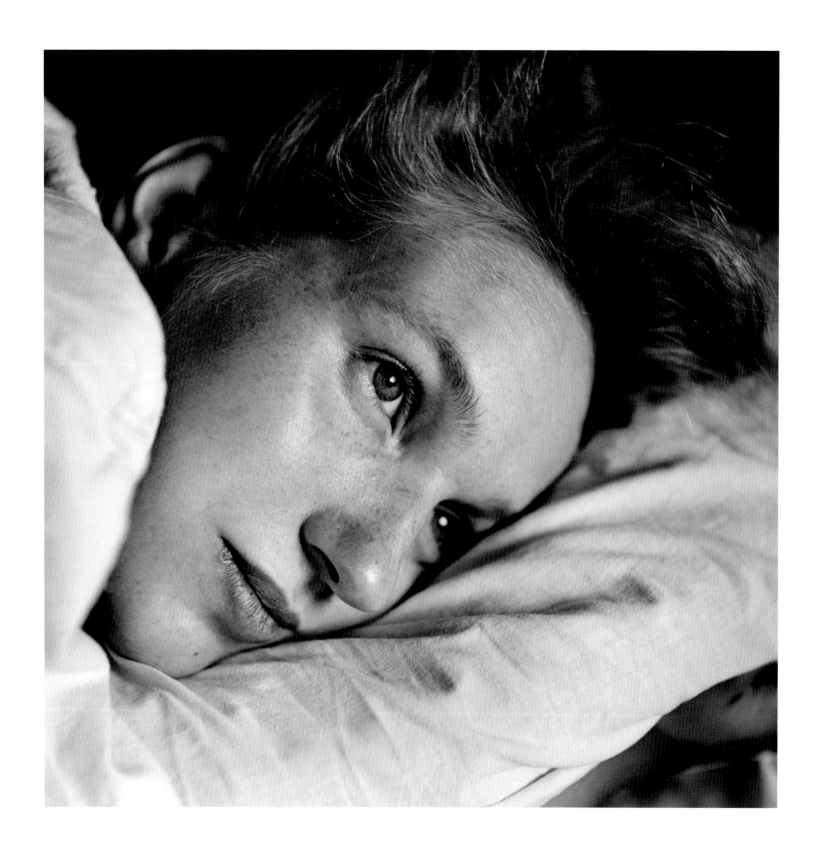

The Beginning

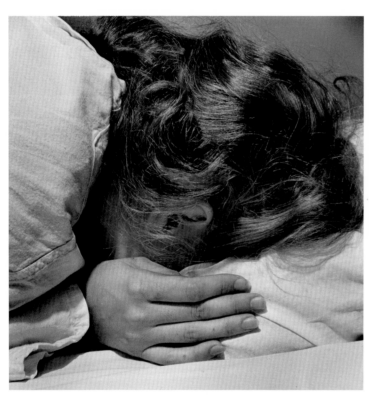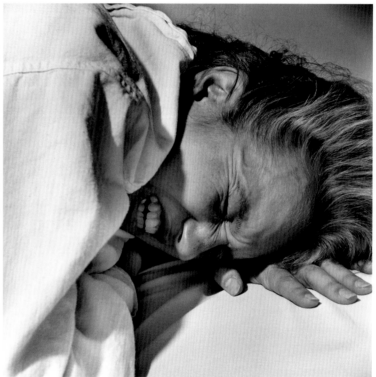

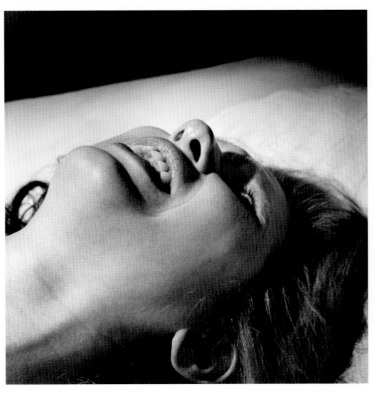
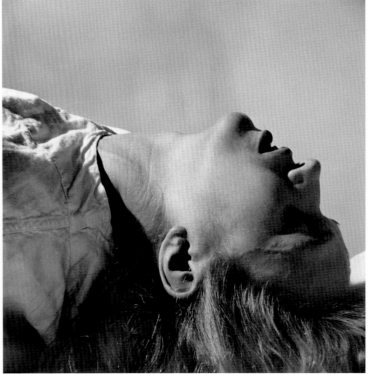

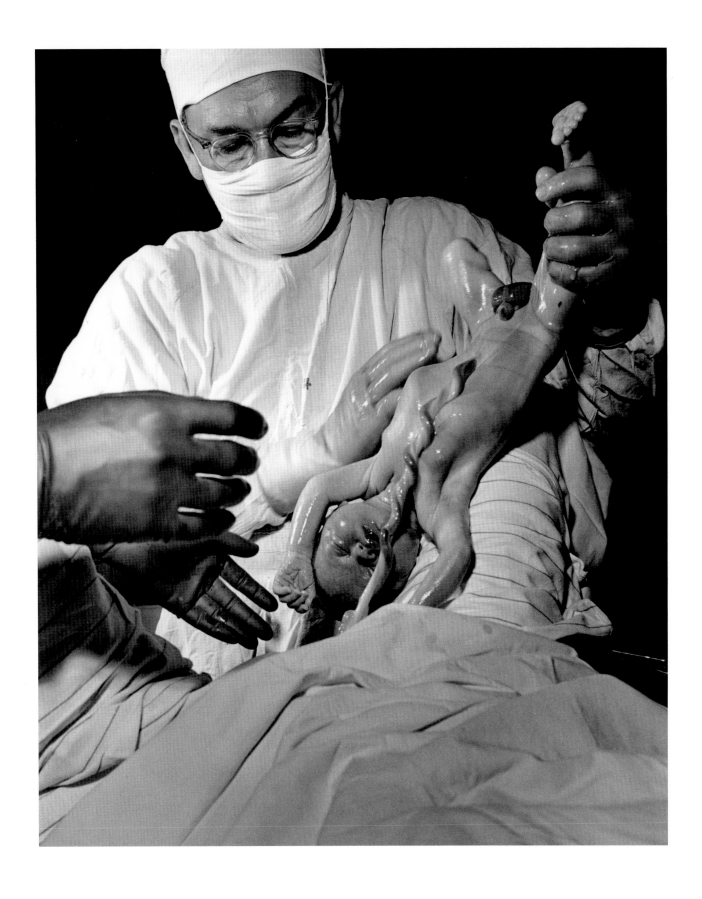

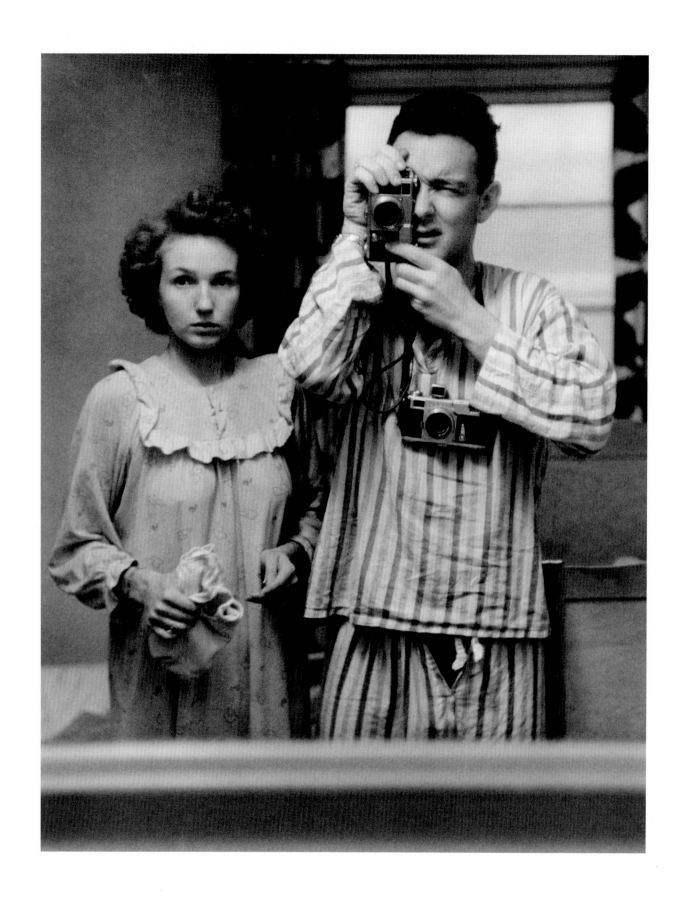

The World is Young

A perceptive man once said that "to look at the world through the eyes of another would be true knowledge." That is what I have attempted here.

It can truly be said that children created this book. No picture among the many thousands that were taken was intended to support any preconceived point of view. Every one shows only what I understood to be happening at the time. If this were not so, these would not be statements of children that are, but illustrations of children that should or might be.

Part of each of us is the child we were. To the extent that we hold on to childhood experiences and understandings, there is a child within, living and directing parts of our adult lives. In the children on these pages it may be possible to see and understand who that child might be.

(Excerpted from Miller's introduction to *The World Is Young*, Simon & Schuster, 1958)

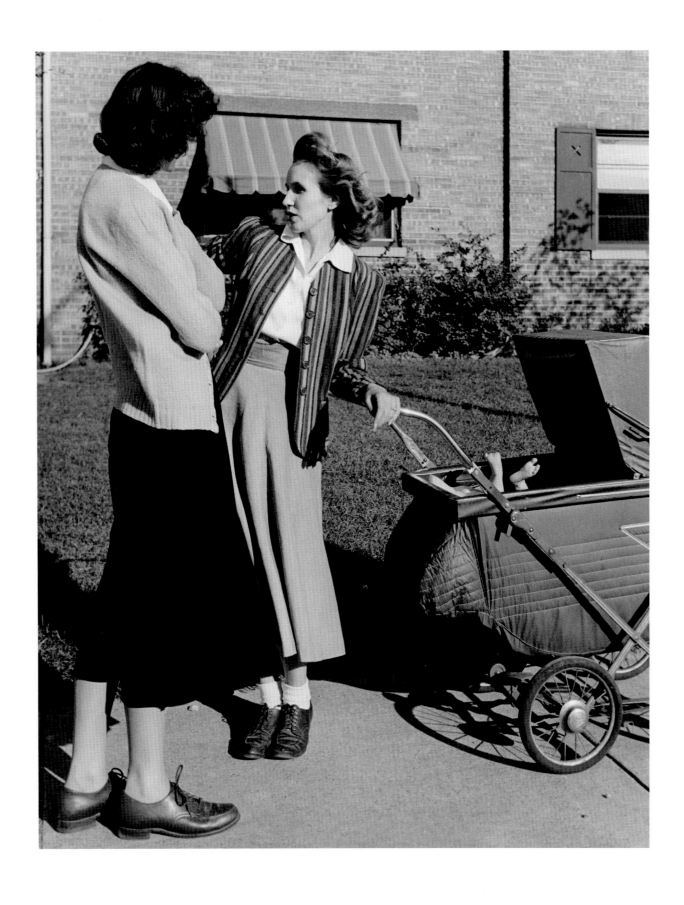

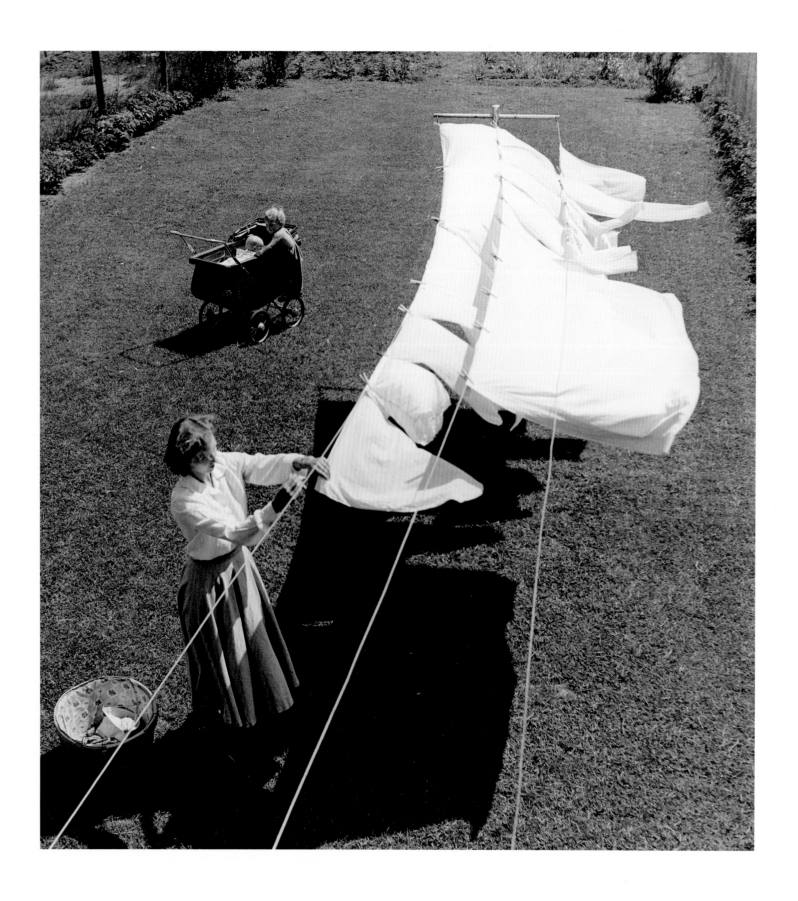

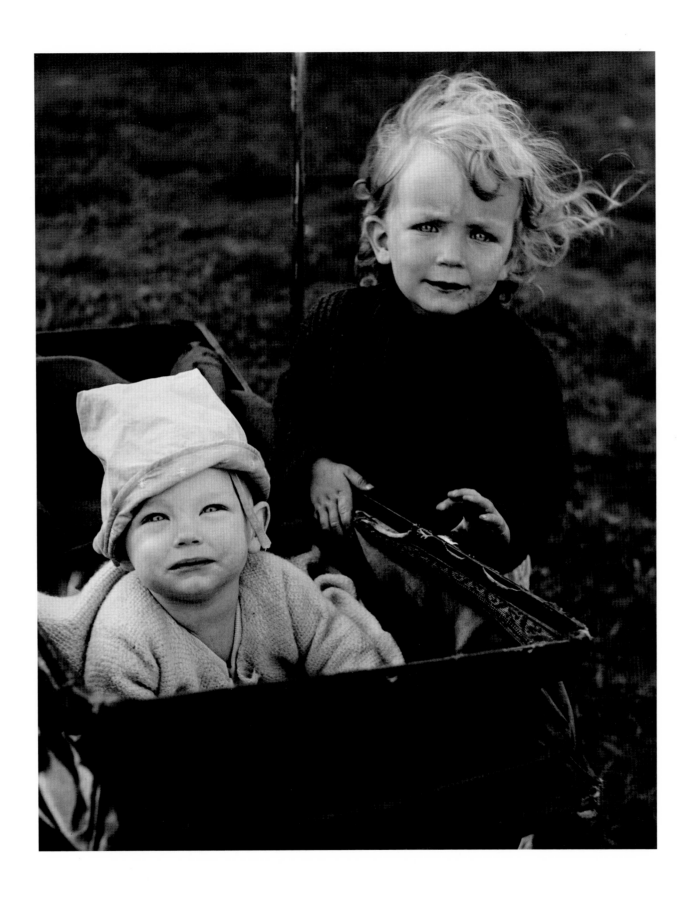

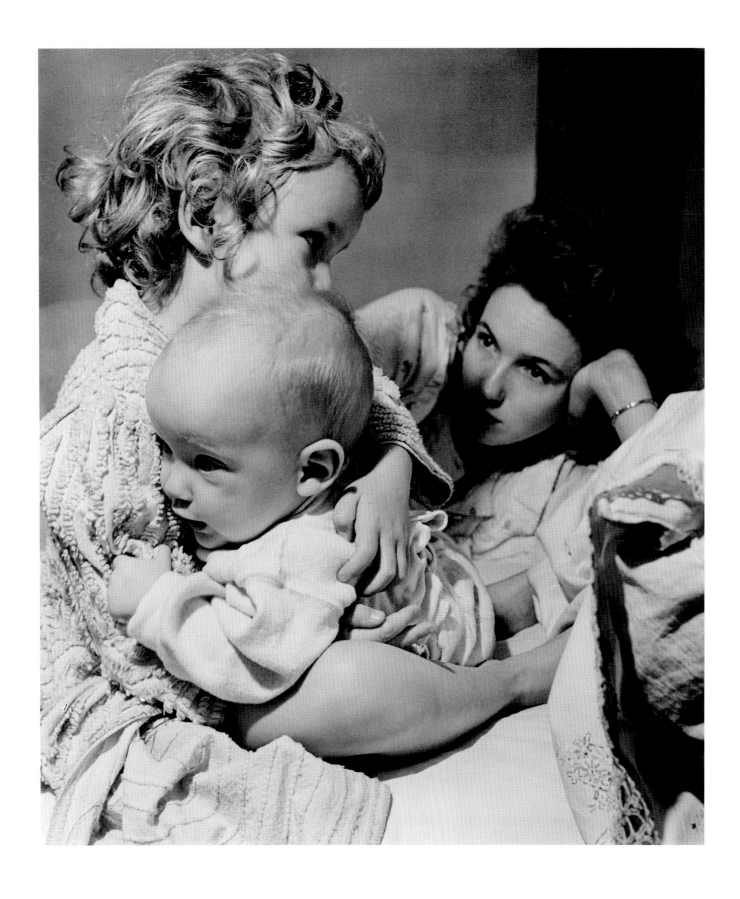

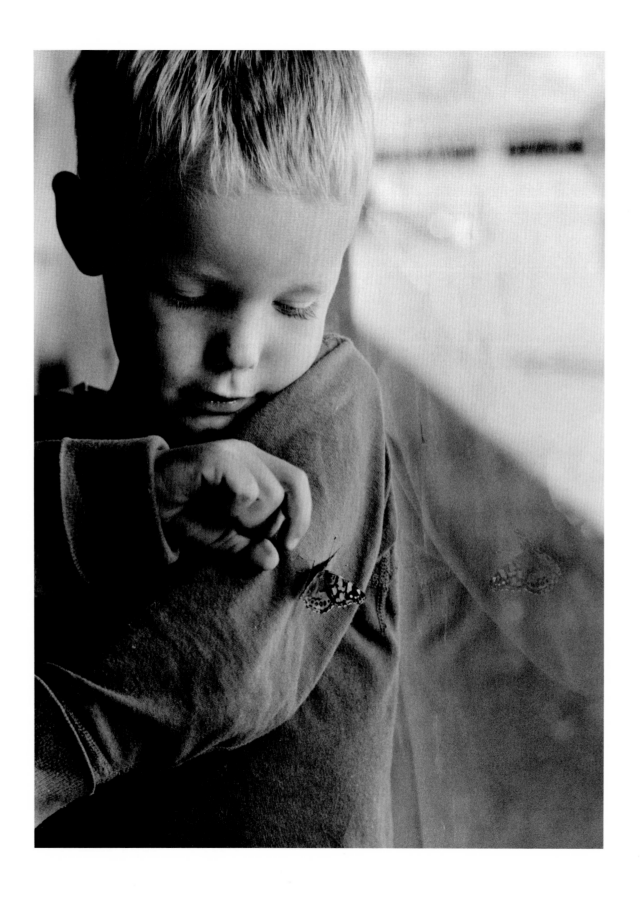

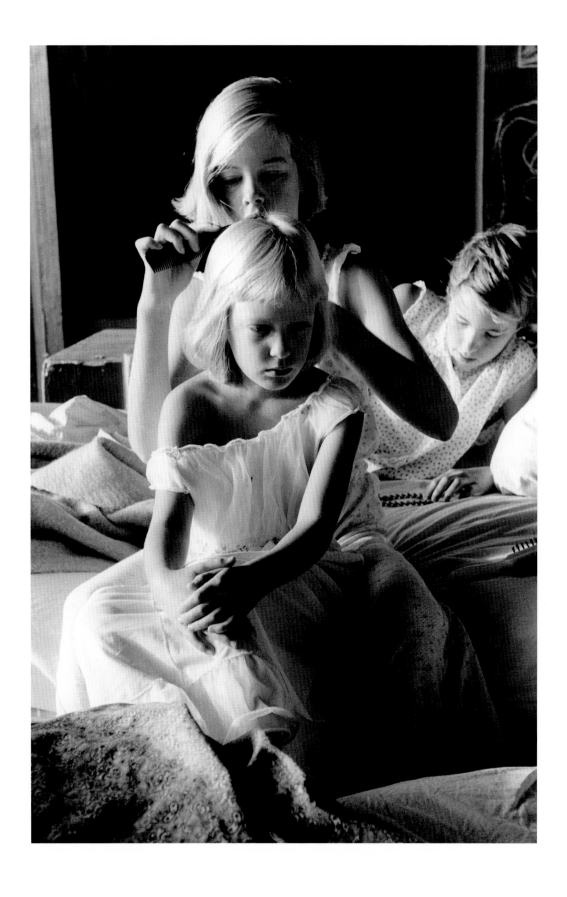

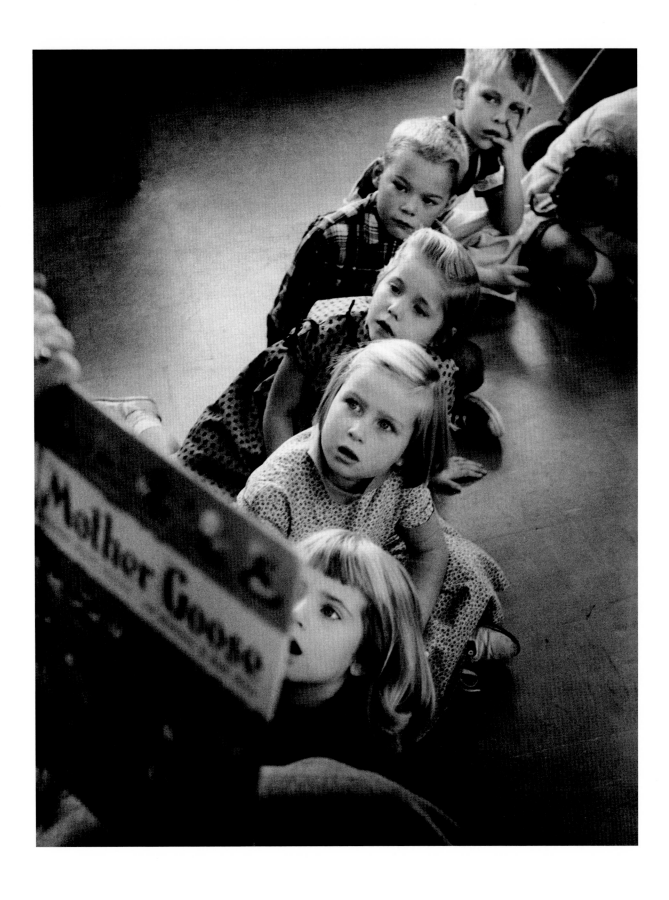

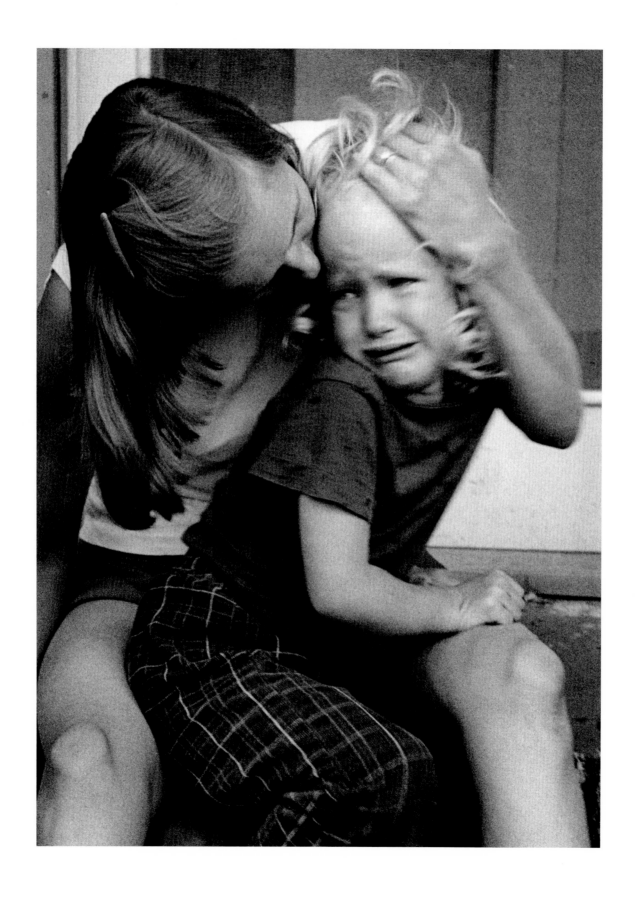

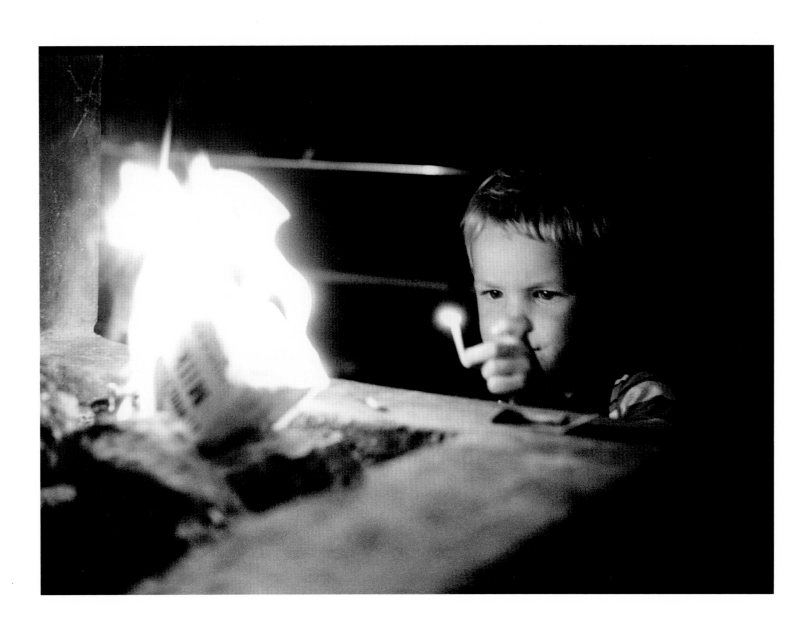

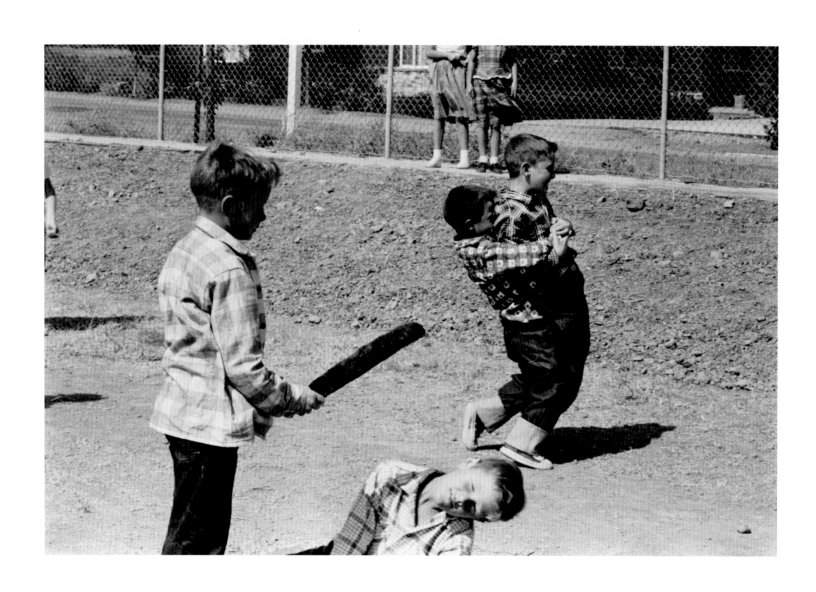

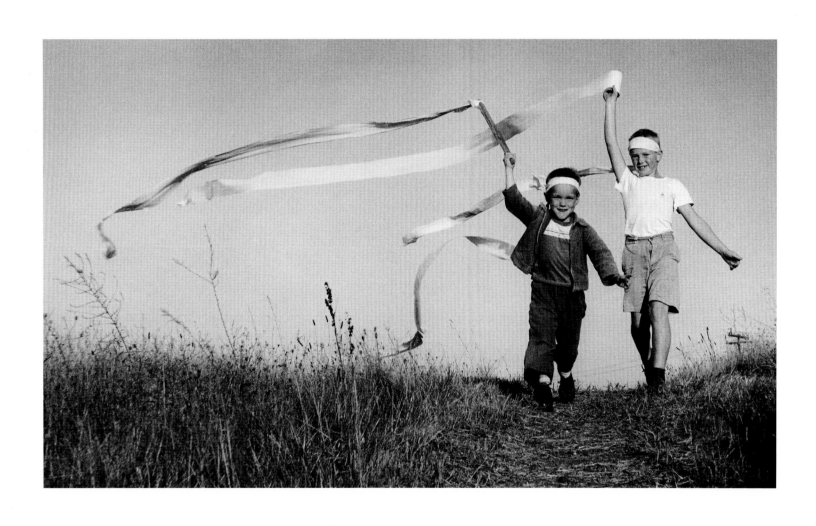

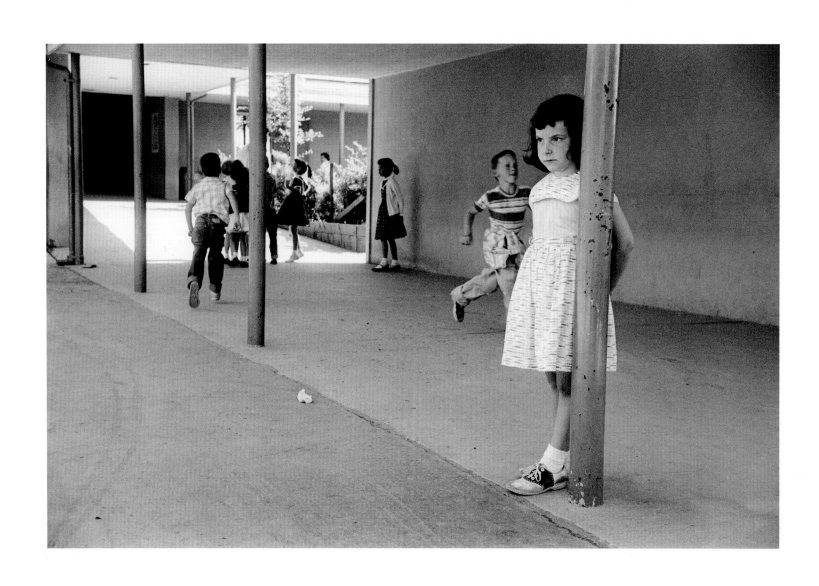

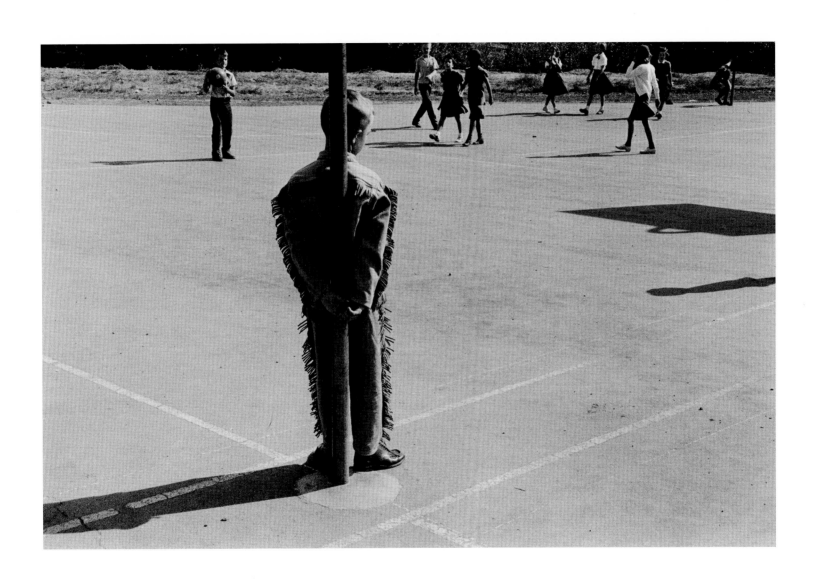

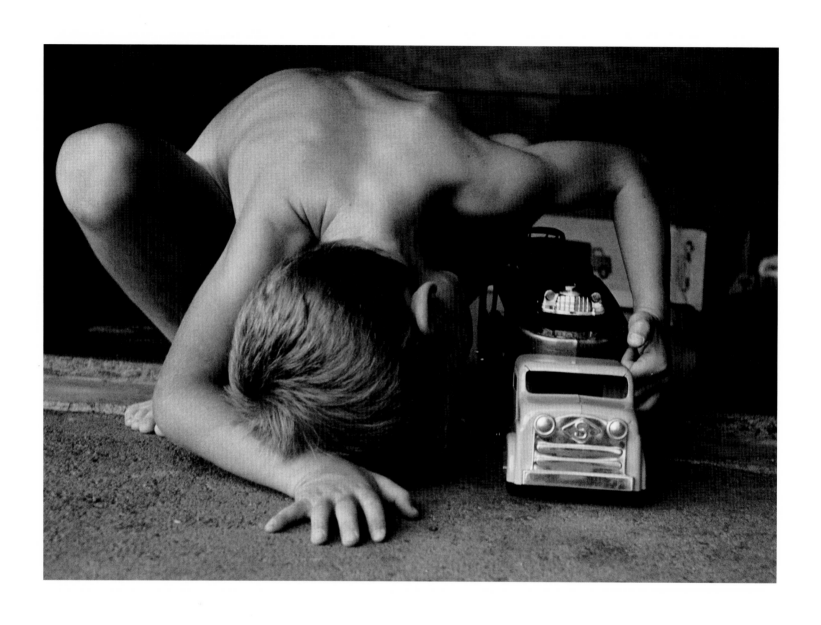

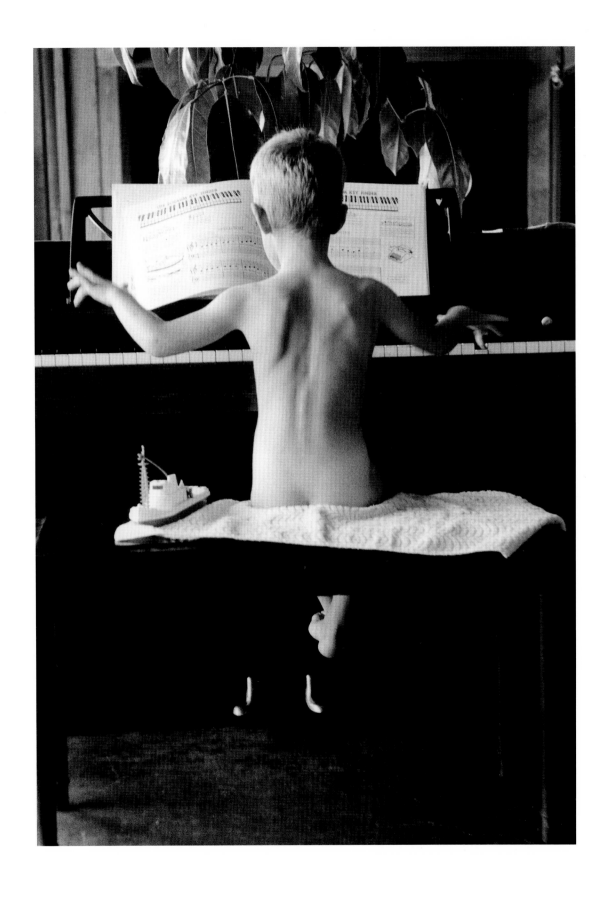

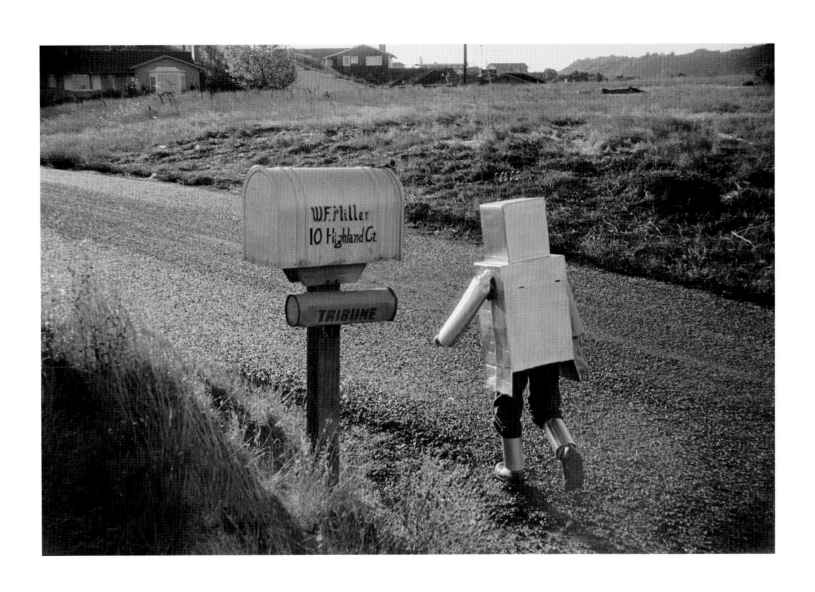

February 20, 1947

My dear Mr. Miller:

 I deeply appreciate
your sending me the bound book of
pictures taken at the time of my
husband's death. I am forwarding
it to the library at Hyde Park to
be kept with other tributes to his
memory.

 With many thanks.

 Very sincerely yours,

Eleanor Roosevelt

Letter to Wayne F. Miller from Eleanor Roosevelt, 1947

Afterword

In the hills near Berkeley, California, Wayne Forest Miller pauses in his home of over half a century and fills his afternoon pipe. He is surrounded by photographs, documents, and souvenirs of a life being lived in full. Decades as a decorated photographer have been followed by decades as an environmental educator, forester, and vintner. Through all of it runs a common thread—love of his family and respect for the family of man. Wayne F. Miller is very American in the best sense of the word. Honor, duty, family, and a love of adventure are integral to his philosophy—and his photography has always been an extension of this.

"Do you believe in God?" I ask Wayne. Withdrawing his pipe and not missing a beat, he answers with the question, "What day of the week is this?" He smiles wryly at his own rhetorical remark and says thoughtfully, "I believe in the goddess of luck."

The goddess long ago took an interest in Wayne. As a young man at the University of Illinois, he strained against convention, opting away from the banking/business template that his hopeful father had designed, pursuing instead the then almost inconceivable career of photography. Wayne left the U. of I. and briefly attended the Art Center in Los Angeles, which proved both rewarding and problematic. The impatient 23-year-old was quick to shift gears when the attack on Pearl Harbor ushered the United States into the Second World War. He signed up, and later joined a unit of combat photographers assigned to Captain Edward Steichen. They were a small, elite crew who were free to view and record the U.S. Navy at war—each man on his own terms—with only Steichen to answer to in any capacity. (Steichen later admitted to the inexperienced Miller that he was accepted into the group solely on the strength of his enthusiasm.)

Steichen's faith proved to be well placed. Miller and his photography thrived in scenarios that took him from battles in the South Pacific to the streets of Naples and from there to India and on to newly surrendered Japan. In Hiroshima he documented the victims of the post-atomic unimaginable with the same humanism he employed in recording the anxious and chaotic lives of the men in the U.S. military.

"I don't see these people that I photograph as being any different than I am," he explains, referring to the Japanese. "Basically, in my work I tried to photograph how I felt the subjects in front of my lens were feeling about their circumstances at the time."

Miller's career path had somehow materialized; his work was satisfying, it mattered, and it was being published. He was making connections in the world of periodicals. The golden age of photojournalism dawned as the world lurched toward the second half of the twentieth century.

Back home and fueled by a resolution to seek ways to avoid such wartime madness in the future through contact and increased understanding, Wayne applied for and received two grants. He was to document the lives of the citizens in Bronzeville, an area of his native Chicago that was home to a great population of African-Americans, many of whom had been lured north during the war by the promise of jobs and the hope of less discrimination. There, from 1946 to 1948, Miller recorded a robust and complex community. He did it with respect and affection, photographing neither with romance nor with condescension. As a mid-century documentary of the black urban working class, this project remains unrivaled in its scope and beauty. When musing upon how he had been able to assimilate to the point where this tall white interloper was allowed to record so many unguarded moments in the intimate lives of his subjects, Miller has no specific answer other than to remember that he was there to watch people, not to observe blacks or negroes, and that his quiet persistence and color-blindness appeared to foster their own tolerance. With "The Way of Life of the Northern Negro," Wayne F. Miller created his second great body of work. During this time he worked freelance and taught at the fabled Institute of Design, Chicago—although his philosophy didn't fit in with the prevailing formalist aesthetic. "I'd go out and grab the day; I didn't sit around and worry about things," says Wayne. "When you pick up responsibilities, you get heavy and your feet don't move so quickly—be it family or ideologies."

After the well-received Guggenheim project, and wanting to avoid being labeled (and thus limited) as a "Midwestern" photojournalist, Wayne and his growing family left Chicago in 1949 and settled in California, but not before his father delivered his first three children. I ask him, "Did it feel strange at all to have your father be the one to deliver your babies?" "No, not in the least," Wayne replies. "Is that because he was such a fine doctor?" "It was because he was such a fine man."

On the west coast Miller continued to pursue his craft as a contract and freelance photographer. From 1952 to 1955, he would also play a crucial role as chief assistant to Edward Steichen (now curator of photography at the Museum of Modern Art) in the production of *The Family of Man*. Much more than a literal display of photographs (Wayne's among them); the exhibition was the greatest event of its kind, unique in concept and celebrating those humanist ideals that Miller had long held close. *The Family of Man*, premiering in 1955, was the first *super show*—a body of imagery greater than the sum of its parts and designed to travel the world with an overriding agenda that sought connection and understanding between peoples in the wake of the most devastating conflict in modern history.

It was a busy time. In July of 1955 He pitched an idea to the publisher Jerry Mason of Ridge Press and received a $10,000 advance to begin what still remains his favorite assignment—his own family. Decrying the dearth of imagery describing and celebrating children and family in a positive light, Miller set out to expand upon a theme he had begun a few years earlier when he created a groundbreaking series of images of his wife Joan giving birth. Titled "The Beginning," it was first published in a 1948 *Photo-Report*, and later shown in Steichen's first exhibition at the Museum of Modern Art. Over the next decade Wayne pursued his exhaustive, elegantly executed project—the daily life of an American family's children—the first comprehensive document of its type. Published in 1958, *The World is Young* quickly became a classic. Meanwhile, he was also traveling widely on various assignments for a variety of periodicals, *Life* chief among them.

Wayne executed more than 150 photographic assignments for *Life* magazine alone during his career. I ask if he got paid immediately for his work or only if and when pieces were published (the potato chip convention story ran seven months after it was shot). Wayne replies, "I'd get paid a day rate on the job. I complained about that because I was getting something like $40 per day. I said [to the editors], "Well, I understand that Gordon Coster gets paid $250 per day!" Wayne pauses for effect and finishes with a grin, "They said, 'Well, that's *true*—but we only used him one day last year!'"

By the 1970s, however, the horizon line of the world of the great news magazines had shifted, as had the philosophy of editorial and documentary photography as defined by the editors. Gone were the days when a burst of creative insight might lead to having an editor green-light a concept by the photographer or writer—especially an idea or story with an indeterminate conclusion. Most photographs were now being employed after the fact—in supporting roles—rather than as contemporaneous actors in unfolding narrative dramas that would soon appear in a *Life* magazine near you.

Despite the unavoidable departure from a career that no longer offered the opportunities and especially the challenges that had once enthralled him, Miller remains essentially unchanged, his current focus having evolved naturally from his interests in people and the land. He developed ideas for the federal government for ways to educate the young in their awareness and regard for the environment, and he purchased a redwood forest and a vineyard to care for and cultivate judiciously, leaving little time for the art of photography.

Wayne has always looked askance at that word, art, especially as it relates to his own photography. Asked if he ever gave much thought to his work as fine art early on, he replies, "Never did. No. I wouldn't know what that meant, frankly."

"So, when people talk to you about it…?" "I change the subject," he answers crisply. "What the hell is fine art? I think fine art is a *day* you've done very well!"

Wayne's attitude can't belie the fact, however, that he has created several of the most important and artistically rewarding bodies of photographic art of the mid-twentieth century. The spirit and gravitas of his pictorial narratives are matched by elegant design and sensitive printing. And his subjects—men at war, the citizens of Bronzeville, urchins of Naples, atomic bomb refugees, his own wife and children, and countless others—are all members of Wayne's extended family. Even a brief pictorial study in 1947 on a high school-age gang in Detroit (executed at no small risk to his personal safety) left Wayne with a cherished memory—the personal connection that members of this gang held for a dedicated teacher for whom they had genuine respect. The teacher came out of school one day to discover that his old car had suddenly been outfitted with four hot new tires. While he appreciated the gesture, he wisely directed the youths to return the stolen merchandise and replace his own worn treads. It was done. Wayne chuckles.

Paul Berlanga
Director, Stephen Daiter Gallery

Plates

Naples, Italy

First appeared in *U.S. Camera Magazine*, December 1944

One of Wayne F. Miller's wartime photo-essays that prefigured his later work with children was Naples. Miller visited the city, going ashore from the USS *Ticonderoga* (while awaiting the invasion of southern France). Recently liberated, the city was teeming with ragtag armies of street urchins, many of whom appeared to be fending completely for themselves. Miller was sympathetic to these resilient little people and was surprised to be informed that most of the vagrant youths were—as a subclass— more of a historical fixture of the city than a result of displacement by the recent conflict. Miller is to this day proud of the salutary telegram that he received from the highly respected W. Eugene Smith. Smith had been in the New York *Life* office when the prints came in to be examined. He looked at the uncredited photographs and knew they had to have been authored by Miller.

Franklin D. Roosevelt Funeral

First appeared in *U.S. Camera Annual*, December 1945

Wayne F. Miller was in Washington, D.C., between operations when the President died April 12, 1945 in Warm Springs, Georgia. Miller met the train bearing Roosevelt's body at Union Station and accompanied the funeral cortège to Lafayette Park across from the White House. He was in uniform and was able to walk unchallenged—often next to the casket-bearing gun carriage and horses—while he photographed the people's responses to the unexpected departure of the fallen leader. Two days later he recorded the burial in Hyde Park.

Miller later met Eleanor Roosevelt unexpectedly while working on an assignment for *National Geographic* Magazine. He was photographing the Hudson River Valley area and unknowingly came upon the Roosevelt family's compound—a group of scenic cottages in the Fall Kill area. Miller knocked on the door of a cottage and none other than Eleanor came to the door wearing an apron. She had been preparing lunch for visiting Russian dignitaries. Miller introduced himself and Eleanor invited him to join the luncheon.

Hiroshima

On August 6, 1945, the American B-29 Superfortress Enola Gay dropped the atomic bomb "Little Boy" on Hiroshima, a Japanese city of about 300,000 people. The force of the atomic blast was greater than 20,000 tons of TNT. According to U.S. statistics, 60,000-70,000 people were killed. Other statistics show that 10,000 others were never found and more than 70,000 were injured. Nearly two-thirds of the city was eradicated.

Within two weeks Wayne F. Miller was there, recording the destruction of the city and the plight of the survivors for the USN. He traveled with *Life* photographer Jay Eyerman and a Japanese translator named Moriyama.

Moriyama had lived in Stockton, California, and had attended the University of the Pacific there. He happened to be in Tokyo at the outbreak of the war, visiting his parents, and was stranded there for the duration. He spent the war as a popular trumpet player on Tokyo radio. He made a gift to Miller for his wife of silk nylons that he had purchased before the war. They were still in the sleeve from the shop at Rockefeller Center, New York.

Miller and his companions shared a railroad car with the recently vanquished Japanese soldiers leaving the Hiroshima area, bound for Tokyo.

Miller remembers: "When the lights went out on the train I really wondered, 'Am I going to be here tomorrow?' You saw [my] pictures—they were like G.I.s! That's who I was photographing! At no time did anyone give me a hard time…. Christ almighty! I just spent four years with them as the enemy and then it was just like changing a channel." (From an interview with Paul Berlanga, 2008)

Brancusi

Published in *Artnews*, October 1954 and *Newsweek*, November 1955

Wayne F. Miller made a brief visit to Constantin Brancusi's Paris studio just after the war. Curtis Publishing's *Magazine X* was about to be launched to compete with *Life* and Miller had been assigned to photograph the great sculptor. He arrived as the afternoon light was beginning to wane. Miller was without an appointment and Brancusi was reluctant to admit him. He did so after the photographer kept repeating the name "Steichen" in different ways. Steichen and Brancusi had become close friends in WWI and he owned several sculptures by the Romanian-born genius. Suddenly completely welcome, Miller entered. Neither man spoke a word of the other's language, but to facilitate communication Miller had brought with him a bottle of cognac, which was well received.

The sculptor insisted (with gestures) on entertaining his guest before any photographs were taken, and Miller became nervous about the diminishing available light by which to work. But the host could not be dissuaded and dinner and drinks preceded pictures. Fortunately, Brancusi had a Victor reflector light stand (with a maddeningly short eight-foot cord) and Miller used it as best he could under the circumstances. He remembers leaving the studio sometime between midnight and two in the morning—and he remembers Brancusi as an exceptionally warm individual. *Magazine X*, however, never materialized.

MIDWEST 1946–49
The Way of Life of the Northern Negro

Appeared in *Ebony*, December 1951

Reefer Party

This essay was shot for *Ebony* magazine. The people portrayed were actual users but the magazine paid for the food and the "sticks" in exchange for their consent to be photographed. Images from this series appeared in *Ebony* Volume III, No. 11, September, 1948; the issue was entitled "Marijuana and Jazz." The featured article, "The Real Truth about Marijuana" by Robert Lucas, focused on the faces of the dope smokers during the subsidized reefer party on Chicago's South Side. During the Depression these "sticks" were a nickel each or three for a dime, but by 1948 the price had risen to between 75 cents and a dollar per joint. This issue of *Ebony* made quite a splash as pioneering exposure in a respected periodical.

During the shoot Miller conversed with the head of the house—which also housed prostitution—the madam. She told Miller the young man lying on the sofa (page 147) was her son. She said, "I don't know what I'm going to do. He just mixes alcohol with the stuff. He just makes it dirty." She spoke as a concerned parent.

Potato Chip Convention

First appeared in *Life* magazine, February 28, 1949

Wayne F. Miller photographed the 1949 National Potato Chip Institute convention at a downtown Chicago hotel. The images capture well the look and feel of a mid-century American business extravaganza. The festivities included a crowned potato chip queen with a potato chip bra, a classic party rhumba line, and a "walking" tin of Jay's Potato Chips (a Chicago-based favorite). Jay's was formerly called Mrs. Japp's Potato Chips.

The name was changed by customer demand soon after the Japanese attacked Pearl Harbor. This photo-essay wound up in print about seven months after it was completed—an unusual but not unheard-of occurrence.

Westminster Dog Show, Madison Square Garden

First appeared in *Chicago Daily News*, May 8, 1948

On a trip to New York, Wayne F. Miller undertook this affectionate and amusing study of the Westminster Dog Show out of personal interest. *Time* magazine reported on the results of the contest on February 23, 1948. Out of 2,540 entries, Champion Ridge Night Rocket, a Bedlington terrier, won "Best in Show." Ridge Night Rocket was also the second dog in history to win both the indoor Westminster and the Morris & Essex show (the "outdoor Westminster").

The terrier, although formidable, most closely resembles a lamb (page 158). Ridge Night Rocket was owned by William A. Rockefeller, a grandnephew of John D. Rockefeller. 1948 was also the first year the competition was televised.

CALIFORNIA 1947–53
Migrant Workers

Enchanted Hills

Rose Resnick (1916–2006) experienced total blindness by the age of three from glaucoma. In 1947, after academic and musical successes, she cofounded the nonprofit Recreation for the Blind with Nina Brandt. In 1950 they opened Enchanted Hills, the first permanent camp for blind children in the country. Resnick served as the camp's executive director until 1958. Her organization then merged with the San Francisco Association for the Blind to form San Francisco Lighthouse for the Blind and Visually Impaired.

San Francisco Police Flying Squad

Wayne F. Miller spent some time in the company of this elite police unit that responded to emergencies throughout the city of San Francisco as they saw fit. This selection of prints gives a sense of Raymond Chandler and have the look of film noir.

Juvenile Detention, Alameda, Oakland

This assignment was shot in 1953 for *Life* magazine through Magnum

FAMILY 1946–58
The Beginning

Appeared in *Photo-Report*, June 1948

"*The universe resounds with the joyful cry I am.*" These words by the poet Scriabin, the Russian composer and pianist, appeared above this image (page 223) when it was reproduced in *The Family of Man*, where Dr. Howard Wayne Miller is delivering David, Wayne and Joan's second child, and his own grandson.

The World is Young

Published in *Life* magazine, October 13, 1958

"I wanted," says Miller, "to let the children speak and act for themselves, not to serve as models to illustrate my or any adult's recollections of what childhood was like…. I have tried to look with children rather than at them and to see through their eyes—and in their forms and faces—the sense and meaning of the experiences that crowd each day when the world is young. Before my eyes…courses were being charted that would be with these children to their dying day[s]. Frustration and defeat, success, pleasure, triumph were being carved into their natures." (Wayne F. Miller, quoted in *Life* magazine Vol. 45, No. 15)

Selected Biography

1918 Born September 19, Chicago, IL

1936-40 University of Illinois, Urbana, Illinois
BS, Business Administration

1940-41 Art Center School, Los Angeles

1942 Married Joan Baker. Four children: Jeanette, 1945; David, 1946; Dana, 1948; Peter, 1951

1942-46 U.S. Navy, Photographer, Lt. USNR
Member of Steichen's USN Combat Photo Unit Citation, USN Institute

1946-48 Guggenheim Fellow. Two concurrent Fellowships to photograph
"The Way of Life of the Northern Negro"

1946-49 Freelance magazine photographer, Chicago
Life, Collier's, Ebony, Fortune, Ladies' Home Journal

1947-48 Instructor in Photography, Institute of Design, Chicago

1949-53 *Life* Magazine, contract photographer, San Francisco

1953-55 "Family of Man" exhibition and book
Principal Assistant to Edward Steichen, Museum of Modern Art, New York City

1955 Chairman, American Society of Magazine Photographers
Memorial Award: American Society of Magazine Photographers
Published *A Baby's First Year* with Dr. Benjamin Spock (Reinhart, Duell, Sloan and Pearce)

1958 Elected Member, Magnum Photos, Inc.
Published *The World Is Young* (Simon and Schuster)
Established a redwood forest tree farm, California

1962-66 President, Magnum Photos, Inc.

1967-70 Special Assistant to the Director, National Park Service, Washington, D.C.
Receives Department of Interior Award for Meritorious Service for developing environmental education programs

1970 Joined the Corporation for Public Broadcasting as executive director of the Public Broadcasting Environmental Center

1972 Yosemite Institute, Founding Board Member

1975 Joan and Wayne Miller named "California Tree Farmers of the Year"
Founding President, Forest Landowners of California

1985 Elected a member, Society of American Foresters

1987-89 President of the Redwood Region Conservation Council

1996 ASMP Photojournalism Award

1999 Japanese edition of *The World Is Young* published by Fukuinkan Shoten

2000 *Chicago's South Side, 1946–1948* published by University of California Press, with essay by Gordon Parks
Honor Award for Distinguished Service in Journalism, University of Missouri, September 22

2001 *An Eye on the World: Reviewing a Lifetime in Photography* published by the University of California—an oral history
with interviews conducted by Suzanne B. Riess and introduction by Daniel Dixon

Acknowledgements

This overview of the photography of Wayne F. Miller is long overdue. It began as an idea almost four years ago when my director Paul Berlanga and I became familiar with the incredible breadth of the work Wayne had accomplished in his first decade and a half as a photographer. Each of our half-dozen visits to Wayne's studio yielded fresh insights and newly discovered images. Thank you Wayne and Joan for your cooperation with and support of our efforts on this project. Who would have thought an initial meeting in 1994 at an Institute of Design reunion in Berkeley would result in this book? A big thank you to Melissa Kaseman, Wayne's assistant, for locating prints for us on short notice and providing information and documents whenever we called.

Thanks to Paul Berlanga and Kim Bourus, my co-editors, for their extraordinary commitment to this project. Paul has put in hundreds of hours doing whatever was needed—including, among many other things, tireless editing and re-editing of text, fact-checking information, and crystallizing insights from numerous discussions with Wayne into a fine afterword. Kim is responsible for our connecting with and securing a contract with powerHouse. Kim calmly guided and muscled the project along from the beginning with unflagging enthusiasm—and her gallery, Higher Pictures, will host the first gallery exhibition of this work. Kim procured the participation of Fred Ritchin, and through him that of Kerry Tremain. We thank you gentlemen for your appreciation of Wayne's work and for producing under pressure. Thanks to Amy Dru Stanley of the History Department at the University of Chicago for lending her talents and perspective to this work, and to the memory of Gordon Parks and the gift to Wayne of his trenchant memoir—a response to Wayne's photography in Chicago's South Side.

My gallery staff deserves praise for their enthusiasm. Jess Mott, for taking our initial image selection and text and designing the maquettes that sold powerHouse on this book. Thanks to Adam Holtzman and Lucas Zenk for their youthful eyesight and experienced opinions on print quality. To Michael Welch for his invaluable help on the initial image selection for the book.

Heartfelt thanks go out to powerHouse: Daniel Power and Craig Cohen, the publishers, whose deep commitment to the project built on our initial ideas. Kiki Bauer for her good design, Daoud Tyler-Ameen for his concerned editing, John McWilliams for his proofreading assistance, and Sara Rosen for her valuable opinions on publicity and marketing. Jon Scott and our friends at JS Graphics (Chicago) for their exceptional scans.

To Magnum Photos Inc., where Wayne has been a member for the last 50 years. Magnum supplied certain images to this project, offered other assistance, and plans to feature the new volume on their website. Magnum has also been instrumental in keeping the somewhat reticent artist's work in the public eye, and has published his work in books such as *Arms Against Fury: Magnum Photographers in Afghanistan* (2002), also published by powerHouse.

I thank you all.

Stephen Daiter
Founder, Stephen Daiter Gallery

Wayne F. Miller in particular would like to thank Kerry Tremain, whom he has come to consider a close friend. Not only has Kerry written the principal text for this volume, but almost a decade ago he co-curated a University of California-sponsored exhibition of Wayne's Bronzeville photography that closely informed the subsequent publication, *Chicago's South Side*.

WAYNE F. MILLER
PHOTOGRAPHS 1942–1958

© 2008 powerHouse Cultural Entertainment, Inc.
Photographs © 2008 Wayne F. Miller/Magnum Photos
Introduction © 2008 Fred Ritchin
"Seeing Feeling" © 2008 Kerry Tremain
Essay © 2000 Gordon Parks, originally published in *Chicago's South Side, 1946–1948*
(University of California Press, 2000)
"When We Were Young" © 2008 Amy Dru Stanley
Afterword © 2008 E. Paul Berlanga

Published in the United States by powerHouse Books,
a division of powerHouse Cultural Entertainment, Inc.
37 Main Street, Brooklyn, NY 11201-1021
telephone 212 604 9074, fax 212 366 5247
e-mail: waynefmiller@powerHouseBooks.com
website: www.powerHouseBooks.com

First edition, 2008

Library of Congress Control Number: 2008932368

Hardcover ISBN 978-1-57687-462-2

Printing and binding by Midas Printing, Inc., China

Duotone separations by Colourscan, Singapore
Book design by Kiki Bauer

Edited by Stephen Daiter
Co-edited by Paul Berlanga, Stephen Daiter Gallery, and Kim Bourus, Higher Pictures

Exhibitions:

Higher Pictures: September 18–November 8, 2008
www.higherpictures.com

Stephen Daiter Gallery: November 7, 2008–January 3, 2009
www.stephendaitergallery.com

Charles A. Hartman Fine Art: January 8–February 21, 2009
www.hartmanfineart.net

Southeast Museum of Photography: November 15, 2008–February 19, 2009
www.smponline.org

For Wayne F. Miller copyright and reproduction inquiries, please contact Magnum Photos at www.magnumphotos.com

A complete catalog of powerHouse Books and Limited Editions is available upon request;
please call, write, or visit our website.

10 9 8 7 6 5 4 3 2 1

Printed and bound in China